The Changing Status of the Artist

ART AND ITS HISTORIES

The Changing Status
of the Artist

EDITED BY EMMA BARKER, NICK WEBB, AND KIM WOODS

Yale University Press, New Haven & London
in association with The Open University

First published 1999 by Yale University Press in association with The Open University

10 9 8 7 6 5 4 3 2

Library of Congress Cataloging-in-Publication Data

The changing status of the artist / edited by Emma Barker, Nick Webb, and Kim Woods.
 p. cm. - - (Art and its histories : 2)
 Includes bibliographical references and index.
 ISBN 0-300-07740-8 (h/b). - - ISBN 0-300-07742-4 (p/b)
 1. Artists- -Italy- -History- -16th century. 2. Artists- -Italy- -Social conditions. 3. Artists- -Europe- -History- -16th century. 4. Artists- -Europe- -Social conditions. I. Barker, Emma. II. Webb, Nick, 1959- . III. Woods, Kim. IV. Series.
N6915.C45 1998
701'.03'09409031 - - dc21 98-23734

Edited, designed and typeset by The Open University.

Printed in Italy

a216b2i1.1

1.1

Contents

Preface

This is the second of six books in the series *Art and its Histories*, which form the main texts of an Open University second-level course of the same name. The course has been designed both for students who are new to the discipline of art history and for those who have already undertaken some study in this area. Each book engages with a theme of interest to current art-historical study, and is self-sufficient and accessible to the general reader. This second book examines the figure of the artist as one of the key concepts that have helped to shape the discipline of art history. More specifically, it focuses on the changing status of the artist between the fifteenth and seventeenth centuries. As part of the course *Art and its Histories*, it includes important teaching elements and the text contains discursive sections written to encourage reflective discussion and argument.

The six books in the series are:

Academies, Museums and Canons of Art, edited by Gill Perry and Colin Cunningham

The Changing Status of the Artist, edited by Emma Barker, Nick Webb, and Kim Woods

Gender and Art, edited by Gill Perry

The Challenge of the Avant-Garde, edited by Paul Wood

Views of Difference: Different Views of Art, edited by Catherine King

Contemporary Cultures of Display, edited by Emma Barker

Open University courses undergo many stages of drafting and review, and the book editors would like to thank the contributing authors for patiently reworking their material in response to criticism. We are especially grateful to Nicola Durbridge, who worked tirelessly to improve the arguments and content of the book. Special thanks also go to Professor Will Vaughan, who provided detailed and constructive criticisms of an early draft of this book and whose ideas and comments influenced the development of the text. The course editor was Julie Bennett, picture research was carried out by Tony Coulson with the assistance of Jane Lea, and the course secretary was Janet Fennell. Debbie Crouch was the graphic designer, and Gary Elliott was the course manager.

Historical introduction: the idea of the artist

EMMA BARKER, NICK WEBB, AND KIM WOODS

The status of the artist is a valid subject for investigation in many different societies and historical periods. Why then has sixteenth-century Europe been singled out as the principal focus of this book? The choice has been made on the grounds that it allows us to trace a crucial shift from the artist as mere artisan belonging to a craft guild to the artist as a creative and learned personality, admired not just for acquired skills but also for innate ability (what we might today call talent or even genius). These developments are most clearly documented in Renaissance Italy but can also be traced elsewhere in Europe. A crucial role was played by the artist and writer Giorgio Vasari (1511–74), whose *Lives of the Artists* did much to establish the pre-eminence of Italian Renaissance art as an object of emulation and scholarship for generations to come. This book seeks to counterbalance this Italian bias by concentrating on artistic practice in Northern Europe, which has until recently been very much the 'poor relation' of Italy.

The second and third parts of the book are concerned with this area: the second part explores the diversity of artistic practice in Germany and the Netherlands during the sixteenth century while the third shifts forward in time to consider the cases of a seventeenth-century Dutch artist and an eighteenth-century French one. In the first part of the book, however, we examine the Italian context in which the question of the 'changing status of the artist' has most usually been discussed. This historical introduction sets the scene by considering some of the major changes in artistic practice that can be documented in Italy from the fourteenth century onwards, culminating in the emergence of a new conception of the artist as a gifted creator. First of all, however, let us consider our own inherited preconceptions about what it means to be an artist.

The concept of the artist-genius

To describe someone as 'an artist' has somewhat different connotations from saying that they are a painter or a sculptor. Rather than specifying what a person does in order to earn a living, the word conveys the idea of a special kind of human being. Most of us will have a fairly clear set of expectations about what such an individual would be like, taking our cue from a pervasive stereotype of the artist. Conventionally, he (the pronoun is deliberate[1]) is imagined as an isolated figure of exceptional creative powers who suffers for his art. Consider, for example, how the French artist Eugène Delacroix (1798–1863) represented *Michelangelo in his Studio* (Plate 1). In this painting of 1850, we see Michelangelo in solitude apart from the ghostly presence of two sculptures. He is not shown working on either of them but brooding over his

[1] See footnote 3 in Case Study 1 on page 33, where this point is expanded.

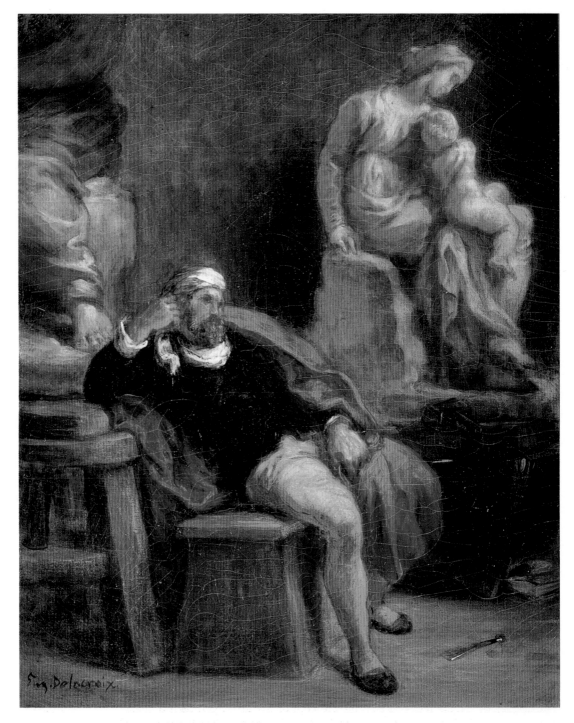

Plate 1 Eugène Delacroix, *Michelangelo in his Studio*, 1850, oil on canvas, 41 x 33 cm, Musée Fabre, Montpellier.

art, his head resting on one hand and his gaze suspended in mid air. This attitude suggests that the creative process is infinitely mysterious, beyond the ken of lesser mortals. It also seems to involve mental anguish; the chisel on the ground suggests that the great artist may have cast his tools aside in a fit of dejection. The image is based on the established iconography of melancholy, exemplified by Albrecht Dürer's engraving *Melencolia I* (Plate 115) (see Case Study 6).

Michelangelo in his Studio gives expression to Delacroix's self-consciousness about his own identity as an artist. It presents the Italian sculptor as a model of the imaginative power and absolute dedication that the French painter aspired to emulate. This image of Michelangelo was drawn from various sources, all of which characterize him as solitary and melancholic. The association between imagination and melancholy is an ancient one (see Case Study 6), which started to be reformulated in terms that anticipate the modern concept of the genius during the Renaissance. However, it was only around 1800 that the emphasis shifted decisively away from the skill of the painter or sculptor to the exceptional personality of the creative artist. It has since been popularized in countless biographies, novels, and films. *The Agony and the Ecstasy* (1965), for example, a Hollywood film based on a best-selling book by Irving Stone, starred Charlton Heston as Michelangelo struggling to paint the Sistine ceiling in the face of endless setbacks (Plate 2). The film's director, Carol Reed, declared that his aim was to portray an artist 'tormented by self-criticism ... a man who thought of his art as an act of self-confession' (Walker, *Art and Artists on Screen*, p.50).

The point that can be drawn from the above discussion is that our own attitudes are inescapably affected by the legacy of the cultural movements of the first half of the nineteenth century now known as Romanticism. Artists and writers of this period were the first to set the highest value on imagination, originality, spontaneity, creativity, and self-expression. Rejecting the prevailing insistence on conformity to a set of approved rules and models,[2] they declared that the work of art should reflect the individual sensibility of its creator. No one simple explanation can adequately account for such a decisive shift in aesthetic values, but it is clear that this transformation is bound up with major economic and perhaps also political developments (this is the period both of the Industrial Revolution and of the French Revolution). More specifically, the idea of the artist-genius is bound up with the emergence of the category of 'fine art' as an activity quite distinct from everyday life (in previous ages, 'art' had not been clearly differentiated from humble, workaday 'craft'). The new emphasis on the creative genius, a solitary figure free from all rules, can be understood as a kind of reaction to the loss of any precise social function for art and the resulting marginalization of artists.

The crucial point, however, is that the concept of the artist-genius is at least as much a kind of myth as it is a historically grounded reality. It surrounds art with a fascinating aura of mystery and drama that effectively compensates for the loss of its original functions. Today, for example, few people who visit

[2] These rules and models were prescribed by academies of art: see Perry and Cunningham, *Academies, Museums and Canons of Art* (Book 1 in this series).

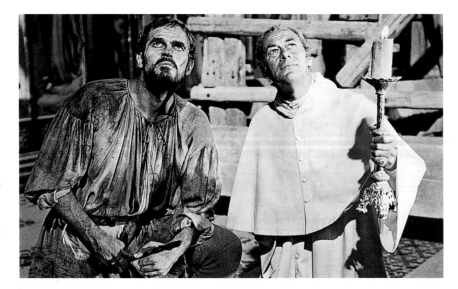

Plate 2 Still from the film *The Agony and the Ecstasy*, 1965, directed by Carol Reed. Photo: Ronald Grant Archive.

the Sistine Chapel in the Vatican in Rome are primarily motivated by piety. Rather, the vast majority of those who throng the Chapel, craning up at the ceiling, are there to admire a masterpiece by Michelangelo Buonarroti (1475–1564), which happens to have been commissioned by Pope Julius II to the greater glory of God. The cult of the great artist exerts a decisive influence over our whole experience of viewing art. If we are told that a particular statue is the work of Michelangelo, we will almost certainly look at it in a quite different way than if it were by some obscure sixteenth-century Italian sculptor. The attribution to Michelangelo will also massively inflate the price that it can be expected to fetch on the art market, something which helps to explain the eagerness of specialists in this field to claim (however unconvincingly) that a newly discovered sculpture is indeed from his hand. What matters in such cases is not so much the technical skill manifested in the work of art as the magic power of a great name.

In recent years, the whole concept of the artist-genius has been subjected to systematic critique. Griselda Pollock, for example, has argued forcefully against the prevailing assumption that the artist is a special kind of individual who expresses his unique personality in his work. Pollock bases her case on material relating to the Dutch painter Vincent Van Gogh (1853–90), the modern archetype of the tortured genius, with particular reference to *Lust for Life*, another film biography based on an Irving Stone novel.[3] However, she does not confine her critique to representations of the artist in popular culture, but argues that the idea of the artist-genius also underlies traditional art-historical practice, which takes the standard forms of the monograph (a study of the artist's life and work) and the *catalogue raisonné* (a catalogue of all the works that constitute the *oeuvre* or complete output of the artist). This preoccupation with the individual artist and, in particular, the belief that all the works by the same person can be understood by reference to his biography,

[3] The case of a late nineteenth-century artist such as Van Gogh cannot properly be considered without reference to the concept of the 'avant-garde': see Wood, *The Challenge of the Avant-Garde* (Book 4 in this series).

serves to 'remove "art" from historical or textual analysis by representing it solely as the "expression" of the creative personality of the artist' (Pollock, 'Artists, mythologies', p.59). Pollock instead proposes a history of artistic *production*, locating the meaning of works of art within a complex network of social relations and representational conventions. This approach tends to reject the very notion of artistic *creation*.[4]

Such critique is based on the contention that the myth of the artist-genius has an ideological function. Its proponents argue that the freedom and creativity associated with the artist superficially differentiate him from ordinary people but, on a more fundamental level, identify this figure as the epitome of what (so it is generally believed) it means to be a human being. The insistence on regarding works of art as the expression of genius, without any connection to social institutions or economic forces, thus testifies to and validates a belief in 'individual human agency'. That is, the idea that the artist is an autonomous creator, a completely free agent, serves to obscure the fact that (so the argument runs) everybody's consciousness is shaped by pre-existing socially constructed codes of meaning. It follows that nobody can express a unique personality in a truly individual style. The figure of the artist-genius can also be viewed as an ideological construct in respect of gender and race. Not only is the great artist invariably male but all the most famous names in the history of art are either European or (since the mid-twentieth century) North American. From this perspective, the cult of the artist is simply one aspect of the specifically modern, western conception of the autonomous, self-possessed individual often known as humanism.[5]

It is, however, important to stress that these arguments represent only one position, even though it is a very influential one, within the current practice of art history. In any case, the critique of the mythology of the artist-genius does not simply mean that we ought to interpret works of art without reference to artists. On the contrary, it can be argued that it makes it all the more important to examine the processes by which certain artists have been singled out from the rest and the criteria by which their work has been judged to be great art. If we no longer take the inherent greatness of a Michelangelo or any comparable figure for granted, then we need to find an explanation for the undeniable fact that they have widely been regarded in these terms. This involves considering not only the career and achievements of such an artist but also how this exceptional renown relates to the collective status of the artistic profession. In the process, we undoubtedly move away from the individualist approach of traditional art history but do not thereby necessarily lose sight of artists as creative, innovative agents. For one thing, as this book shows, they have played an important part in the construction of their identity and made many claims on their own behalf.

[4] T.J. Clark, for example, in 1974 felt obliged to ask if the word was allowable any more (see his essay 'The conditions of artistic creation', in Fernie, *Art History and its Methods*, p.249).

[5] Humanism in this general sense needs to be distinguished from the sixteenth-century humanist movement discussed on pages 15–19. See also the definition of humanism in Fernie, *Art History and its Methods*, pp.343–4.

From craftsman to court artist

Even the briefest of surveys reveals that there is nothing fixed and invariable about the status of the artist. Our modern veneration for the artist-genius stands in striking contrast to the disdainful attitude that can be found in some ancient texts. In the first century, the Roman philosopher Seneca declared, 'One venerates the divine images, one may pray and sacrifice to them, yet one despises the sculptors who made them' (Kris and Kurz, *Legend, Myth and Magic*, p.41).[6] During the period that we call the Renaissance, however, it is possible to discern elements of both attitudes and the situation that then prevailed was correspondingly complex. Consider, for example, a letter written in 1470 to the Duke of Ferrara by the Italian painter Francesco del Cossa (*c*.1436–78), in which the latter complained that all the artists working on a series of fresco paintings for the Duke at the Schifanoia Palace (Plate 3) were being paid by the same rate per square foot of wall regardless of reputation.[7] Cossa did not succeed in obtaining the higher rate that he claimed was his due on account of the name that he had made for himself and of his sustained studies into his art (this latter claim relates to the notion of the learned artist, which we will discuss below).

This letter can be used as evidence that certain artists were now asserting an individual reputation that set them apart from other members of their profession. From this perspective, Cossa's aspirations need to be set in the context of contemporary debates about art that would give rise to a new, exalted conception of the artist in the sixteenth century. Alternatively, the letter can be taken to demonstrate the relative lowly status of a painter who cannot expect his patron to regard him as anything better than a decorator. The crucial point here is that we should not simply assume that the transformation of the artist's status mentioned at the beginning of this introduction took the form of a unified development that can be traced in a linear fashion. On the contrary, not only did conditions of artistic practice differ from country to country, but even within Italy[8] we need to distinguish between different social contexts. The position of artists at a princely court like Ferrara could vary greatly from that of artists working in a city like Florence, where an artist could achieve great renown (as, for example, in the case of Filippo Brunelleschi, who is mentioned below). Despite Cossa's experience, however, employment at court usually offered greater opportunities for artists and could significantly boost their reputations (we will return to this point below).

[6] Other Roman writers commented that even Pheidias, a sculptor who worked on the carvings for the Parthenon in the fifth century BCE, could not escape their disdain. On the role of Pheidias in the construction of the Parthenon, see Colin Cunningham, 'The Parthenon marbles', in Perry and Cunningham, *Academies, Museums and Canons of Art* (Book 1 in this series).

[7] For the contents of the letter, see Welch, *Art and Society in Italy*, pp.121–2 and Edwards, *Art and its Histories: A Reader*.

[8] It is important to realize that during this period 'Italy' as we know it today did not actually exist; the peninsula was divided up into a great many separate states.

Plate 3 Francesco del Cossa and Cosmè Tura, *The Month of April*, c.1467–72, fresco, Palazzo Schifanoia, Ferrara. Photo: Scala.

If the idea that the Renaissance was a period in which the artist's status was rising cannot be regarded as unproblematic, the same goes for the stereotypical picture of the medieval artist as an anonymous craftsman (as the first case study in this book will show). Nevertheless, the fame achieved by individual artists in the period before 1400 does not necessarily have significant implications for the status of the artistic profession as a whole. In most Italian cities during the fourteenth and fifteenth centuries, the activities of artists, like those of other craftsmen, were regulated by guilds, which monitored standards of work and endeavoured to control competition by outsiders. In Florence, painters belonged to the guild of doctors and apothecaries, although in other cities they often had a guild of their own. Sculptors could be members of the goldsmiths, stonemasons, or carpenters guild, depending on the materials they used and the city they lived in. For both painters and sculptors, the fundamental unit of production was not the individual artist but the workshop, in which artefacts would be made more or less in collaboration. Under these conditions, art constituted a trade based on apprenticeship rather than a personal vocation based on talent. Artists tended in consequence to have relatively humble social origins.

Within this system, what we now regard as the 'fine arts' of painting, sculpture, and architecture were not set apart from the applied or decorative arts (such as embroidery or goldsmithing). A single workshop would often make anything from altarpieces to painted furniture. All such activities were regarded in a highly disdainful light by learned commentators who classified the skills involved as mere 'mechanical arts' as opposed to the more exalted 'liberal arts'. The fundamental distinction between these two categories was that the first involved manual labour while the second required the activity of the mind. Whereas the mechanical arts were further tainted by association with monetary gain, the liberal arts were cultivated by gentlemen as worthy activities in their own right. The liberal arts consisted of four subjects concerned with measure (arithmetic, music, geometry, and astronomy, known as the quadrivium) and three based on the use of language (grammar, logic, and rhetoric, known as the trivium). An important challenge to the categorization of painting and sculpture was made by the Florentine artist Cennino Cennini (c.1370–c.1440). In his treatise on art of around 1400, Cennini argued that these arts should be classified as liberal arts, and subsequently other writers took up this claim.

However, as with the letter by Cossa, we need to be careful in using Cennini's treatise as evidence of a new, exalted conception of the artist's vocation. It is largely concerned with the materials and methods that would be required by a craftsman ready to cater to all kinds of requirements. In particular, it offers advice on the training of apprentices within a painter's workshop. The standard procedure was for them to be set to copy drawings from the collection built up by the master of the workshop, not just his own but also drawings by other masters as well. Although we might assume that the end result of such a training would be a uniform workshop style, Cennini actually states that the aspiring artist should eventually develop his own individual style. This remark seems to manifest a distinctive concern with originality and creativity – although it should be recognized that we may be underestimating the esteem accorded to these qualities in the craft tradition. Overall, we can characterize Cennini's text as a point of transition between

the world of the craftsman and the ambitions of the artist. The very fact of its being a treatise on art by a practitioner makes it significant in this respect, even though it is less scholarly than later examples.

In spite of the fact that artists made many new claims on their own behalf during the Renaissance (this subject will be explored in Case Study 2), their social position remained relatively low throughout the period. It is said, for example, that Michelangelo's father, a government official, initially opposed his son's choice of profession. Michelangelo himself insisted: 'I was never the kind of painter or sculptor who kept a shop. I was always taught to avoid this for the sake of my father and my brothers' (Burke, 'The Italian artist and his roles', p.7). Although he regarded sculpture as his vocation, Michelangelo refused to be identified as a sculptor because of its associations with artisanal labour. As this indicates, the manual labour involved in modelling and carving meant that sculpture was often held to be a more mechanical pursuit than painting. The disdain of ancient writers (as in the comment of Seneca quoted above) finds an echo in the writings of the Italian artist Leonardo da Vinci (1452–1519), who compared the sweaty, dusty figure of the sculptor to a baker. At this date, around 1500, Leonardo was still complaining that painting had been excluded from the liberal arts.

Nevertheless, a significant upgrading of the artist's status can be discerned by the sixteenth century. A select group of artists, including Michelangelo and Raphael (1483–1520) in Rome and Titian (1488–1576) in Venice, achieved unprecedented wealth and fame. Several were knighted or ennobled. However, their attainment of this new status should not simply be attributed to individual 'greatness'. A crucial role was played by transformations in artistic patronage during the Renaissance. The expanding power and wealth of Italian rulers such as the Medici dukes in Florence[9] and the papacy in Rome provided opportunities to execute projects on a massive scale (like the ceiling of the Sistine Chapel). They also enabled the artists in their service to escape from the control of the guilds. In 1540, for example, Pope Paul III formally freed Michelangelo and other sculptors at the court of Rome from the obligation to belong to the local guild. At the same time, however, the position of court artist involved its own kind of servitude (as in Cossa's case), as well as the risk of having princely favour withdrawn (see, for example, the discussion in Case Study 3 of Benvenuto Cellini's relationship with his royal patron, Francis I of France). A large proportion of the most renowned artists of the sixteenth and seventeenth centuries, both in Italy and elsewhere, can be defined as court artists.

Humanism and the idea of the artist

As we have seen, the changes in the status of the artist during the Renaissance represented a shift away from the craft tradition. At the same time, it is possible to discern a new conception of the artist as a learned individual who had made a serious study of his art. This was fostered by the emergence of the academy as a new form of art institution to rival the workshop. The art academy originated in relatively informal gatherings of artists. One of the first recorded examples was presided over by the Florentine sculptor Baccio Bandinelli (1488–1559) in Rome in the 1530s (see Plate 4, which shows a group

9 Florence, formerly a republic, finally fell under the control of the Medici family in the 1530s. Duke Cosimo I became Grand Duke of Tuscany in 1569.

of artists sketching by candlelight). In the long run, academies came to provide a new kind of artistic training, including drawing from the live model and classical statues as well as the study of perspective, anatomy, and proportion and also ancient literature. The first official art academy was the Florentine Accademia del Disegno,[10] founded in 1563, with Michelangelo and Duke Cosimo I de' Medici as honorary presidents. It was dedicated to painting, sculpture, and architecture, by then defined as the three arts of design. Academies were also established at Perugia in 1573, Bologna in 1582, and Rome in 1593.

In order to understand the emergence of the new elevated conception of the artist institutionalized by the academy, we need to consider the wider cultural context in which it took place. A key role was played here by the intellectual movement known as 'humanism', which can broadly be defined as the revival of interest in classical literature and learning that took place in Renaissance Europe. (It is worth noting at this point that the word Renaissance means 'rebirth'.) Humanism carried implications for many different aspects of human endeavour, including politics and, most significantly for our purposes, art. In particular, it encouraged a new focus on the virtues and deeds of individual human beings who had left their mark on history. For artists, this not only meant that they might receive commissions for monuments commemorating famous men but also made it conceivable for them to attain comparable fame themselves.

Plate 4 Enea Vico, *The Academy of Baccio Bandinelli*, *c*.1535, engraving, 30.2 x 43.7 cm. © The British Museum, London.

[10] *Disegno* means 'drawing' but carries connotations of mental activity as well as manual dexterity. See, for example, the definition of design by Vasari in his *Lives of the Artists*, vol.I, p.249 (extract in Fernie, *Art History and its Methods*, p.39).

A major role was played here by the accounts of Greek painters and sculptors by the first-century Roman writer Pliny the Elder. These appear in his *Natural History*, which became the object of renewed interest during the Renaissance. Although the status of the Roman artists of Pliny's day was not assured, his history provided powerful evidence for the esteem enjoyed by artists in ancient Greece. It was thus a great compliment for an artist of the Renaissance to be compared to, for example, the fourth- and fifth-century BCE Greek painters Apelles and Zeuxis, even though none of their work had survived from antiquity. Among other passages that offered precedents for according a new status to artists was Pliny's life of the Greek painter Eupompus. He describes Eupompus as the first learned painter to be well versed in arithmetic and geometry 'without which, so he held, art could not be perfect' (*The Elder Pliny's Chapters*, p.119). Pliny reports too that it was through his influence that drawing became a respectable part of a liberal education. Drawing, he explains, was classified as a 'free art', which no slave was permitted to practice. This passage was cited by many Renaissance artists, both in Italy and Northern Europe, including Domenicus Lampsonius in his *Life of Lambert Lombard* (see Case Study 4). In his influential guide to polite conduct, *The Courtier* (1528), the Italian courtier Baldassare Castiglione (1478–1529) cited Greek precedent to show that drawing and painting were worthy and even necessary accomplishments for gentlemen.

The broad implications of humanism for artists are threefold. In the first place, it encouraged emulation of ancient models in art. The rediscovery of ancient art in Italy during the Renaissance parallels the revival of ancient literature. (However, this does not mean that the use of classical forms by artists should simply be attributed to humanist influence.) Secondly, it encouraged artists to aspire to the fame achieved by their ancient predecessors with the possibility of being memorialized in a biography in their turn. One such biography was written in the 1480s, for example, on the celebrated architect Filippo Brunelleschi (1377–1446), whose greatest achievement was the construction of the dome of Florence Cathedral. Thirdly, it gave rise to a new conception of the learned artist. In his important humanist treatise, *De pictura* (*On Painting*) (1435), the Florentine architect and scholar Leon Battista Alberti (1404–72) insisted that the artist should be 'as learned as possible in all the liberal arts' (*On Painting*, p.90). His treatise demonstrates the application to painting of principles derived from both mathematics and rhetoric.[11] He was probably as much concerned to elevate the status of painting in the eyes of noble patrons as to provide practical instruction for young artists.

Alberti dedicated *Della pittura*, the Italian translation of his Latin text, not to a painter but to an architect, Brunelleschi.[12] We might note here that architecture was held in somewhat higher regard than painting and sculpture

[11] Rhetoric (also known as oratory) is the art of using language for the sake of effect. The Latin texts on oratory by the Roman writers Cicero (106–44 BCE) and Quintilian (30–100) were fundamental works for the humanists and also for art theorists during the Renaissance, especially Alberti. Narrative or history paintings with figures, known as *istorie* (singular, *istoria*), are fundamentally rhetorical in their use of drama and emotion to make an impact on the viewer. (Examples are discussed in Case Study 1.)

[12] The techniques of perspective outlined by Alberti in his treatise had been pioneered by Brunelleschi.

during this period. It was believed to subsume the two other arts within itself and thus to be superior to them. The architect was also protected from the taint of manual labour since he primarily directed work done by others. The notion of the learned architect derived support from a treatise on architecture by the first-century Roman architect Vitruvius, which had been known during the Middle Ages but attracted new attention after the humanist-inspired discovery of a better manuscript in 1418. Among other topics, Vitruvius discussed the use of the human body as a standard of measurement, which was of interest to artists as well as architects (Plate 5). Alberti wrote his own architectural treatise, *De re aedificatoria* (*On the Art of Building*) (*c.*1452) on the model of Vitruvius' text in order to make its principles more accessible. Several sixteenth-century architectural treatises also draw on Vitruvius, including the *Four Books of Architecture* (1570) of the Italian architect Andrea Palladio (1508–80). Palladio's career is crucial for the establishment of architecture as a respectable and learned profession.

For painters, humanism made its most direct impact in opening up a new range of subject-matter, based on ancient precedent. Alberti actually recommends that artists should associate with poets and orators who could suggest new 'inventions' for their paintings. As an example, he cited the description or 'ekphrasis' (the building up of a picture in words) by the first-century Greek writer Lucian of a lost painting, *The Calumny of Apelles*, which represents the denunciation of an innocent youth by a group of evil-doers.

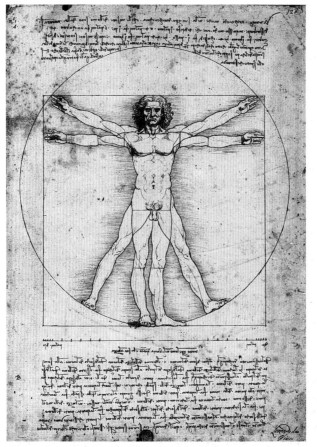

Plate 5 Leonardo da Vinci, '*Vitruvian Man*' (*Human Figure Inscribed in a Square and a Circle*), 1492, pen and ink on paper, 34.4 x 24.5 cm, Galleria dell'Accademia, Venice. Photo: by courtesy Soprintendenza ai Beni Artistici e Storici di Venezia.

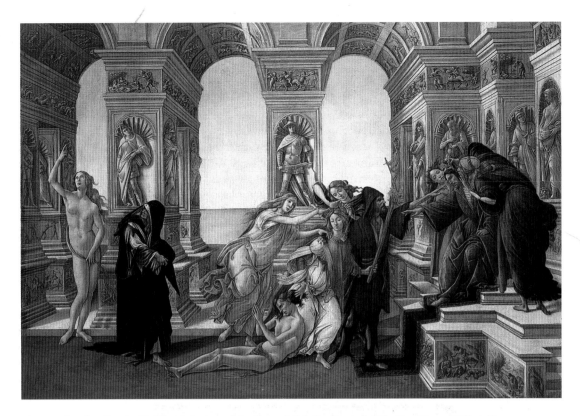

Plate 6 Sandro Botticelli, *The Calumny of Apelles*, c.1494–5, oil on panel, 62 x 91 cm, Uffizi, Florence. Photo: Scala.

An attempt to reconstruct this painting was made by the Florentine artist Sandro Botticelli (1446–1510), whose depictions of mythological and allegorical subjects are presumed to reflect the interests of humanist patrons (Plate 6). *The Calumny* was widely taken to exemplify the notion of a 'poetic' painting, justifying the statement in the *Arts poetica* (*Art of Poetry*) by the first-century BCE Roman poet Horace to the effect that poetry and painting are equal because both create through the exercise of the imagination. Since poetry was a branch of rhetoric, this text was very useful to art theorists seeking to show that painting ought to be classified with the liberal arts. Cennini, for example, wrote that painting 'calls for imagination and skill of hand ... it justly deserves to be enthroned with theory and to be crowned with poetry' (*The Craftsman's Handbook*, p.2). Most importantly for our purposes, these parallels gave rise to a new rhetorical language for discussing art which was shared by artists and their noble patrons. 'Invention' and 'imagination' are key terms in this language, as is *ingegno*, which is discussed in Case Study 2.

Vasari and the artist as hero

In the long term, the most important of the texts on the visual arts written in Renaissance Italy is undoubtedly *The Lives of the Artists* by Vasari, which was first published in 1550 and republished in a substantially revised and expanded edition in 1568. It charts the 'rebirth' and progress of Italian art from the fourteenth century up until the present through the contributions of individual artists. Both its biographical format and the conception of artistic

progress as the revival of the achievements of antiquity allow the *Lives* to be identified as a humanist work. The same can be said of the criteria for artistic excellence that Vasari outlined for the benefit of present and future artists (he played a pivotal role in the foundation of the Florentine Academy). Vasari was a native of Tuscany and had a long association with the ruling Medici family, so it is hardly surprising that the three phases of development into which he divides his history of Italian art are all initiated by Florentines. Although the *Lives* did much to establish Italian art as an aesthetic norm, prejudicing the assessment of Northern European artists who were less likely to write learned treatises or belong to academies, it did have imitators elsewhere. Karel van Mander (1548–1606), for example, has been called 'the Dutch Vasari' largely on account of the artists' lives that he included in his 1604 treatise, *Het Schilderboek* (*The Painter's Book*) (see Case Study 4).

In humanist fashion, Vasari documented and described individual lives as a means of presenting an instructive moral. He sought to define the *virtù* of each artist, that is, not merely his virtues but rather his distinctive character as an artist. Many of the lives begin with introductions explaining why their subjects deserve to be admired and emulated by other artists or, on occasion, why their careers should be taken as salutary warnings. The Florentine painter Paolo Uccello (1397–1475), for example, is said to have squandered his natural gifts as a result of his obsession with the technicalities of perspective, ending up 'solitary, eccentric, melancholy and poor' (*Lives*, vol.I, p.95). As this reveals, the figure of the isolated artist was then a more negative image than it would later become. The artist who most perfectly embodies the social virtues of the artist is Raphael, whose modesty, goodness, and perfect manners matched the courtly ideal of Castiglione. However, the hero of the *Lives*, the artist whose career is presented as marking the culmination of the 'rebirth' of art, is not Raphael but Michelangelo (he was Vasari's teacher and a Tuscan, naturally). His love of solitude, Vasari insisted, was not a sign of eccentricity but a mark of exemplary devotion to art. The contrast between the two artists' characters found its corollary in the different contributions that each was said to have made to the progress of art.

Michelangelo exemplified the Renaissance ideal of the universal artist, one who excelled in all three of the arts of 'design'. According to Vasari, he had been sent into the world by God in order to show other artists how to bring all the arts to a state of perfection. Works by the 'divine' Michelangelo were thus quite literally miraculous. In his account of the painting on the ceiling of the Sistine Chapel of God creating Adam (Plate 7), Vasari declares that the figure of Adam is so beautiful that 'it seems to have been fashioned by the first and supreme creator rather than by the drawing and brush of a mortal man' (*Lives*, vol.I, p.356). The image continues to be widely regarded as a powerful demonstration of the artist's god-like power to create form out of matter. However, while Vasari undoubtedly anticipates modern ideas of artistic creation, he also emphasizes the role of God as the ultimate creator.[13] For Michelangelo himself as well as for art theorists of the period, the visual conception (*concetto*) of the artist was not a purely personal vision but the expression of a divine ideal. A sonnet written by the artist suggests that the

[13] Vasari associated the arts of design with God's creation of the universe in his preface to the *Lives*, vol.I, p.25 (extract in Fernie, *Art History and its Methods*, p.29).

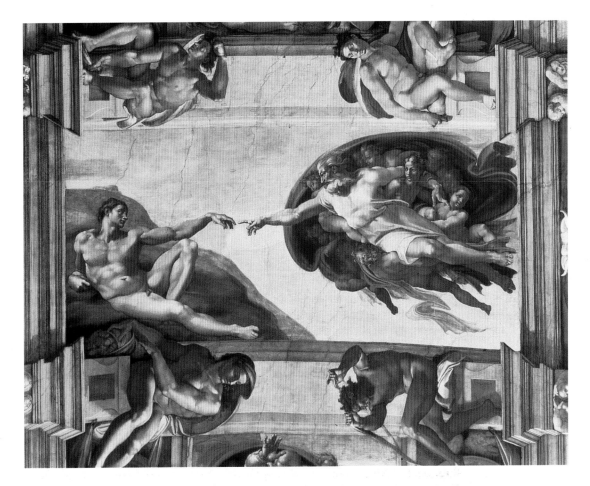

Plate 7 Michelangelo, *The Creation of Adam*, 1508–12, fresco, ceiling of the Sistine Chapel, Vatican Museums and Art Galleries, Vatican City. Bridgeman Art Library, London / New York.

material form can never quite do justice to the mental image.[14] Nevertheless, Vasari clearly regarded Michelangelo as a profoundly original artist. Raphael, by contrast, is characterized as a skilful and judicious borrower, whose graceful, balanced style was formed through careful study of the work of many other artists, especially the figures painted by Michelangelo on the Sistine ceiling.

Of special importance to the question of artistic innovation is Vasari's account of Michelangelo's design for the New Sacristy or Medici Chapel at the church of San Lorenzo in Florence. Here, Vasari explains, 'he departed a great deal from the kind of architecture regulated by proportion, order, and rule which other artists did according to common usage and following Vitruvius and the works of antiquity but from which Michelangelo wanted to break away' (*Lives*, vol.I, p.366). Later, Vasari adds, Michelangelo developed these new ideas in the library at San Lorenzo, creating a particularly startling effect with the strange breaks in the steps in the entrance hall (Plate 8). Here, the

[14] For the text of the sonnet, see Kemp, *Behind the Picture*, p.198, where it is discussed with reference to Michelangelo's attitude to artistic conception, and Edwards, *Art and its Histories: A Reader*.

notion of a 'rebirth' of art in Italy on the model of ancient art gives way to a celebration of artistic progress going beyond anything that had been done in antiquity. Vasari declares that Michelangelo and perhaps also Raphael have actually surpassed the ancients. There is, however, an element of ambiguity here, for while Vasari claims artists are now so accomplished that they can free themselves from the rules, he also expresses the fear that the arts have progressed so far that they can only decline from this point. Vasari thus has a basically organic conception of artistic development in terms of birth, maturation, and decline, which has proved immensely influential on art history.[15]

With regard to the discipline of art history as a whole, Vasari's fundamental legacy has been to establish the idea of the history of art as a progression of great artists building on each other's achievements. His book is perhaps the most important ancestor of the modern art-historical monograph, which (as we noted earlier) interprets an artist's work by reference to individual personality and experience. He was certainly not the first to view works of

Plate 8 Michelangelo, staircase of the entrance hall, Laurenziana Library, Florence, *c.*1524–34. Photo: Biblioteca Laurenziana / Alberto Scadigli.

[15] See Fernie, *Art History and its Methods*, p.23. This model of art history can be viewed as a projection of the development of the individual artist (youth – maturity – old age) discussed below.

art in these terms. A maxim had circulated since the fifteenth century to the effect that 'every painter paints himself'. Nor does he ignore the social context in which works of art were produced as totally as some later writers would. The contribution made by the patron is not only acknowledged but also celebrated. Indeed, Vasari's text was to a large extent directed towards an élite of patrons associated with the ducal and papal courts. (Taking its cue from Vasari, *The Agony and the Ecstasy* gives almost as large a part to Michelangelo's patron, Pope Julius II, as to the artist himself, centring on the close yet stormy relationship of two great men.[16]) Undoubtedly, the *Lives* did much to reinforce the idea of the artist as a special kind of person, through its elaboration of an exemplary biographical framework based on existing lives of saints and other notable figures. It provides, for example, a detailed account of the honours paid to Michelangelo after his death, even claiming that the coffin was opened to reveal no decomposition 25 days after death, a conventional sign of sainthood.

Most crucial perhaps, at least for the art-historical monograph, is the contribution made by the *Lives* to the view that the style of the artist evolves over the course of his life, as youthful efforts are succeeded by the achievements of maturity which in turn give way to the late works. A famous passage in Vasari's life of Titian differentiates between the artist's early and late style, the one characterized by careful finish and the other by loose, bold brushwork (*Lives*, vol.I, p.458). Later writers have come to assume that the last works of a great artist should manifest a profound mastery that moves beyond conventional practice and also a shift towards a greater spirituality that testifies to his sense of his own impending death. The concept of a 'late style' can be exemplified with reference to Michelangelo's *Rondanini Pietà* (Plate 9), on which he is said to have worked only days before his death. The poignancy of this sculpture is enhanced by the way that the Madonna and the dead Christ are fused into a single form (although it should be said that the near abstract look can be explained by the fact that it is actually unfinished). It undoubtedly had an intensely personal meaning for the devout and highly self-conscious Michelangelo. In evaluating any such work of art, however, we need to bear in mind how much we may be projecting onto it, on the basis of our reverence for the artist and of what we know (or think we know) of the circumstances in which it was made. This was already noted in antiquity by Pliny: 'the last works of artists and the pictures left unfinished at their death are valued more than their finished pictures ... The reason is that we see traces of the design and the original conception of the artists, while sorrow for the hand that perished at its work beguiles us into the bestowal of praise' (*The Elder Pliny's Chapters*, p.169).

[16] The circumstances of an artist like Michelangelo who worked on commission for patrons were fundamentally different from those of later artists who produced works for sale on an open market and ran the risk of finding that nobody would buy them. These latter circumstances to some extent explain the Romantic notion of the neglected artist.

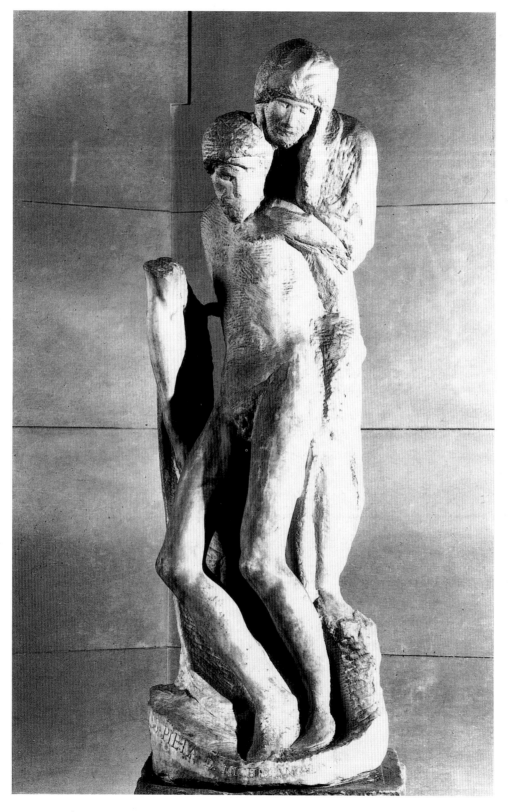

Plate 9 Michelangelo, *Rondanini Pietà*, 1564, marble, height 195 cm, Castello Sforzesco, Milan. Photo: Saporetti.

References

Alberti, L.B. (1966) *On Painting*, ed. and trans. J.R. Spencer, New Haven and London, Yale University Press.

Burke, P. (1994) 'The Italian artist and his roles', in *The History of Italian Art*, trans. E. Bianchini and C. Dorey, Polity Press, vol.1, pp.1–28.

Cennini, C. (1960) *The Craftsman's Handbook: The Italian "Il libro dell'arte"*, ed. and trans. D.V. Thompson, Jr, New York.

Edwards, S. (ed.) (1999) *Art and its Histories: A Reader*, New Haven and London, Yale University Press.

Fernie, E. (ed.) (1995) *Art History and its Methods: A Critical Anthology*, London, Phaidon.

Kemp, M. (1997) *Behind the Picture: Art and Evidence in the Italian Renaissance*, New Haven and London, Yale University Press.

Kris, O. and Kurz, E. (1979) *Legend, Myth and Magic in the Image of the Artist*, New Haven and London, Yale University Press.

Perry, G. and Cunningham, C. (eds) (1999) *Academies, Museums and Canons of Art*, New Haven and London, Yale University Press.

Pollock, G. (1983) 'Artists, mythologies and media – genius, madness and art history', *Screen*, vol.21, no.3, pp.57–96.

The Elder Pliny's Chapters on the History of Art (1977) ed. E. Sellers and trans. K. Jex-Blake, Chicago (first published London, 1896).

Vasari, G. (1987) *Lives of the Artists*, vol.I, ed. and trans. G. Bull, Harmondsworth, Penguin.

Walker, J. (1979) *Art and Artists on Screen*, Manchester University Press.

Welch, E. (1994) *Art and Society in Italy 1350–1500*, Oxford University Press.

Wood, P. (ed.) (1999) *The Challenge of the Avant-Garde*, New Haven and London, Yale University Press.

PART 1
BIOGRAPHY AND THE
IMAGE OF THE ARTIST

Introduction

KIM WOODS

The aim of the first part of the book is to investigate the status of Italian artists from the fourteenth to the sixteenth centuries through three very different sets of sources. Evidence in this relatively early period is sometimes hard to come by, and constructing the artistic identities of artists can be a difficult task. For all the artists about whom we have information, there are countless more about whom we know nothing, whether through political bias (Vasari was really interested only in Tuscan artists, for example) or mere accident of history. In his *Commentaries*, the Florentine sculptor Lorenzo Ghiberti (c.1381–1455) expressed profound admiration for one Master Gusmin, goldsmith of Cologne. Goldsmiths' work was particularly vulnerable to being melted down for its materials when money was short or fashions changed. Indeed, according to Ghiberti, it was experience of this that drove Master Gusmin to abandon his art and become a hermit. Try as they might, art historians have never succeeded in identifying either work or information connected to this enigmatic figure. Against this background of loss, the salt-cellar discussed in Case Study 3 and the autobiographical information that we have related to it are of magnified importance.

One of the lessons to be learned from this part of the book is to use what information we do have circumspectly, while resisting the temptation to draw hasty conclusions where we have few facts on which to base them. The first case study shows us how the accounts given of the artists Ambrogio and Pietro Lorenzetti in Ghiberti's *Commentaries* and Vasari's *Lives* only take us so far in answering questions of status, and can even mislead by imposing an inappropriate Renaissance perspective on fourteenth-century artists working under very different conditions. Ghiberti and Vasari commend Ambrogio Lorenzetti for producing impressive *istorie*[1] a century before Alberti codified the genre in his treatise *On Painting*. More fundamentally, the signature on Ambrogio Lorenzetti's work belies Vasari's assumption that artistic identity did not matter in the period before the Renaissance.

There are, in fact, several examples of European artists who achieved personal renown before the Renaissance period, many of them connected to the courts. An exception to the anonymity of most manuscript illuminators in the Middle Ages is the French artist Jean Pucelle (c.1300–c.1355), whose name is known

[1] See footnote 11 in the historical introduction on page 17.

Plate 10 (Facing page) Ambrogio Lorenzetti, detail of *The Presentation in the Temple* (Plate 15).

Plate 11 Jean Pucelle, *The Crucifixion* and *The Adoration of the Magi*, 1325–8, grisaille and colour on vellum, 8.8 x 6.4 cm, *Hours of Jeanne d'Evreux*, fols 68 verso and 69 recto. Photo: © 1991 The Metropolitan Museum of Art, New York. The Cloisters Collection, 1954, MS 54.1.2.

from documentary sources and inscriptions in surviving manuscripts. His status as an illuminator of rare quality is testified by the fact that the Book of Hours[2] of Queen Jeanne d'Evreux, wife of Charles IV of France, which was illustrated by Pucelle in 1325–8, is ascribed to him by name in Jeanne's will of 1371 (Plate 11). By the time this appears in the inventory of bibliophile Jean, Duc de Berry (1340–1416), brother of Charles V of France, it is described simply as the 'Hours of Pucelle'. Although such examples may be the exceptions that prove the general rule of anonymity, they do show that the Lorenzetti brothers were not just an isolated case.

The second case study presents us with artistic evidence in the form of artists' self-portraits, in which artists deliberately construct and promote specific self-images. It is perhaps less important for our purposes to know whether the self-images corresponded to reality than to see that this is how artists wished to present themselves to the world. The self-portrait may have been a personal self-revelation or a status-conscious image that placed the artist on a par with his aristocratic patrons. Parallels may be drawn with artists

[2] A Book of Hours is designed for the use of a lay person wishing to follow the monastic offices, and often contains richly illuminated calendars and services.

practising elsewhere in Europe in this period. The south German sculptor Peter Parler (*c*.1330–99) was appointed master of works of Prague Cathedral by Emperor Charles IV in 1353. Just as Ghiberti and Filarete included their self-portraits on the bronze doors they made for the Florentine Baptistery and Saint Peter's in Rome (Plates 35–38), so Parler included a self-portrait (Plate 12) as well as portraits of fellow masters of works in a series of busts dating from 1374 to 1385 decorating the triforium[3] of Prague Cathedral. In Parler's case, the act of doing so meant that he put himself on a par with his patron and with the other royal and ecclesiastical dignitaries whose busts also formed part of the series. By contrast, a self-portrait drawing by the German artist Albrecht Dürer (Plate 13), some of whose work will be considered in the second part of this book, seems to have been done in a more experimental fashion and for private consumption.

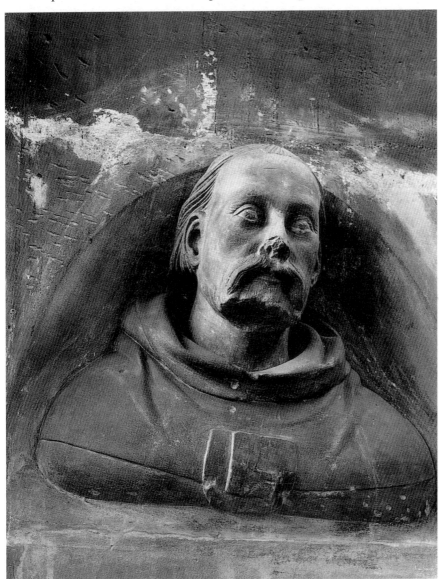

Plate 12 Peter Parler, *Self-portrait*, *c*.1380, sandstone, life size, Prague Cathedral. Photo: Bildarchiv Foto Marburg. The inscription accompanying the bust celebrates other architectural and sculptural works for which Parler was responsible.

[3] Arcade over an aisle.

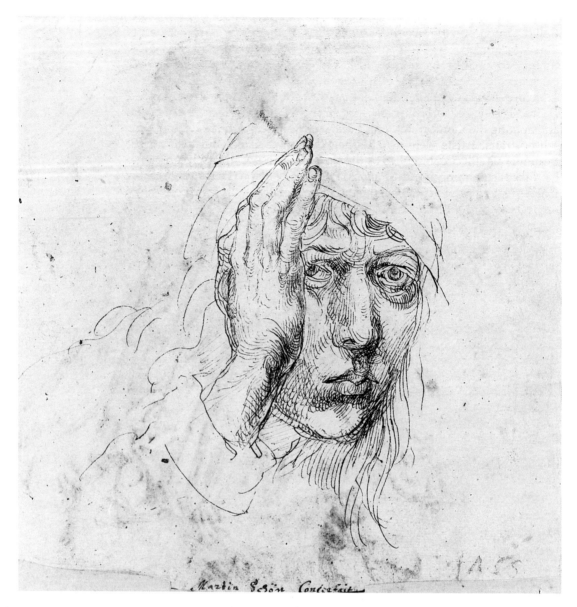

Plate 13 Albrecht Dürer, *Self-portrait*, c.1491–2, pen and ink, Erlangen University Library. The inscription is later and incorrect. This is one of several self-portrait drawings by the artist.

Benvenuto Cellini, whom you will encounter in the third case study, constructed his own myth of greatness not by means of self-portraiture but through his autobiography. It was not the first, however. Ghiberti designed his *Commentaries* primarily as an autobiography, although he also included a section on ancient art, a series of short biographies of Italian artists, and a section on optics. It has been suggested that his writings resemble the informal memoirs sometimes written by Italian merchants for the benefit of their descendants. Cellini takes the genre further, to include personal anecdotes, sometimes of a scurrilous nature, but his autobiography is of immense historical value, and assures him a place in the annals of art history as much for the evidence he provides about artistic status and practice as for his personal achievements.

Cellini epitomizes the two other themes that emerge from this first part of the book. First, his text illuminates the relationship between artist and patron. Cellini would have us believe that King Francis I deferred to his artistic greatness just as, according to Pliny the Elder, Alexander the Great (356–323 BCE) deferred to Apelles. Rather than wait entirely on his patron's wishes, Cellini also worked on his own initiative from his own personal ideas, perhaps anticipating the modern stereotype of the creator genius. In producing their self-portraits, artists were usually their own paymasters, but their artistic freedom was still circumscribed by the need to impress. Conversely, Ambrogio Lorenzetti's paintings for the Palazzo Pubblico of Siena (Plates 22–25) show that a great work of art can emerge no less when the artist is responding to the requirements of a patron, as was the norm during this period.

Secondly, for all that Cellini was in many ways a thoroughly Renaissance artist, he maintained with passion the medieval lack of distinction between what we now call the 'fine arts' and the 'decorative arts'. Vasari includes biographies of many artists who started off as goldsmiths, including Brunelleschi and Botticelli, but none who remained exclusively goldsmiths. In the 1560s, Cellini produced two possible designs for a seal for the newly formed Florentine Academy. The designs champion the art of casting and modelling in precious materials (principally goldsmithing) in addition to the three commonly accepted arts of design: sculpture, architecture, and painting. The choice of design for the seal was not resolved until 1597, when the Academy adopted Michelangelo's suggestion for three interlocking circles, representing sculpture, painting, and architecture, thereby firmly rejecting Cellini's fourth art. This downgrading of the decorative arts, confirmed by the academies, has been with us ever since.

'Little desire for glory': the case of Ambrogio and Pietro Lorenzetti

DIANA NORMAN

… and never having found any memorial of the masters, and many times not even what date [their works of art] were made, I cannot but marvel at the lack of sophistication and little desire for glory of the men of that age.

(Vasari, *Le vite*, vol.1, p.271, trans. D. Norman)

This statement by Vasari expresses a common perception of medieval artists. Artists of this period were trained as contributors to an essentially co-operative enterprise – be it the construction of a great cathedral or the production of an altarpiece within a workshop. According to popular view, therefore, they did not seek personal fame through their artistic endeavours, but were content to remain as anonymous craftsmen working for the greater glory of God.

It is striking, therefore, that in a room of the Uffizi Gallery in Florence that is devoted to the display of the 'early masters' of Italian art, two paintings have texts that advertise, prominently, who was responsible for, their execution (Plates 14 and 15). Across the lower border of *The Annunciation with Saints Ansanus and Massima* (Plate 14) is a Latin inscription which states that Simone Martini and Lippo Memmi of Siena painted it in 1333.[1] The slightly later painting, *The Presentation in the Temple* (Plate 15), has a similar text recording that Ambrogio Lorenzetti of Siena painted it in 1342.[2] The presence of these two paintings in the same room in the Gallery is not entirely coincidental. Both were painted for altars in Siena Cathedral as contributions to a series of four altarpieces whose subjects were intended to celebrate the Virgin Mary's role as the Mother of God. This was a particularly apt theme for such a location because, early in their history, the Sienese had adopted the Virgin as the saint to whom they had a special devotion. In addition, these altarpieces were intended to embellish altars where the relics of other locally revered saints were housed. This aspect of the paintings' original function can be seen in *The Annunciation*, where Saint Ansanus and his fellow martyr, Saint Massima, are depicted on panels on either side of the central painting (Plate 14). Various entries in the cathedral inventories indicate that *The Presentation* once had images of Saint Crescentius and the Archangel Michael on either side of the main painting.

[1] Inscribed beneath the central painting is: 'SIMON MARTINI ET LIPPUS MEMMI DE ANNO DOMINI MCCCXXXIII SENIS ME PINXERUNT'. The present order of the words produces the odd reading: 'Simone Martini and Lippo Memmi from in the year of [our] lord 1333 Siena painted me'. It appears that at some date this text has been re-assembled in the wrong order.

[2] 'AMBROSIUS LAURENTII DE SENIS FECIT OPUS ANNO DOMINI MCCCXLII' (Ambrogio, son of Lorenzo, from Siena made [this] work in the year of [our] lord, 1342).

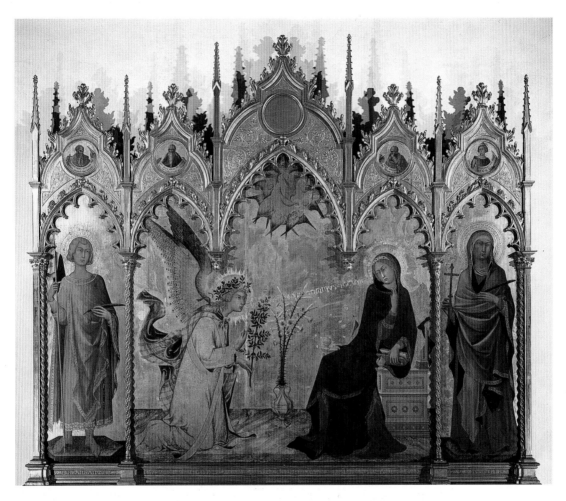

One of the major problems for recovering a sense of the identity of the medieval artist and his or her achievement[3] is that much work has either been lost entirely or – due to changes in taste and fashion – taken out of its original setting and drastically altered. For example, the two fourteenth-century altarpieces in the Uffizi were removed from their original altars during campaigns of renovation that took place in the sixteenth and seventeenth centuries. *The Annunciation* was first placed in another church in Siena, where it was described by a number of seventeenth- and eighteenth-century writers. It was then sent to Florence in 1799, probably already stripped of its original framework and having lost its predella. Once incorporated into the Uffizi collection, it was placed in an early nineteenth-century frame which, although 'medieval' in form, is probably much more florid than the original frame (compare Plates 14 and 16). *The Presentation* was placed in a convent near Siena Cathedral and then moved to the Uffizi in 1822. By that date it too had lost part of its upper frame, its predella, and – more serious still – its subsidiary paintings of Saint Crescentius and the Archangel Michael (Plate 17).

Plate 14 Simone Martini and Lippo Memmi, *The Annunciation with Saints Ansanus and Massima*, 1333, tempera on panel, 265 x 305 cm, Uffizi, Florence. Photo: Scala. Originally designed for the altar of Saint Ansanus in Siena Cathedral. The present frame is early nineteenth century.

[3] During the medieval period, it was generally men who trained and practised as artists. A woman might occasionally contribute to the highly diversified output of the medieval workshop, particularly if it was owned by her family, but never as a member of a professional trade association such as a guild. If she was a widow, a woman might manage her late husband's business. Women who entered into religious orders were frequently engaged in artistic production such as manuscript illumination and textile work.

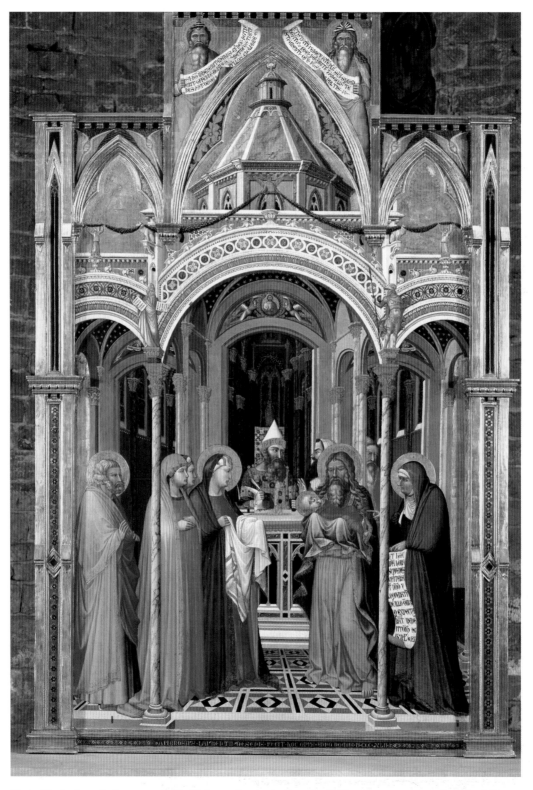

Plate 15 Ambrogio Lorenzetti, *The Presentation in the Temple*, 1342, tempera on panel, 257 x 168 cm, Uffizi, Florence. Photo: Scala. Originally designed for the altar of Saint Crescentius in Siena Cathedral. Elements of the original frame survive but the altarpiece has now lost its side panels and predella.

Plate 16
Reconstruction of Simone Martini and Lippo Memmi, *The Annunciation with Saints Ansanus and Massima.*

Plate 17
Reconstruction of Ambrogio Lorenzetti, *The Presentation in the Temple with Saint Crescentius and the Archangel Michael.*

This case study aims to address the challenge furnished by these two early Italian altarpieces and their prominent 'signatures', by examining a range of factors contributing to the popular perception of the medieval artist as a modest, self-effacing craftsman. In so doing, it will focus, in particular, upon the work of Ambrogio Lorenzetti (c.1300–c.1348), a painter whose subsequent reputation rests, in part, on two relatively early biographies written about him. In order to assess how such early accounts can affect our perception of the status of a medieval artist, the case study will also examine the work and early critical acclaim of Ambrogio Lorenzetti's brother and occasional collaborator, Pietro Lorenzetti (c.1280–c.1348).

Ghiberti and Vasari on Ambrogio Lorenzetti

Another important factor that militates against a painter like Simone Martini or Ambrogio Lorenzetti obtaining a reputation as a uniquely gifted and creative individual is the fact that before the fourteenth century there is remarkably little contemporary, written biography on medieval artists and their work. However, one Italian painter, the Florentine Giotto (c.1266–1337), enjoyed an early reputation as a 'great' artist and had a short biography written about him at the end of the fourteenth century. This was penned, though, by a Florentine writer, Filippo Villani, intent on celebrating the fame and prestige of his city as much as that of Giotto himself. Although Sienese not Florentine, Ambrogio Lorenzetti was also the subject of an early and highly laudatory biographical account, written by Ghiberti. As well as being a successful sculptor, who worked on many prestigious commissions in Florence and other Tuscan cities, Ghiberti wrote a number of reminiscences about his chosen profession. These were the *Commentaries*, written between c.1445 and c.1452. In addition to writing on the work of a number of his predecessors, Ghiberti included in the *Commentaries* extracts from Pliny and Vitruvius, whose observations on the art and architecture of antiquity had survived, although in a rather fragmentary and distorted form. Not published until the nineteenth century, it is likely that the *Commentaries* had only a limited readership, and were probably intended to be read by the writer's immediate family and professional associates for their instruction and enjoyment.

The *Commentaries* were, however, consulted by Vasari, who used them as the basis for his account of Ambrogio Lorenzetti in his famous and highly influential *Lives of the Artists*. As indicated in the historical introduction, Vasari's *Lives* was enormously influential in establishing the idea of the artist as an uniquely gifted and creative individual. He was also strikingly unsympathetic towards art produced in what we would now call the medieval period. For Vasari, this art belonged to the Dark Ages, and only with Giotto and his mentor Cimabue (c.1240–c.1302) did art begin to cast off what he termed a 'crude' and 'brutal' form. According to Vasari's model, fourteenth-century art corresponded to 'infancy', which would be followed by the 'youth' of fifteenth-century art and the 'maturity' of sixteenth-century art – the art of his hero, Michelangelo, and of his own generation.

Please read the extracts below from Ghiberti's *Commentaries* and Vasari's life of Ambrogio Lorenzetti and consider the following questions.

1 **What is it that particularly impresses each author about Ambrogio Lorenzetti's work?**

2 **What evidence is there that Vasari was dependent on Ghiberti for his information on this early painter?**

3 **What can we glean from each account about the writers' views on the role and status of an artist?**

> In the city of Siena, there were excellent and learned masters, among whom was Ambrogio Lorenzetti, a very famous and notable artist who left many works. He was a very noble master of composition among whose works is one, in [the friary of] the Friars Minor [Franciscans], very large and well-executed, which fills the whole wall of a cloister … there is the official executioner, with many men at arms, there are men and women, and when the friars are beheaded, there is a tempest with hail, lightening, thunder and earthquakes, so that one seems to see painted all the perils of the sky and earth, and it seems that everyone seeks shelter in great trepidation – men and women pull their clothes over their heads, the men-at-arms hold their shields over their heads and the hail beats down on them, it really seems that the hail bounces from the shields as if driven by a great wind … For a painted narrative it seems a marvellous thing … He was a most perfect master, a man of great talent, a most noble designer and very learned in the theory of this art.
>
> (Ghiberti, 'I commentari', pp.40–1, 112, trans. D. Norman)

> If the obligation that artists of fine talent undoubtedly owe to nature is great, how much greater should ours be to them, seeing how, with great diligence, they fill [our] cities with noble buildings and with useful and pleasing narrative compositions, while usually gaining for themselves fame and riches by their works. As did Ambrogio Lorenzetti, painter of Siena, who showed fine and prolific invention both in his well-considered compositions and the placing of figures in his narrative painting. A scene painted very gracefully by him in the cloister of the Friars Minor offers true evidence of this … In this painting [of an execution] he simulated with much art and skill the storminess of the air, and in the labours of the figures, the fury of the rain and wind. From these [paintings] modern masters learned the manner and the beginnings of this [kind of] invention for which, as it was not used before, he deserved immense commendation. [Vasari then lists various other places where Ambrogio worked before concluding] … Ambrogio returned to Siena, where he lived honourably the rest of his life, not only being an excellent master of painting but having devoted himself to letters in his youth – which were such a useful and sweet ornament to his life, along with painting – that they rendered him no less amiable and pleasing than the profession of painting had done. Thus he not only associated with the men of learning and of virtue, but was also employed with much honour and usefulness on the affairs of his republic. The manners of Ambrogio were, in every way, praiseworthy and rather those of a gentleman and of a philosopher than of an artist.
>
> (Vasari, *Le vite*, vol.1, pp.521–4, trans. D. Norman)

Discussion

1 Ghiberti clearly admired Ambrogio Lorenzetti as 'a master of composition' who could execute paintings depicting a large number of figures, actively engaged in a range of actions suggestive of various kinds of human emotion. He also admired his ability to represent very specific weather conditions and praised the painter for his technical abilities as a draughtsman and his interest in the intellectual or theoretical aspects of

his art. Vasari, likewise, applauded Ambrogio Lorenzetti for his powers of inventiveness and his ability to portray a large number of figures, and the behaviour of the weather and its emotional effect upon people. He also made even greater claims for Ambrogio Lorenzetti's status as a man of intellect.

2 Vasari's description of the painting in the Franciscan friary in Siena identified in a more concise form the qualities that Ghiberti praised in his more detailed description. This suggests that Vasari may well have read the *Commentaries* before writing his own account of the painting. Like Ghiberti, Vasari also selected for special notice Ambrogio Lorenzetti's powers of 'composition' and intellectual interests.

3 Vasari was clearly interested in Ambrogio Lorenzetti as a painter of multi-figural compositions, which implies that, as an artist, he had similar kinds of preoccupation. By identifying Ambrogio Lorenzetti as a 'gentleman' and a 'philosopher', he also appears to be making a claim for their profession. The fact that he chose to retain these elements of Ghiberti's biography means that he approved of Ghiberti's criteria for praise. In addition, Vasari apparently used his biographical account of a fourteenth-century painter to offer two short soliloquies on the role of the artist within society. He began his biography with a comment on the debt that society owed to artists and he ended it with a number of grandiose claims for Ambrogio Lorenzetti as a man who served his government well and associated with men of intellect.

◆◆◆

The background to Ghiberti's 'Commentaries' and Vasari's 'Lives'

As with all pieces of writing, our understanding is enhanced if we know something about the preoccupations and biases of the writers. Both Ghiberti and Vasari were practising artists, and each in his own way sought to enrich his work by studying the artistic traditions to which he felt his culture was indebted. For Italian artists of the fifteenth and sixteenth centuries, this was the art and culture of antiquity, particularly that of the Roman republican and imperial eras, remnants of which were still in plentiful supply within Italian cities and in the surrounding countryside. Significantly, much of the art that did survive was in the form of sculpted reliefs (Plate 18), which showed precisely the kinds of complex groupings of figures that Ghiberti and Vasari so approved of in Ambrogio Lorenzetti's work. In their own work, Ghiberti and Vasari frequently portrayed similarly elaborate figural compositions (Plates 36 and 19).

Imagery of this sort was partly dictated by the functions that paintings and sculptures were expected to perform at that date. The Church had quickly grasped the potential of such art to represent biblical and hagiographic[4] events as a means of teaching the faithful the essential tenets of Christian belief and dogma. In addition, art of this kind received support from ancient texts that used the classical methods of presenting an argument (such as rhetoric) to

4 Events drawn from the lives of the saints.

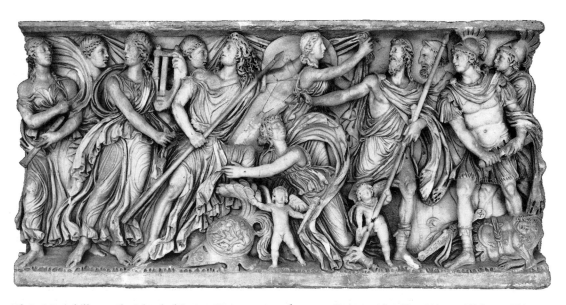

Plate 18 *Achilles on the Island of Scyros*, Roman sarcophagus relief, marble, 90 x 189 cm, Woburn Abbey, Bedfordshire. Photo: Forshungsarchiv für Römische Plastik, Köln. During the fourteenth century, this relief was one of eight walled into the stairs leading up to the church of Santa Maria in Aracoeli, Rome.

Plate 19 Giorgio Vasari, *The Adoration of the Magi*, 1547, oil and tempera on panel, San Fortunato, Rimini. Photo: Index, Florence. Originally commissioned by a community of Olivetan monks as an altarpiece for the church of Santa Maria di Scolca in Rimini.

describe the endeavours and achievements of the artists of antiquity. Narrative art was one category of art that received support in this way, and this was given even greater currency in the mid-fifteenth century by the writing and circulation of Alberti's *On Painting.* In this short treatise, Alberti emphatically stated that the highest goal for artists was the representation of *istorie*, the sort of painting that involved orchestrating a large number of figures and showing them in a variety of dramatic and emotive poses.

It may also be that, in writing his eulogy of Ambrogio Lorenzetti, Ghiberti utilized another style of writing that he had learned from his reading of ancient texts. A common literary device within writing of this kind was the use of 'ekphrasis', whereby the writer literally built up a word picture of an admired work of art. This is of particular interest in the present case, because the paintings described in Ghiberti's *Commentaries* belong to a series originally executed for the cloister of the Franciscan friary of San Francesco, and the scheme no longer survives, being the victim of a change in fashion in the

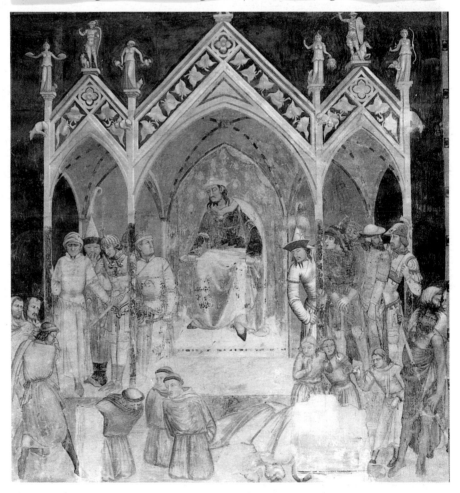

Plate 20 Ambrogio Lorenzetti, *The Martyrdom of Franciscans at Ceuta*, c.1326–30, fresco, width c.338 cm, San Francesco, Siena. Photo: Lensini Fabio, Siena. Originally executed as one of a series of paintings for the chapter-house of San Francesco. The painting probably represents the execution of seven friars by the Sultan of Morocco and thus commemorates an important event in the history of Franciscan evangelization. It is not known exactly when the chapter-house scheme was executed, but it probably occurred after 1326.

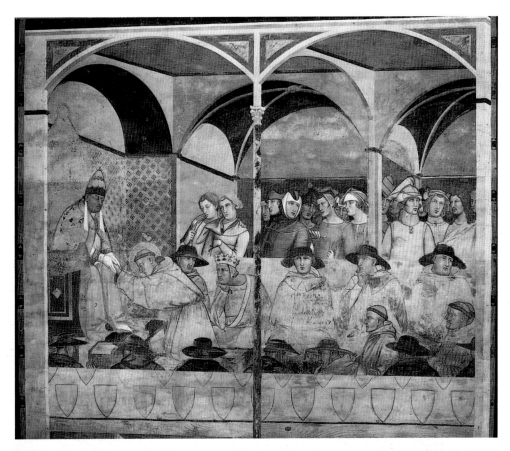

Plate 21 Ambrogio Lorenzetti, *Saint Louis of Toulouse Performing Homage to Pope Boniface VIII*, *c.*1326–30, fresco, width *c.*410 cm, San Francesco, Siena. Photo: Lensini Fabio, Siena. Originally executed as one of a series of paintings for the chapter-house of San Francesco. The painting represents an event in the life of the Franciscan saint, Louis of Toulouse, and thus commemorates another important historical event for the institutional life of the Franciscan Order. Louis is shown repeating his religious vows and accepting the title of Bishop of Toulouse from Pope Boniface VIII, thereby forfeiting his claim to the throne of the south Italian kingdom of Naples, much to the bemusement of his father, Charles II, king of Naples.

eighteenth century. Two frescoes by Ambrogio Lorenzetti executed for the nearby chapter-house do survive, although they have been transferred to a chapel in the church itself (Plates 20 and 21). From these and other surviving paintings, it is possible to determine that the scheme of decoration for the chapter-house comprised large-scale narrative paintings depicting events both from Christ's Passion (as recounted in the Gospels) and from the history of the Franciscan Order. Barely a trace of what Ghiberti saw in the cloister remains, although recently a few fragments have been recovered. Piecing together various kinds of historical evidence, including reference to these paintings by sixteenth- and eighteenth-century Sienese historians, it appears that the painting that Ghiberti so admired depicted the martyrdom of three friars in the city of Thanah (near present-day Bombay) in 1321. Moreover, the recovered fragments of this particular painting show portions of sky filled with hailstones, which offer further concrete evidence that Ghiberti's account may well have been accurate in detail and that Ambrogio Lorenzetti did, indeed, paint this scene of martyrdom as taking place during a storm, thereby increasing the drama and tension of the depicted event.

Ambrogio Lorenzetti and his work

As for many medieval artists, it is tantalizing how little historical evidence we have about Ambrogio Lorenzetti and his work. There are a number of brief references to payments made to him by important city institutions such as the cathedral board of works, the city treasury, and Siena's principal hospital of Santa Maria della Scala. His will, which was drawn up in evident haste on 9 June 1348, also survives (see Wainwright, 'The will of Ambrogio Lorenzetti, pp.543–4). In it, he made the poignant request that if he, his wife, and his three daughters were all to die his estate was to go to a local confraternity.[5] Since this was the year in which the Black Death struck Siena with terrible ferocity, and since we have no further reference to him or his family in Siena's documentary records, it is likely that Ambrogio Lorenzetti died of bubonic plague in 1348. There is also a brief confirmation of Vasari's

Plate 22 General view of the Sala della Pace, Palazzo Pubblico, Siena. Photo: Lensini Fabio, Siena. This room in the Palazzo Pubblico (town hall) was originally called the Sala dei Nove (Room of the Nine), after the city magistracy who met in it. It is now known as the Sala della Pace (Room of Peace) after Ambrogio Lorenzetti's painting of Peace (see Plate 24).

[5] Group or society of laymen who joined together to practise religious devotions.

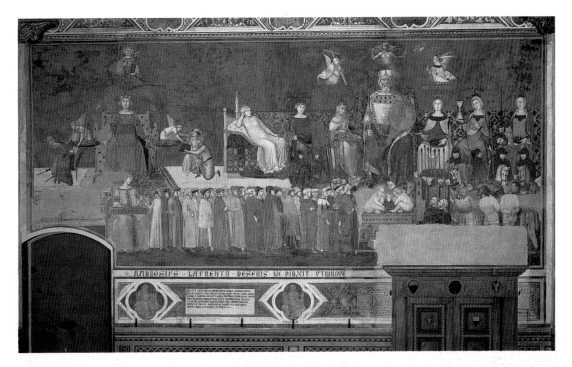

Plate 23 Ambrogio Lorenzetti, *The Allegory of Good Government*, 1338–9, fresco, width 770 cm, north wall, Sala della Pace, Palazzo Pubblico, Siena. Photo: Lensini Fabio, Siena. The subject of the painting is an allegorical representation of what was then believed to constitute good government. It relies on the classical convention of personifying positive human qualities in the form of female figures. The painting shows a male personification of the city government surrounded by female figures personifying virtues such as Justice, Concord, and Peace. The message to Siena's government is that in order to pursue just policies, it should emulate human virtues of this kind.

reference to the painter as an employee of the republic, since in 1347 he was recorded as a member of a special government committee appointed to discuss strengthening the city's constitution (Starn and Partridge, *Arts of Power*, pp.33, 318, n.83). The government record also states that Ambrogio Lorenzetti spoke 'with his wise words' on this particular topic.

Despite the sparseness of the historical record of Ambrogio Lorenzetti, he has enjoyed a high reputation as a painter of distinction. Why is this so? Partly it can be accounted for by the fact that his work received such laudatory notices from Ghiberti and Vasari. In addition, his surviving work provides evidence of the kinds of notable skill and ability that later artists and critics praised and sought to equal.

Please study Plates 15 and 21–25, and read the information about these paintings by Ambrogio Lorenzetti given in the captions.

What is it about the paintings that might have appealed first to Ghiberti and Vasari and then to later artists and critics, thereby ensuring that Ambrogio Lorenzetti secured his reputation as one of the great masters of western art?

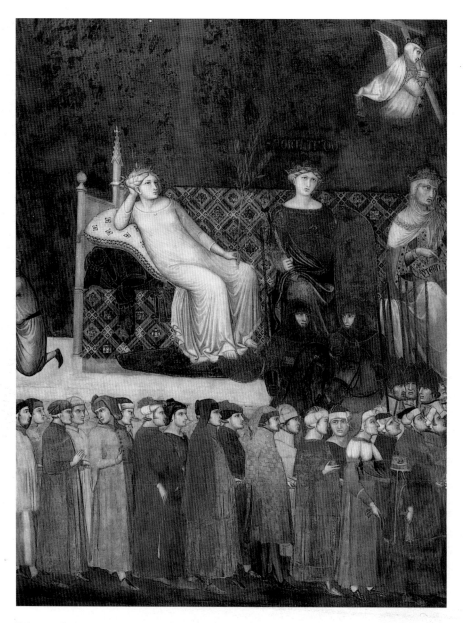

Plate 24
Ambrogio
Lorenzetti, *Peace,
Fortitude and
Procession of City
Officials*, detail of
*The Allegory of
Good Government*
(Plate 23). Photo:
Lensini Fabio,
Siena. The men
are portrayed in
the costume
worn in the
fourteenth
century by
officials such as
the Nine and the
city's judges,
thus giving it a
topical
dimension.

Discussion

Ghiberti and Vasari admired Ambrogio Lorenzetti's work because it provided evidence of his abilities as a painter of *istorie*. *Saint Louis of Toulouse* (Plate 21) provides a good example of Ambrogio Lorenzetti's skill in this respect. It also shows his ability to capture emotional life-likeness and, on occasion, to display great wit, as seen in the bemused expression on King Charles's face as he contemplates his son's act of renunciation of his worldly goods and powers.

It is also clear that the painter was skilled in portraying on the flat surface of a wall or wooden panel the illusion of a convincing three-dimensional space within which to place his figures. Thus, Saint Louis's act of homage takes place in a roomy pavilion filled by an array of ecclesiastical and princely dignitaries. Similarly, in *The Well-governed City*, a large number of people

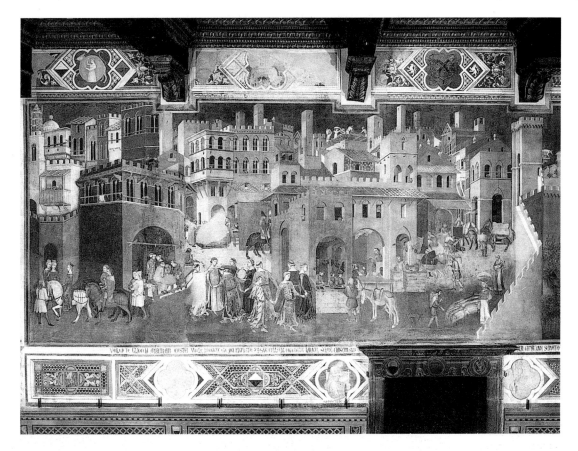

Plate 25 Ambrogio Lorenzetti, *The Well-governed City*, 1338–9, detail of the left-hand side of *The Effects of Good Government in the City and Countryside*, fresco, width 1404 cm, east wall, Sala della Pace, Palazzo Pubblico, Siena. Photo: Lensini Fabio, Siena. In contrast to *The Allegory of Good Government*, this painting shows a more naturalistic scene of a walled city, set on a hillside and surrounded by a panoramic vista of cultivated countryside. In many respects the city appears to represent Siena itself, since it is located on a hill and contains buildings of the type still visible in Siena today. Painted inscriptions suggest, however, that the painting was also intended to represent an 'ideal' of a well-governed city.

circulate through the streets and open spaces (Plate 25). In *The Presentation in the Temple* there is a very sophisticated rendition of the exterior and interior of the Temple of Jerusalem, including the illusion of a deep and penetrating space within the building itself (Plate 15).

The evidence for Ambrogio Lorenzetti's intellectual and theoretical interests is clearly apparent and yet difficult to pin down. Paintings like *The Presentation in the Temple* and the Sala della Pace murals (Plates 22, 23, and 25) contain many texts. (This, in itself, does not necessarily suggest markedly intellectual abilities on the part of the painter, since the choice of what texts to include within a painting was usually the responsibility of the painting's commissioners.) The learned nature of the Sala della Pace scheme as a whole suggests that Ghiberti's and Vasari's remarks on Ambrogio Lorenzetti's intellect were well founded. There are also a number of striking instances of the painter showing a marked interest in imitating and striving to equal the art of antiquity. This is particularly evident in his portrayal of the allegorical figure of Peace in the Sala della Pace (compare Plates 18 and 24).

◆◆◆

Fraternal collaboration between Ambrogio and Pietro Lorenzetti

A fact that neither Ghiberti nor Vasari recognized was that Ambrogio Lorenzetti worked on at least two artistic projects with his brother, Pietro Lorenzetti. Given that early biographers of art sought to establish the idea of the artist as a unique and talented individual, *collaborative* practice between fellow artists would not have been something they would have wished to dwell upon. Yet the training and practice of artists at that time was based on precisely such arrangements. A young boy apprenticed to a painter would learn his trade by studying not only 'nature' but also the work of other artists. This much is clear from Cennini's late fourteenth-century treatise on art. Once trained and thought capable of contributing to the diversified output of the painter's workshop, the apprentice would be assigned tasks of varying responsibility, ranging from painting large, undifferentiated areas of background to working on details such as the heads and hands of the most important figures in the painting. This diversified approach involving a number of painters working collaboratively was used for both panel paintings and mural paintings. Furthermore, when he had become an established head of a workshop, an artist had to be a skilled entrepreneur, taking on commissions, judging what he and his apprentices could fulfil, and then negotiating with other experienced artists to enter into short-term, temporary professional arrangements in order to get a particular job of work done.

We do not know exactly what kind of professional relationship Ambrogio Lorenzetti and his brother had with one another. They may have jointly owned a family workshop, or alternatively they may have maintained their own separate working practices but occasionally come together to work on particularly large and prestigious commissions. It is apparent from examining the patterns used on the gold leaf of panel paintings by both painters that they either owned tools in common or borrowed them from one another. There are at least two major Sienese commissions on which they worked together. The first of these is the chapter-house frescoes at San Francesco, where, as we have already seen, Ambrogio Lorenzetti probably painted *The Martyrdom* and *Saint Louis of Toulouse* (Plates 20 and 21). He may also possibly have painted *The Burial of Saint Claire*, of which there is now only a beautiful fragment in the National Gallery, London.[6] Pietro Lorenzetti probably painted *The Crucifixion* (Plate 26) and *The Resurrected Christ*, which is now housed in the museum of the Seminary on the outskirts of Siena. There is a considerable body of historical evidence that the two painters also contributed to a series of frescoes (now lost) depicting the early life of the Virgin for the external façade of the Sienese hospital of Santa Maria della Scala.

[6] Inventory no. 1147. Saint Claire, a contemporary of Saint Francis, was the founder of the female order of the Franciscans. There are also two smaller fragments of female saints (inventory nos 3071 and 3072), which were probably once part of the wide painted borders of the chapter-house scheme of decoration. As subsidiary features, it is likely that they would have been the handwork of more junior members of the Lorenzetti workshop.

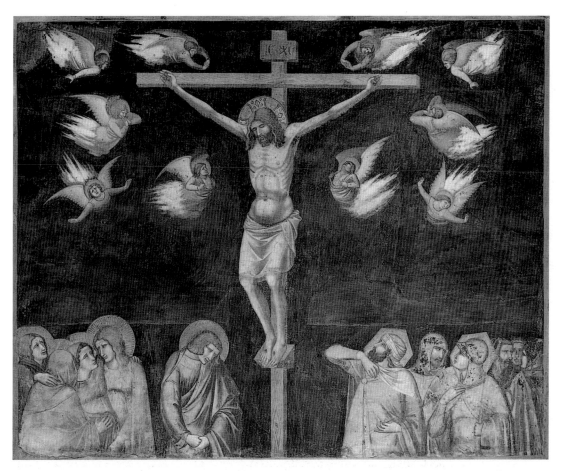

Plate 26 Pietro Lorenzetti, *The Crucifixion*, 1320s, fresco, 309 x 393 cm, San Francesco, Siena. Photo: Lensini Fabio, Siena. Originally executed as one of a series of paintings for the chapter-house of San Francesco (see Plates 20 and 21).

Pietro Lorenzetti and his work

If the historical evidence about Ambrogio Lorenzetti is tantalizingly slight, that about Pietro Lorenzetti is even less substantial. The only major piece of contemporary biographical information we have about him is a property transaction he undertook in 1342 on behalf of the orphaned sons of a fourteenth-century Sienese sculptor, Tino di Camaino (Borghesi and Banchi, *Nuovi documenti per la storia dell' arte senese*, p.11). The presence of Pietro Lorenzetti's name on two altarpieces, one for the church of Santa Maria del Carmine and the other for the altar of Saint Savinus in Siena Cathedral (Plates 27 and 28),[7] together with various payments in the account books belonging to the cathedral board of works, indicate that, like his brother, he secured a number of highly prestigious commissions within the city. We also have documentary evidence that he worked in other Italian cities, such as the Tuscan city of Arezzo. However, significantly for our present purposes, he lacked an early biographer.

[7] The latter altarpiece carries the inscription: 'PETRUS LAURENTII DE SENIS ME PINXIT A. MCCCXLII' (Pietro, son of Lorenzo, from Siena painted me in the year 1342).

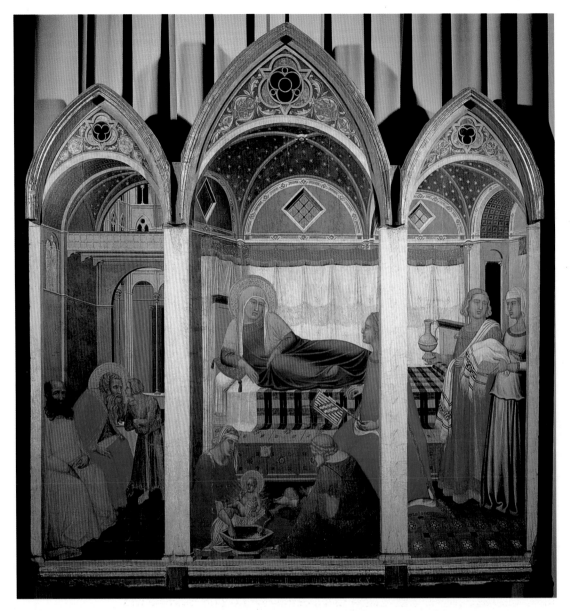

Plate 27 Pietro Lorenzetti, *The Birth of the Virgin*, 1342, tempera on panel, 187 x 182 cm, Museo dell'Opera del Duomo, Siena. Photo: Lensini Fabio, Siena. Originally designed for the altar of Saint Savinus in Siena Cathedral. The painting depicts an event from the apocryphal accounts of the Virgin's early life. The altarpiece has lost its frame, predella, and side panels depicting Saints Savinus and Bartholomew. There is a small panel painting in the National Gallery of London which shows the rare scene of Saint Savinus being ordered to worship an idol. This was probably once part of the predella. In 1335 the cathedral board of works who commissioned the painting is recorded as employing a grammar teacher, who was given a small sum of money for translating the life of Saint Savinus from Latin into Italian. This suggests that Pietro Lorenzetti could not read Latin.

Ghiberti makes no mention of Pietro Lorenzetti, despite knowing his brother's work and even identifying the subjects of the Lorenzetti paintings at the hospital of Santa Maria della Scala. These, according to well-informed seventeenth-century sources, carried an inscription giving the names of the

Plate 28 Reconstruction of Pietro Lorenzetti, *The Birth of the Virgin with Saints Savinus and Bartholomew.*

two painter brothers. Vasari wrongly named Pietro Lorenzetti, due to misreading a painted text on an altarpiece that is now in the Uffizi. In addition, Vasari supplied a very confusing and fragmentary account of Pietro Lorenzetti's activities and achievements as a painter. According to Vasari, the painter enjoyed his success due to his imitation of Giotto. Since he was born in Arezzo, Vasari would also have known Pietro Lorenzetti's work for the Pieve or principal baptismal church there. However, rather than discuss this work in any detail, Vasari used it as a pretext for writing a detailed justification of his own sixteenth-century architectural remodelling of the ancient church. Vasari's account regrettably cast a long shadow of influence over seventeenth- and eighteenth-century biographical accounts written by local Sienese painters, even though they had the evidence of the paintings themselves to hand.

Please examine Plates 26, 27 and 29–33 and read the information about these paintings by Pietro Lorenzetti given in the extended captions.

What evidence can you see in these paintings of the painter seeking to achieve comparable goals to those of his more highly lauded brother?

Plate 29 General view of the north transept, Lower Church, San Francesco, Assisi. Photo: Scala. The frescoes that decorate this part of the transept have convincingly been attributed to Pietro Lorenzetti. They represent an extensive series of paintings depicting the Passion of Christ. The precise dates of the scheme are not known, but technical and historical evidence indicates that it was probably painted in a single campaign before 1319.

Discussion

Like his brother, Pietro Lorenzetti was clearly capable of executing *istorie* and composing multi-figural compositions. He was also capable of showing a variety of characterization in his work and a high pitch of emotion. On the Arezzo altarpiece, *The Virgin and Child and Saints* (Plate 33), the Virgin of the Annunciation is shown reacting to the arrival of the Archangel Gabriel, and the faces of the onlookers in *The Crucifixion* (Plate 26) portray a range of grief-stricken expressions. In addition, there is a real sense of the painter striving to enliven his representation of sacred events by the inclusion of detail based on day-to-day experience and observation, such as the kitchen scene within *The Last Supper* (Plate 32). The representation of fire is also very striking here. This is similar in its ambition and imagination to that of the portrayal of violent weather conditions described by Ghiberti and Vasari in Ambrogio Lorenzetti's lost painting showing the martyrdom of three friars at Thanah.

Plate 30 Pietro Lorenzetti, *The Entry into Jerusalem*, *c*.1315–19, fresco, 244 x 310 cm, north transept, Lower Church, San Francesco, Assisi. Photo: Archivio Sacro Convento Assisi / G.Ruf. The painting depicts Christ's triumphal entry into the city of Jerusalem on a donkey in order to observe the Jewish feast of Passover. As in the case of the city depicted in *The Well-governed City* by Ambrogio Lorenzetti (Plate 25), Jerusalem appears as a typical medieval Italian city.

There is a corresponding sophistication in Pietro Lorenzetti's representation of space. Although the townscape of his *Entry into Jerusalem* (Plate 30) is far less assured than that of Ambrogio Lorenzetti's *Well-governed City* (Plate 25), Pietro Lorenzetti's mastery of the depiction of interior space is comparable to that of his brother. *The Birth of the Virgin* (Plate 27) is not based on a systematic scheme of perspective, but it is striking how Pietro Lorenzetti creates a sense both of the roomy interior of the bedroom of the Virgin's mother, Saint Anna, and of the passageway in which her father, Saint Joachim, receives the news of her birth. A more modest sense of a domestic interior is achieved in the scene of the Annunciation on the Arezzo altarpiece (Plate 33). In the altarpieces shown in Plates 27 and 33, Pietro Lorenzetti has also skilfully taken account of the frames and made them appear as if they are part of the buildings represented within the paintings themselves.

Plate 31 Pietro Lorenzetti, *The Last Supper*, *c.*1315–19, fresco, 244 x 310 cm, north transept, Lower Church, San Francesco, Assisi. Photo: Archivio Sacro Convento Assisi/G.Ruf. The painting depicts the last meal that Christ shared with his apostles on earth.

Plate 32 Pietro Lorenzetti, *Kitchen Scene*, detail of *The Last Supper* (Plate 31). Photo: Archivio Sacro Convento Assisi/G.Ruf. There is no biblical source to justify this domestic scene.

Plate 33 Pietro Lorenzetti, *The Virgin and Child and Saints*, 1320, tempera on panel, 298 x 309 cm, Pieve, Arezzo. Photo: Scala. Originally commissioned by the Bishop of Arezzo for the high altar of the city's baptismal church. This multi-panelled altarpiece has now lost its frame and its predella. It shows a very conventional subject for fourteenth-century altarpieces – that of the Virgin and Christ Child, surrounded by other saints. At the centre of the upper tier is a narrative painting of the Annunciation. Above this is a painting of the Virgin being transported into heaven after her death, a religious theme known as the Assumption of the Virgin.

As far as Pietro Lorenzetti's intellectual and theoretical interests are concerned, there is nothing in his work to compare with the learning and sophistication of the Sala della Pace scheme created by his brother. What survives of his work suggests, instead, a painter who devoted himself to representing a conventional range of religious subject-matter. When confronted with the task of a painting a more unusual subject – such as an event belonging to the legend of a relatively obscure saint – he apparently had to seek help in securing a translation of a Latin source (see the caption to Plate 27). Nevertheless, he was also clearly capable of imaginative and intelligent resolution to the artistic challenges that such commissions presented.

◆◆◆

Conclusion

What, then, are we to make of Vasari's general point regarding the 'lack of sophistication' and 'little desire for glory' of early medieval artists mentioned in the quotation at the beginning of this case study? The evidence we have seen relating to Ambrogio and Pietro Lorenzetti suggests that this is a marked over-simplification of their attitude to their professional calling. The high incidence of inscriptions on their paintings, testifying to their identity, suggests a clear desire to be known for their work. In addition, it is likely that this prominent display of their names was intended to act as a guarantee of the quality of their work. At the same time, their paintings provide evidence of an essentially professional and business-like approach to the practice of art. In the case of certain commissions, they were willing to sacrifice any claim for 'uniqueness' or 'individuality' by collaborating with one another in order to expedite matters with skill and efficiency.

We therefore need to be alert to the powerful influence of early writers on art for our subsequent evaluation of these two painters and their work. On the one hand, many of the qualities that we tend to admire in Ambrogio Lorenzetti's work are indeed those already singled out for praise by Ghiberti and Vasari. On the other hand, there are aspects of the late medieval culture to which Ambrogio and Pietro Lorenzetti belonged which were not appreciated by either Ghiberti or Vasari from the perspective of their very different cultures. One of the enduring fascinations of the art of the late medieval period is precisely that it belongs to a culture that did not on the whole adopt the later preoccupation with the cult of the individual. Such an attitude should not be dismissed, however, as merely 'little desire for glory': rather, it should be seen as a different – and not necessarily less 'sophisticated' – understanding of the artist's role and status. By viewing it in this way, we avoid the automatic assumption, which is common in the history of western art, that the artists of the fifteenth or sixteenth century are necessarily greater or more worthy of study than their predecessors.

References

Borghesi, S. and Banchi, L. (eds) (1898) *Nuovi documenti per la storia dell'arte senese*, Siena, Enrico Torrini.

Ghiberti, L. (1912) '*I commentari*', in *Lorenzo Ghibertis Denkwürdigkeiten*, ed. J. von Schlosser, Berlin, Julius Bard.

Starn, R. and Partridge, L. (1992) *Arts of Power: Three Halls of State in Italy, 1300–1600*, Berkeley and Los Angeles, University of California Press.

Vasari, G. (1906) *Le vite de' più eccellenti pittori, scultori ed architettori* (1568), vol.1, ed. G. Milanesi, Florence, G.C. Sansoni.

Wainwright, V. (1975) 'The will of Ambrogio Lorenzetti', *Burlington Magazine*, vol.117, pp.543–4.

Italian artists in search of virtue, fame, and honour *c.*1450–*c.*1650

CATHERINE KING

In this case study I will be concerned with the following questions about the status of artists in Italy between about 1450 and 1650.

> What assertions were being made about the status of artists and about art in Italy at this time?

> How did Italian artists communicate new ideas about their rights and their capacities during this period?

I begin by summarizing the evidence provided by written texts that has been used by historians in the past to help to answer these questions. I shall then turn to look at my own field of research, which considers some of the visual evidence that may be useful in finding answers. I shall focus on self-portraits, with the following questions in mind.

> Do the self-portraits made in the Italian-speaking peninsula provide evidence of newly emerging definitions of art and architecture? (Since architects were always trained as painters or sculptors, they did produce self-portraits.)

> Did self-portraits have a wider audience than any written text could reach?

> Did different sorts of self-portrait for different functions and audiences represent different images of the artist?

The aims of this case study are to make you aware of the differing functions served by the increasing numbers of self-portraits being made; to emphasize the importance of considering their different roles in weighing self-portraits as evidence; and to evaluate the kinds of evidence they provide by comparison with literary texts.

Written evidence

Italian texts from the fourteenth century onwards sometimes praised individual artists. In about 1300, for example, the poet Dante Alighieri had noted the way public acclaim moved from admiring Cimabue to praising Giotto, his successor. In the 1380s, Villani included Giotto in his biographies of famous Florentines. In the 1470s, Raphael's father, Giovanni Santi, wrote a poetic account of modern art, including mention of famous Flemish artists as well as Italians. The earliest surviving autobiography of an artist appears in Ghiberti's mid-fifteenth century *Commentaries*, and a series of brief lives of artists composed during the late fifteenth and early sixteenth centuries culminated in the extensive *Lives of the Artists* by Vasari. Other written evidence supports the idea that the individuality of the artist was becoming a more important artistic commodity. For example, fifteenth-century contracts for

commissions increasingly show patrons insisting that they were paying for the personal skills of an individual artist rather than merely expensive and showy pigments and gold leaf. Around the end of the fifteenth century, Isabella d'Este, Marchioness of Mantua, is recorded as seeking out examples of the work of the best contemporary artists, such as Giovanni Bellini and Perugino.

Renaissance theories of artistic invention

The appearance of treatises on art (beginning with Cennini's in c.1400) proved that art was worthy of public theoretical discussion. In *On Painting*, published in 1435, Alberti emphasized that what should be admired in an image was the artistic skill involved in using ordinary pigments to feign the effects of gold, rather than the use of quantities of gold leaf itself. His treatise also emphasized the importance for artists of having knowledge of mathematics and geometry that would allow them to calculate correct proportions for figures and present convincing perspectival constructions. Stress was also placed on painters' knowledge of ancient art, history, and mythology. Such expertise would suggest that the work of the artist should be placed in the company of the liberal arts. It was the business of the artist, in Alberti's view, like the poet, to render an idea by depicting an event from religious or secular history or mythology, or by making an allegory that would convince the viewer and move him or her to good action. This placed art on the level of rhetoric, through the shared aim of representing or speaking well in order to make the members of the audience into better people.

As we saw in the historical introduction, adopting a theoretical approach to art meant that it could be considered to be one of the liberal arts. It also allowed artists themselves to be perceived as possessors of innate talent. It was argued that the liberal arts required both innate talent (*ingegno* in Italian and *ingenium* in Latin), which could not be taught, and practice or skill (*arte* or *ars*), which could be learned by anyone. In contrast, it was maintained (by scholars!) that the mechanical arts only required skill, and therefore anyone could be taught them. Medieval and Renaissance definitions of the liberal arts put a special value on individuality, because they associated excellence in these arts with 'personal disposition'. The term *ingegno* is one of the etymological roots for the later use of the term 'genius', and modern English translations of Renaissance texts such as Vasari's *Lives* often translate *ingegno* as 'genius'. However, it is important to stress that they are distinct terms and do not carry the same meaning. According to the earliest Italian–English dictionary (1598), compiled by John Florio, for instance, *ingegno* signifies 'inventiveness' and 'nature, inclination, disposition' (Florio, *Worlde of Wordes*, p.147).

Alberti argued that the artist needed *ingegno*, but qualified this by saying that he believed that 'the power of acquiring wide fame in any art or science lies in our industry and diligence more than in ... the gifts of nature' (*On Painting*, p.39). However, he also insisted on the imaginative and inventive powers needed by artists, as did other treatise writers such as Leonardo. Although the ideas of *ingegno* and imagination seem to be particularly connected to the idealizing styles of sixteenth-century art (as in Vasari's *Lives*), art theorists also applied them to the effects of naturalism and illusionism favoured by the Italian painter Caravaggio (1571–1610) and his followers in

the early seventeenth century. A patron of Caravaggio, Vincenzo Giustiniani, for example, wrote that the artist painted 'from the imagination and life' (Samek-Ludovici, *Vita del Caravaggio*, p.40.) Throughout the period covered in this case study, it was considered necessary for artists to use knowledge of the rules and theories of art and special qualities of imagination in order to produce a convincing pictorial or sculpted illusion of reality, although at some times a naturalistic effect was the more highly valued, and at others idealization was favoured.

Love of money, fame, art, and virtue

The new definitions of art were frequently at least partly motivated by desire for higher social and economic status. This is undoubtedly the case with Vasari, who took care to note that Raphael not only painted for successive popes but lived like a prince himself. However, the definitions might also indicate a genuine desire for high moral and spiritual status, which might entail spurning wealth and position (or, better still, attracting them without trying to). Explicit in Cennini's treatise is the idea that artists must pursue their art for love and not primarily for monetary gain: 'there are those who pursue it [their art] because of poverty and domestic need, or for profit and because of love of art too, but above all these are to be extolled who enter the profession through a sense of exaltation and enthusiasm' (Holt, *Documentary History of Art*, vol.I, p.139). Similarly, in his *Commentaries*, Ghiberti contrasted the love of money with the love of his art: 'I, O most excellent reader, did not have to obey money but gave myself to the study of art which since my childhood I have always pursued with great zeal and devotion' (Holt, *Documentary History of Art*, vol.I, p.156).

Alberti and Leonardo contrasted the profit motive with the desire to obtain fame as an artist. Alberti advised that 'Avarice was always the enemy of renown and virtue', while Leonardo agreed that 'to gain this renown [in art] is a far greater thing than is the renown of riches' and explained that the way to obtain renown was through hard work (King, 'Late sixteenth-century careers advice', pp.77–8).

To describe the hard path of labour and self-denial required to make a good artist, writers on art appropriated ideas previously applied to the career progress of statesmen and scholars. Various exemplary stories were drawn upon, such as the fable of the 'Choice of Hercules' by the Greek writer Xenophon (*c*.435–354 BCE). This told of Hercules rejecting pleasure to pursue the difficult path through his labours to immortality, joy, and fame. In a similar fashion, the Roman writer Silius Italicus (25–101) described the 'Dream of Scipio', which revealed to the warrior hero the dishonour brought by pleasure and the honourable rewards of virtue. This theme was illustrated by Raphael, about 1501 (Plate 34). Choosing to pursue virtue, Scipio ascended to the Temple of Jupiter, the mythological king of the gods, where he earned the laurel wreath of victory over hardship. Use was also made of a story by the Roman writer Valerius Maximus (20 BCE–50 CE), in which a republican hero called Marcellus built the Temple of Honour at Rome, which could only be entered through the adjoining Temple of Virtue. The Florentine Academy emphasized the centrality of these ideals in its design for the base of the catafalque for Michelangelo's lying in state at the church of San Lorenzo after his death in 1564. This elaborate structure symbolizing the artist's achievement (which was placed beside his body before the altar of the church) was adorned

Plate 34 Raphael, *The Dream of Scipio* (National Gallery gives the title *An Allegory (Vision of a Knight)*), *c.*1500–1, tempera on poplar, 17 x 17 cm, National Gallery, London. Reproduced by permission of the Trustees of the National Gallery.

at its four corners with allegorical figures of Skill, Talent (*ingegno*), Study, and Virtue. The artists of Venice planned a catafalque for Titian in 1576 on similar lines, with the overall motto 'Virtue through hard work' and (in a reminder of the story of the choice of Hercules) the emblem of 'a steep mountain with a lofty summit piercing the heavens like a pyramid' (King, 'Late sixteenth-century careers advice', p.84).

Throughout the period we are considering, artists' ambitions were always constrained by the facts of their training and business practices. Even after the foundation of the academies, artists continued to work within the framework of the workshop and guilds. Moreover, contrary to the impression given by Vasari, work was often achieved not by an individual artist but by teams of assistants organized by a master. They would produce his 'personal' style. The prime example of this kind of practice in later Italian art is that of the Roman sculptor Gian Lorenzo Bernini (1598–1680), whose elaborate projects for Saint Peter's in Rome, such as papal tombs, involved large numbers of other artists. In practice, most successful artists had to be shrewd businessmen, although they might find that seemingly less commercial activities, such as writing and self-portraiture, could actually serve as means of self-advertisement and thus help secure commissions.

Visual evidence – self-portraits

In the first place, we need to distinguish between the different material contexts in which self-portraits could appear. A self-portrait that formed part of a public work would reach more people and perhaps a more varied audience than one that appeared in a manuscript or printed book. Editions of printed books usually consisted of no more than a thousand copies, while manuscripts existed in only a few hundreds of copies. In addition, the readership of both sorts of work would be confined to an élite section of the population.

Secondly, as we look at the different kinds of self-portrait being produced in Italy between the mid-fifteenth and the mid-seventeenth centuries, we need to consider the extent to which they put forward claims to high status for the artists and their art.

The portrait signature (a continuous tradition from antiquity)

I want you to begin by comparing self-portraits made at about the same time in Florence and Rome by two Florentine bronze sculptors, Ghiberti and Filarete (Plates 35–38).

1 What audiences were they reaching?

2 What views of the artist do they seem to be representing?

Use the captions to help you.

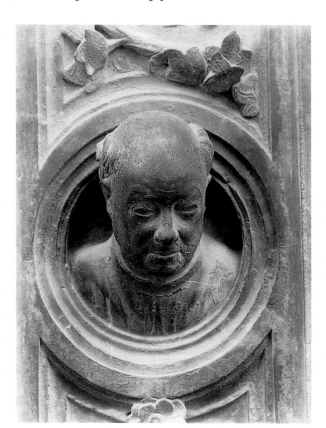

Plate 35 Lorenzo Ghiberti and assistants, *Self-portrait*, 1424-52, gilt bronze, bronze doors, eastern flank, Baptistery, Florence. Photo: Alinari. The self-portrait is in the is in the middle of the front of the doors. The Latin inscription alongside reads in translation: 'Made with wonderful skill by Lorenzo Ghiberti'.

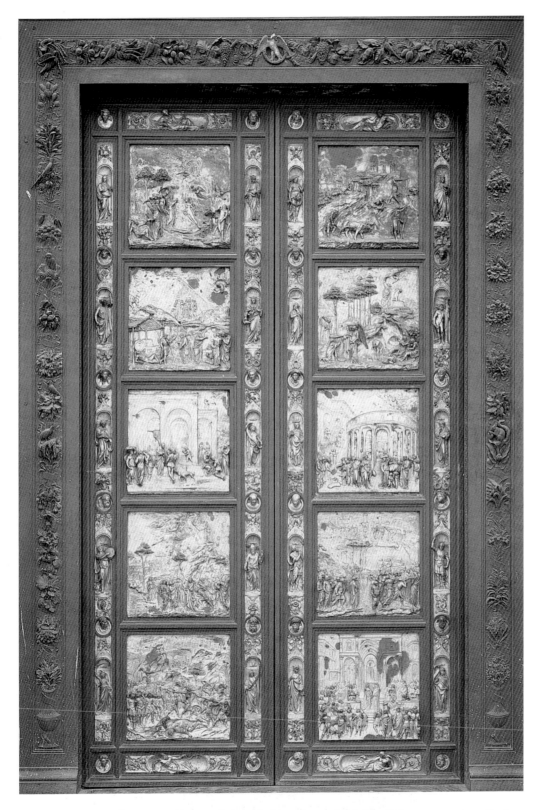

Plate 36 Lorenzo Ghiberti and his workshop, bronze doors, 1424–52, gilt bronze, eastern flank, Baptistery, Florence. Photo: Scala.

Plate 37 Filarete and his workshop, bronze doors, 1433–45, Saint Peter's, Rome (originally for the centre of the façade, presently on the right of the façade). Photo: Archivio Fotografico, Monumenti, Musei e Gallerie Pontificie, Vatican.

Plate 38 Filarete and assistants, detail of *Self-portrait* (of himself and his team), 1433–45, bronze, 123 x 22 cm, bronze doors, Saint Peter's, Rome. Photo: Archivio Fotografico, Monumenti, Musei e Gallerie Pontificie, Vatican.The self-portrait is on the lowest part of the right valve of the doors, on the back. The Latin inscriptions give the names of Filarete and his assistants beside each figure, the date of completion (30 July 1445) and the statement (in translation): 'To other artists satisfaction from payment or from pride, but for me – joyfulness'.

Discussion

1 Both self-portraits were placed where thousands of people could see them but the fact that both used Latin inscriptions ensured that only an élite audience would understand their full import.

2 Ghiberti focused solely on *his* marvellous skill. He placed the image where it could not be missed, and in the inscription and his self-portrait he emphasized only his role, even though he employed a very large team of sculptors. By contrast, Filarete is relatively modest, because he does not depict himself alone but shows the whole team responsible for the doors. Also, the relief is placed in a lowly position, difficult to see in the dark interior of the church and requiring the viewer to kneel down to look at it. He is shown holding compasses, perhaps to emphasize his geometrical knowledge. He claims that he works not for money or pride in his work but for joy[1] – an idea that suggests art is an elevated vocation.

◆◆◆

There are two important points to make in addition. First, the 'portrait signature' did not suddenly appear in Italy in the fifteenth century. On the contrary, artists had placed them on their work throughout antiquity and the Middle Ages. Second, when work was designed for a church, as with these two doors, the intention appears to have been for the artist to draw attention to an achievement that could earn him spiritual rewards in the hereafter as well as worldly fame. Our knowledge of this long tradition suggests that Ghiberti and Filarete hoped to draw both the eyes and the prayers of viewers.

We should also note that both Ghiberti and Filarete can be shown to have made written statements affirming the dignity of art, indicating that their self-portraits could be read as using a familiar tradition to assert new ideas. Ghiberti's *Commentaries* provides evidence of ambitions and interests that set him apart from other artists, and Filarete was equally innovative. He had changed his name from 'Antonio from Averlino near Florence' to 'Filarete'

[1] Filarete and his assistants are shown dancing as they leave Rome. At his feet is a pig (presumably to be roasted in a celebration meal) and a lamb. To the right is a camel apparently also given to the artist as a parting present.

Plate 39 Filarete, drawing from his treatise on architecture, showing the house of the architect with the figure of Virtue on its roof, *c*.1460, ink on paper, Biblioteca Marciana, Venice, MS Lat VIII.2(2796), fol. 139 recto. Photo: Conway Library, Courtauld Institute of Art, University of London.

(a transliteration of Greek words meaning 'lover of virtue'), thereby identifying himself with the role of heroic artist. He also wrote a treatise on architecture, about 1460, featuring an imaginary city among whose buildings he illustrated and described the house of the architect (Plate 39). This house had two doors – one of virtue leading to a steep stair with the inscription over it 'Hard work with joy', and one of vice which led to a sloping shute and was inscribed 'Pleasure with sadness'. Filarete therefore sought to present the architect as a morally superior professional, who looked for joy as the reward for attainment, and worked hard, rather than seeking mere financial success or worldly pleasures.

Medallic self-portraits *c*.1450

The casting of medals commemorating individuals was developed from the 1430s onwards. Sculptors sometimes made medals portraying themselves, although they often made their versions smaller than those of their powerful clients. Medals were made for intimate viewing, as they would be held in the hand, but since they were cast, they could also be made in editions of a dozen or so to be sent to the artist's colleagues or patrons.[2] Around 1450, for example, one of the founders of the medallic art, Antonio Pisanello, made himself a medal with his own portrait on the obverse, and a reverse that represented

[2] Casts were a way of reproducing a design but, as each cast would be individually chiselled and polished to add detail and remove imperfections, each medal was unique.

Plate 40 Pisanello, *Self-portrait*, *c*.1450, bronze medal (obverse and reverse), diameter 5 cm, Museo Civico di Palazzo Te, Mantua. Photo: Index/Giovetti.

his aspirations by means of the initial letters of the seven Christian Virtues wreathed in a laurel crown : **F**ides, **S**pes, **K**aritas, **I**usticia, **P**rudentia, **F**ortitudo, and **T**emperantia – Faith, Hope, Charity, Justice, Prudence, Fortitude, and Temperance (Plate 40).

Bystander self-portraits *c*.1300

Another new kind of self-portrait – the bystander self-portrait – was also a version of the sort of portrait that artists made for patrons. With the movement towards a more naturalistic art during the fourteenth century, the practice emerged of depicting the person who had commissioned a work of art as a bystander at the pictured event. It seems that artists were doing the same thing for themselves. Villani reports that Giotto included himself with Dante in frescoes for the Palazzo del Podestà in Florence in about 1300, and Ghiberti records that the Florentine artist and sculptor Orcagna had carved his portrait in a relief for a tabernacle at the oratory of Orsanmichele in Florence in 1357. Corroborative evidence in the form of proven inscribed likenesses of artists to compare with bystander self-portraits is often lacking, but their insertion seems to have been quite common. Plates 41 and 42 show self-portraits of the painters Raphael and Sodoma (so it is reported by Vasari) on the right margin of their fresco of the philosophers of the ancient world in the Stanza della Segnatura in the Vatican.

Raising the dignity of the artist may not have been the main motivation for bystander self-portraits. They could simply be addressed to acquaintances or, in the case of religious images, they would have devout significance. But the fact that their presence was written about by artists (Ghiberti, Vasari) suggests they were also cause for pride. They might be seen to assert the new powers afforded by realistic skills, as they enabled artists to appear in their own pictures – and thereby appropriate for themselves a privilege that had originated for the benefit of their patrons.

Plate 41 Raphael and Sodoma,
The School of Athens, 1508–11,
fresco, 770 cm at base, Stanza
della Segnatura, Vatican, Rome.
Photo: Archivio Fotografico,
Monumenti, Musei e Gallerie
Pontificie, Vatican.

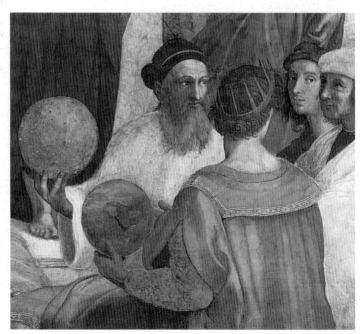

Plate 42 Raphael and Sodoma, *Self-portraits*, detail of *The School of Athens* (Plate 41). Photo: Archivio Fotografico, Monumenti, Musei e Gallerie Pontificie, Vatican.

Introductory self-portraits 1523

Some artists began using self-portraits to introduce themselves and their skills to powerful and distant patrons. The earliest surviving example by a man was made in 1523 by Parmigianino, who came from Parma and gave his self-portrait to Clement VII in Rome (Plate 43). The earliest known female equivalent was painted in 1558 by Sophonisba Anguissola of Cremona as a gift for a princely patron in Italy or Spain (Plate 44). The Latin inscription around the circular object held by Sophonisba explains (in translation): 'I painted myself in the mirror'. Such a portrait would serve to introduce the painter to the patron as a trustworthy servant. Both artists emphasize their youthful candour in presenting such faithful mirror images of themselves. The goal here seems to be to secure employment at court, not raise the status of art. It is important to realize that the act of showing oneself to another was very different for a young woman than it was for a young man. In Italian society at this time, women were not supposed to play an independent role in public life. Consequently, Sophonisba's self-portrait needed to emphasize her extreme modesty. In order to avoid displaying her body, she places the mirror in front of her bosom, like a shield.

Plate 43 Parmigianino, *Self-portrait*, 1523, convex wood surface, diameter 24.4 cm, with frame, Kunsthistorisches Museum, Vienna. The photograph does not show the original integral frame.

Plate 44 Sophonisba Anguissola, *Self-portrait*, *c.*1555, oil on parchment, 8 x 6.5 cm. Emma F. Munroe Fund. Courtesy, Museum of Fine Arts, Boston. There is some damage at the bottom right of the portrait.

Family mementoes *c*.1529

On occasion, artists made self-portraits as family mementoes. Vasari, for example, describes the Florentine painter Andrea del Sarto making a self-portrait in about 1529, which he gave to his wife (Plate 45). Andrea had just finished painting the portrait of a monk on a tiled surface (so that it would withstand weathering because it was for an exterior site) and made his own portrait on a tile to finish up the left-over materials there and then. It is a small portrait, showing the head and shoulders only. Self-portraits were usually modestly sized and not full length. Presumably, artists needed to show that they knew their place (only very powerful patrons would have full-length, life-size portraits).

Plate 45 Andrea del Sarto, *Self-portrait*, *c*.1529, ceramic tile, Uffizi, Florence. Photo: Scala. The tile has been broken and repaired.

Funerary self-portraits *c*.1500

From the early sixteenth century, some Italian artists made self-portraits for their own funerary commemoration, imitating the portraits they made for patrons in funerary chapels. For example, in about 1500, the Mantuan painter Andrea Mantegna made a bronze bust of himself for his funerary chapel in Mantua. In the 1560s, the Veronese painter Giovanni Caroto painted a portrait of himself and his wife Placida kneeling in his brother's funerary chapel at Santa Maria in Organo (Plate 46). As the portraits appeared on an altar panel of the Madonna, it is clear that their significance was devotional. They served to remind clergy and family to offer prayers for the souls of the painter and his spouse. Since the painter was making for himself the sort of altarpiece that he painted for his clients, this might indicate that artists were also drawing attention to their improved social status.

Plate 46
Giovanni Caroto,
Self-portrait (with
Placida his wife),
c.1560, canvas,[3, 4]
81 x 53 cm,
Museo Civico,
Verona. Photo:
Index, Florence.

Participant self-portraits *c.*1550

Some artists represented religious events for their tombs which included
participant self-portraits. Instead of the artist being shown in the role of a
bystander, he was depicted as taking a key part in a pictured or sculpted
religious drama. Worshippers were taught to meditate on the sufferings of
the Passion by sharing the emotions of the persons they mentally pictured. A
participant self-portrait could represent the attempt of the artist to identify
with a Christian hero. For example, Ascanio Condivi recorded that his friend
Michelangelo had carved himself in the guise of Nicodemus mourning over
the dead Christ. According to John 19:40, Nicodemus had brought spices to
anoint Christ's body at the Entombment and in legend Nicodemus was said
to be a sculptor. Michelangelo intended to place this sculpture, before which
he wished to be buried, in Santa Maria Maggiore in Rome (Plate 47). Such
portraits reflected the spiritual concerns of the artist rather than the desire
for worldly fame and were acts of devotion exclusive to artists.

[3] The painting was transferred to canvas following a fire that burned the chapel.

[4] In some cases, the paint medium cannot be indisputably identified unless a small sample is
removed for analysis. Where, to preserve the painting, this has not been done, only the base
on which the painting has been executed is specified in the caption.

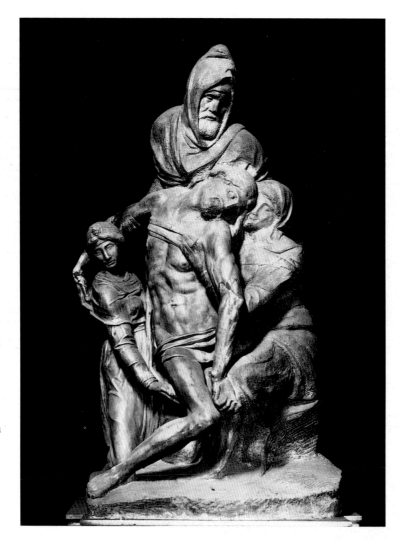

Plate 47
Michelangelo,
Self-portrait (as
Nicodemus
supporting the
dead Christ, with
the Virgin Mary
and an angel),
c.1550, marble,
height 226 cm,
Cathedral,
Florence. Photo:
Alinari.

Self-portraits in books and museums 1539

From the mid-sixteenth century onwards, portraits of artists were being collected. Between 1539 and 1543, Bishop Paolo Giovio had what he called a *musaeum* (Latin, museum) built at his house on Lake Como in northern Italy and placed in it a collection of the portraits of scholars, statesmen, and artists. In 1552, the ruler of Florence, Cosimo I de' Medici, sent the painter Cristoforo dell'Altissimo to Como to copy them. Giovio's collection included, for example, a self-portrait of Leonardo in the form of a drawing (Plate 48). Giovio provided important precedents for Vasari's *Lives*, both through the lives that Giovio had himself written about a number of artists and through his project of collecting artists' portraits. Vasari took over the plan of recording the appearance of the artists and in the second edition of the *Lives* (1568) he provided woodcut portraits of the artist at the head of each biography. Some portraits were based on self-portraits – such as the tile portrait of Andrea and the self-portrait of Leonardo, which Vasari knew from the Medici collection. However, Vasari dignified these portraits with frames symbolizing the arts of painting, sculpture, and architecture (Plates 49 and 50).

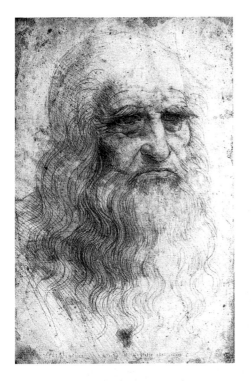

Plate 48 Leonardo da Vinci, *Self-portrait*, *c*.1512–15, red chalk, 33.5 x 21.5 cm, Biblioteca Reale, Turin. Photo: Chomon, reproduced by permission of Ministero per i Beni Culturali e Ambientali.

Plate 49 Andrea del Sarto, *Self-portrait*, framed by an allegory of painting, 1568, woodcut, from Giorgio Vasari, *Le vite de'piu eccellenti pittori*, Appresso i Giunti, Florence, 1568. Bodleian Library, Oxford, AA 110 Th. Seld., vol.2, p.149.

Plate 50 Leonardo da Vinci, *Self-portrait*, framed by allegories of painting and architecture, 1568, woodcut, from Giorgio Vasari, *Le vite de'piu eccellenti pittori*, Appresso i Giunti, Florence, 1568. Bodleian Library, Oxford, AA 110 Th. Seld., vol.2, p.1.

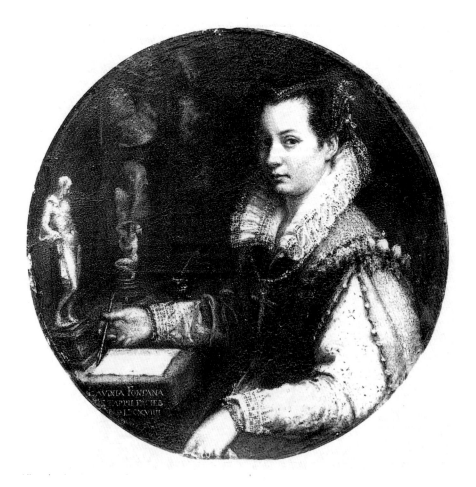

Plate 51 Lavinia Fontana, *Self-portrait*, 1579, copper, diameter 15 cm, Uffizi, Florence. Photo: Alinari. The Latin inscription reads (in translation): 'Lavinia Fontana married into the Zappi family made this 1579'. The portrait has been cropped in this photograph.

A self-portrait could be expressly designed to be placed in a collection. This was the case with the self-portrait by Lavinia Fontana of Bologna made for the Dominican scholar Alonso Chaçon (Plates 51 and 52). He planned to publish an engraved gallery of 500 portraits of illustrious scholars, statesmen, and artists, which he called his *museo* (Italian, museum). In the letter asking for the portrait, he had promised the artist 'great glory' (King, 'Looking a sight', pp.401–2). Fontana sent the portrait to be engraved in 1579 but the book was never published.

Compare the self-portrait by Fontana (Plates 51 and 52) with those by Andrea and Leonardo (Plates 45 and 48). How do you think knowledge that the portrait would have a public audience affected Fontana's self-representation?

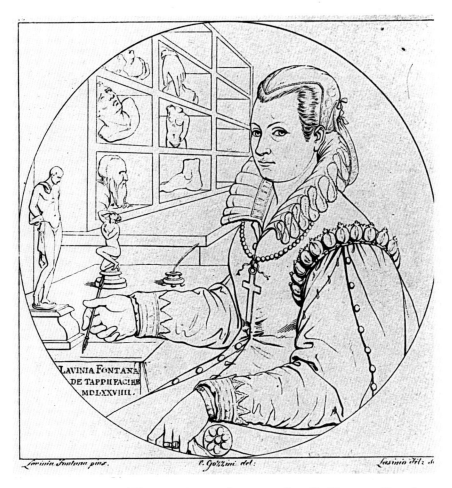

Plate 52 Engraving of Plate 51, nineteenth century, Castello Sforzesca, Raccolta Seletti, Milan.

Discussion

In the original self-portraits by Andrea and Leonardo the head and shoulders fill the picture field, suggesting the way in which our field of vision is filled by a person when we are close to them. Fontana's self-portrait distances us more, and she places herself to one side so that we can see the signs of her learned study of anatomy and classical sculpture from casts and statuettes. She also makes claims about her piety and social status by showing herself with a large cross on a rosary round her neck, a rich-looking dress, and an armchair (poor people possessed only stools).

◆◆◆

Andrea and Leonardo did not include tools of their trade in their self-portraits. Since few women received an artist's training, those who did so were likely to emphasize their identity as artists in any self-portrait. Women were treated differently from men in Italian society, being defined as dependent legally on their fathers, or, if married, their husbands, rather than independent like a man. Consequently, women's self-portraits showed whether a woman was

married or not. The statement that Lavinia has married would also be intended to prevent male viewers from imagining that she was making an image of herself intending to attract a suitor.

Self-portraits made for public consumption might be designed to prove that the artist was worthy to be included in the gallery of fame along with statesmen and scholars.

Commemorating career achievements 1535

From the early sixteenth century onwards, Italian artists occasionally made self-portraits to commemorate their acquisition of some personal honour. In about 1535, for example, Bandinelli portrayed himself with the chain and medallion of the Order of Saint James of Compostela that had been conferred on him by Emperor Charles V. A decade later, Titian painted himself sporting the golden chain commemorating his knighting by the same emperor (Plate 53). In 1571, Vasari portrayed himself with the papal order of the Cavalier of the Golden Spur. Once again, artists were appropriating for themselves the kinds of portrait that they were commissioned to make for powerful clients, in this case to record their career achievements.

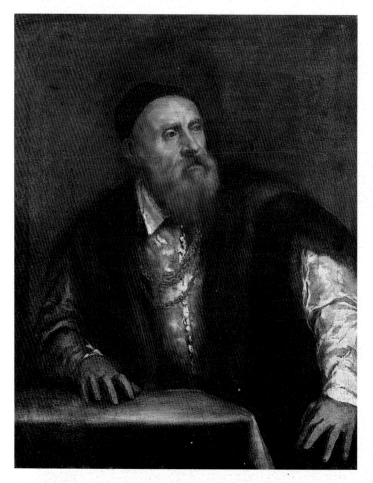

Plate 53 Titian, *Self-portrait*, *c.*1550, canvas, 96 x 75 cm, Gemäldgalerie, Staatliche Museen zu Berlin Preussischer Kulturbesitz. Photo: Bildarchiv Preussischer Kulturbesitz/Jörg P. Anders.

Self-portraits with artistic allegories 1542

Both Vasari and Federico Zuccaro (1540/3–1609) (who founded the Roman Academy in emulation of the Florentine one founded by Vasari) placed self-portraits in their reception rooms in conjunction with allegories that elevated the importance of art. This use of artists' houses was an ingenious method of communicating a message about their status, which had precedent in the way that their social superiors advertised their status through the decoration of their palaces.

In 1542, Vasari decorated the vault of a room in his house at Arezzo with personifications of Painting, Sculpture, Architecture, and Poetry, surrounding a figure of Fame blowing her trumpet (Plate 54). At the same time (or at least by 1568), Vasari painted the eight lunettes[5] below the vault with his own portrait, together with portraits of the seven artists who had taught him, including his father and grandfather and the artist to whom he had first been apprenticed, Luca Signorelli.

Plate 54 Giorgio Vasari, Camera della Fama (from left to right: pendentives,[6] Painting and Sculpture; lunettes, Michelangelo, Andrea del Sarto, and Lazzaro Vasari), 1542–68, fresco, Casa di Vasari, Arezzo. Photo: Index/Tosi.

[5] Semi-circular openings or surfaces at the top of a wall below a vaulted ceiling supported on columns or piers.

[6] Spherical triangles formed by a dome rising from a square base.

Plate 55 Federico Zuccaro, *The Labours of Hercules surround the Ascent of the Hero to the Temple of Honour via that of Virtue*, c.1590, fresco, Palazzo Zuccaro, Rome. Photo: Biblioteca Herziana, Rome.

Zuccaro emulated Vasari when he came to decorate his own house in Rome in the 1590s (Plate 55). He painted the vault of the entrance with the allegory of 'The Choice of Hercules', to which he appended the exhortation (in Latin): 'Climb up, stranger, to the golden summit by the arduous path of virtue like the laborious hero. Shun the transient valley which is a raging torrent of hell' (King, 'Late sixteenth-century careers advice', p.86). At the summit of the hill were two temples, with the Temple of Virtue providing the only entrance into that of Honour (echoing the story of Marcellus). The visitor then entered the reception room, in which Zuccaro portrayed himself with his family in eight lunettes. Zuccaro not only showed himself as he then was in his role as head of the family with his wife behind him (Plate 56), but also included a retrospective portrait of himself as a boy gazing up adoringly at his elder brother Taddeo, who had died young before being able to fulfil his brilliant promise (Plate 57). In the allegory in the middle of the painting above, on the vault, Virtue in the shape of the mythological Roman goddess Minerva holds the hardworking hero (perhaps meant to be Taddeo) by the hand. Apollo, the mythological god of the creative arts, specifically poetry and music, and leader of the Muses (the companions of the liberal arts) presides over the scene, with Fame flying overhead and Envy and Deceit cowering. The inscription gave the traditional advice: 'With virtue leading' (Plate 58). Also on the vault were personifications of the qualities of worthy artists: Hard Work, Perseverance, Energy, Diligence, Sincerity (Plate 59), Knowledge, and Charity.

Plate 56 Federico Zuccaro, *Self-portrait* (with Francesca Genga his wife), *c.*1590, fresco, lunette from hall, Palazzo Zuccaro, Rome. Photo: Biblioteca Herziana, Rome.

Plate 57 Federico Zuccaro, *Self-portrait* (as a boy with his elder brother Taddeo), *c.*1590, fresco, lunette from hall, Palazzo Zuccaro, Rome. Photo: Biblioteca Herziana, Rome.

Plate 58 Federico Zuccaro, *Led by Virtue the Artist Achieves Fame*, *c.*1590, fresco, vault decoration from hall, Palazzo Zuccaro, Rome. Photo: Biblioteca Herziana, Rome.

Plate 59 Federico Zuccaro, *Sincerity*, c.1590, fresco, detail of vault decoration from hall, Palazzo Zuccaro, Rome. Photo: Biblioteca Herziana, Rome.

Although the location of these self-portraits may seem to be private ones frequented only by the Vasari and Zuccaro families, they were actually visited by large numbers of artists and patrons travelling through Arezzo to Rome. Moreover, Zuccaro left this house in his will to be used as lodgings for young artists visiting Rome.

Self as model 1623

Artists seeking to represent a variety of intense emotions in people in their paintings or sculptures might mime in mirrors so that they could use themselves as models. Because of the resulting distortions of appearance, it is difficult to identify the works as self-portraits. However, a secure example of an artist using himself as a model seems to be Bernini's life-size sculpture of the Old Testament hero David made in Rome in 1623 (Plates 60 and 61). This is recorded by Bernini's son Domenico in his biography of his father as having been made with the help of a mirror.

Plate 60 Gian Lorenzo Bernini, *David*, 1623, marble, life-size, Galleria Borghese, Rome.
Photo: Scala.

Plate 61 Gian Lorenzo Bernini, detail of head of *David* (Plate 60). Photo: Scala.

Can you imitate in a mirror the expression on David's face? What does it feel like – emotionally and physically? Would you regard this as indicating that the artist was expressing himself in his art?

Discussion

I felt I was concentrating hard mentally on one thing, and it was painful to hold the pose. It suggested to me that Bernini was finding an arresting expression for his marble figure through using his knowledge of his own inner feelings as well as their outward appearance. The result does seem to render David's resolution against the giant enemy Goliath in a personally expressive way.

◆◆

Self-portrait as 'Painting' 1630

One Italian artist experimented with showing herself playing the role of the art of painting itself. In 1630, Artemisia Gentileschi painted her own portrait in the role of 'Painting' for her patron, Cassiano dal Pozzo (Plate 62).

Plate 62
Artemisia
Gentileschi, *Self-portrait* (as an
allegory of
painting), 1630,
canvas,
Kensington
Palace, London.
Royal Collection,
© Her Majesty
the Queen.

1 **What distinguishes this self-portrait from others?**

2 **Which of those that we have just been looking at does it most closely resemble?**

3 **Does the artist make any particular claims for herself?**

Discussion

1 This self-portrait is unusual because the artist avoids conventional portrait poses where sitters face the spectator or are shown in profile and appear in repose (see the medal of her for comparison, Plate 63). She gives a view of herself which is intimate, because she does not turn formally to greet us as viewers, as if we were visitors, but appears absorbed at her painting.

2 The self-portrait seems rather like Bernini's *David*, since Gentileschi assumes a fictional identity in lending her own features to 'Painting'.

3 In making this portrait the artist also claims her own worthiness to stand as 'Painting'.

◆◆◆

Plate 63 Anonymous, *Artemisia Gentileschi*, c.1630, bronze medal, Staatliche Museen zu Berlin Preussischer Kulturbesitz. Photo: Bildarchiv Preussischer Kulturbesitz.

A handbook on how to represent different ideas, written by Cesare Ripa in 1593, had specified that the personification of Painting should wear a gold chain with a theatrical mask on it (to signify skill in conveying a dramatic scene) and untidy hair (to signify Painting's fantastic imaginings and her carelessness for everything except her art). To depict oneself in this guise was only possible for a female artist, because the Italian noun for 'painting' has a feminine gender (*la pittura*). Rather than the gold chain of worldly honour sported by Bandinelli, Titian, or Vasari, Gentileschi wears the jewel of Painting. Although the female artist could not allegorize herself as Hercules or Scipio choosing the virtuous path to art, she could symbolize devotion to art by identifying herself with the feminine 'Painting'.[7]

The 'genius' of Salvator Rosa 1662

The ultimate example of self-advertisement and moral striving is perhaps represented by the etching that the Italian painter and poet Salvator Rosa made in about 1662, stating the qualities that he aspired to in his own talent (Plate 64). As an engraving, it could reach a large number of viewers. The image, which is inscribed in Latin, reads in translation 'Sincere, Free, Critical but Fairminded painter, despising wealth and death: here is my talent [*Genius*], Salvator Rosa'. Although the word *genius* was sometimes translated as 'guardian angel', 'talent' is probably preferable here. Rosa's engraving is hard to 'read' because he was drawing on an immensely rich system of signification derived from the imagery of medieval literature and theology as well as from Greek, Roman, and Egyptian antiquity. What he meant can be partially reconstructed by reference to handbooks of symbolism available to him and his audience.

[7] For further information on female self-portraiture in the Renaissance, see Catherine King, 'Made in her image', in Perry, *Gender and Art* (Book 3 in this series).

Plate 64 Salvator Rosa, *Self-portrait* (as an allegory of his talent), *c*.1662, etching with drypoint, 3rd state, 46.2 x 27.7 cm. George Peabody Gardner Fund. Courtesy, Museum of Fine Arts, Boston.

The recumbent man seems to represent Talent and the overturned cornucopia (horn of plenty) under his arm could signify rejection of wealth (usually, a cornucopia signifies abundance). The tomb, smoking urn, and cypress trees probably symbolize death. According to a handbook on symbolism written by Pietro Valeriano (*Hieroglyphica*, 1575), the fish in the foreground could stand for hatred (of death and money). The woman in the centre of the engraving who is giving Talent her heart, and who holds the dove of innocence, can be identified as Sincerity. Next in the inscription and on our right is a woman wearing the cap of Liberty, which Roman slaves wore on being freed, and holding the sceptre of power (in this case, meaning power over oneself). Both these personifications could be found in a well-known handbook on iconography by Cesare Ripa (*Iconologia*, 1611). The standing man seems to represent Fairness; he holds balances, which is in accordance with Ripa's description, although Rosa makes his personification hold out a book as well. The kneeling woman with palette and brushes on the left can be identified as Painting. Finally, the satyress probably represents the term *succensor* (righteous anger), that is, to be angry in a good cause. As the Latin text indicates, Rosa had assumed the role of critic and published a sequence of poetic *Satires*, using this literary form to point to what he considered to be faults in his society.

In what ways does this image build on earlier claims put forward by artists and to what extent does it seem to suggest a new conception of the identity of the artist? (You might want to refer back to the historical introduction, where modern ideas of genius are discussed.)

Discussion

The image follows the earlier representations that we have seen in claiming status for the artist on the grounds that he seeks high moral and artistic standards rather than money and that he seeks freedom to invent as if he were a poet. You might have noticed that Rosa used the same image of Sincerity as did Zuccaro in decorating his house (Plate 59). However, Rosa is the first artist that we have encountered who actually sets himself up as a critic of his society, thus claiming for himself a higher moral authority than other people.

◆◆

Conclusion

We can now draw together some general conclusions about the kinds of claim that artists were making for themselves, as well as considering how effective they were in promoting these claims.

Which of the types of self-portrait that we have considered particularly emphasized social success?

Discussion

In the medals, the bystander portraits, the family portraits, and the funerary portraits, the artists are appropriating for themselves forms of portrait that

originated for the benefit of their wealthy patrons. For them to have their self-portraits hanging in collections along with those of scholars, writers, and statesmen would have been a mark of social prestige. Portraits commemorating high office and decorating artists' own houses also imitated the practices of their social superiors. However, it is important to emphasize that some portraits, such as the participant portraits, were very definitely about devoutness and not about social status.

◆◆

Which types of self-portrait were most associated with intellectual status?

Discussion

Almost any self-portrait (except the 'self as model' perhaps) could be said to emphasize the intellectual attainments of art, since those who were good at liberal arts were said to have innate *personal* talent as well as being well taught. However, some types of self-portrait did emphasize specific themes, such as love of one's art (Plates 38, 51, 62, 64), or love of virtue (Plates 40, 55–58), or love of academic skills (Plates 38, 51), which reinforced the ambition of artists to be treated as poets and philosophers. Having a self-portrait in a gallery would be important too (Plate 51).

◆◆

Which types of self-portrait reached the largest audiences?

Discussion

Public images like the portraits on the doors of a church or baptistery, or on tombs, or murals in a church, could be seen by anyone walking about a city. Other locations for self-portraits would lead to more restricted viewing. Portraits on engravings, or in books, or editions of a medal had circulation among an élite section of the population. Self-portraits in artists' houses or the houses of their patrons could be shown off to an exclusive group of art-lovers and practitioners who might be powerful enough to make their views felt.

◆◆

A final issue for us to consider is whether visual images or written texts were more important in making new claims about art and artists. Images could reach out to those who were without access to books. In the rich oral culture of Italy at this period, conversation going on around public self-portraits could have been an important way of changing mass expectations. However, it has to be said that, in the case of all the self-portraits in this case study with inscriptions on them, the inscriptions were written in the scholarly language of Latin. By contrast, most of the written texts arguing for change in status were at least in Italian, although the fact that editions were so small stresses that texts could also be exclusive. However, what is so important about the visual images is that they were sometimes produced by artists who did *not* write down their ideas and publish them. Consequently, such evidence for the changing status of the artist has a unique value, in that it was a way for artists to represent their views, even if they were not sufficiently literate or influential to publish a book.

References

Alberti, L.B. (1966) *On Painting*, ed. and trans. J.R. Spencer, New Haven and London, Yale University Press.

Florio, J. (1598) *A Worlde of Wordes*, London.

Holt, E. (1957) *A Documentary History of Art*, vol.I, New York, Doubleday.

King, C. (1988) 'Late sixteenth-century careers advice: a new allegory of artists' training', Albertina inv. no. 2763, *Wiener Jahrbuch für Kunstgeschichte*, vol.XLI, pp.77–97.

King, C. (1995) 'Looking a sight: sixteenth-century portraits of women artists', *Zeitschrift für Kunstgeschichte*, vol.58, pp.381–406.

Perry, G. (ed.) (1999) *Gender and Art*, New Haven and London, Yale University Press.

Ripa, C. (1611) *Iconologia*, Padua.

Samek-Ludovici, S. (1956) *Vita del Caravaggio dalle testimonianze del suo tempo*, London, Victoria and Albert Museum.

Valeriano, P. (1575) *Hieroglyphica*, Basel.

Benvenuto Cellini
and the salt-cellar

COLIN CUNNINGHAM AND KIM WOODS

'When I set this work before the King,' wrote Benvenuto Cellini (1500–71) in his autobiography, 'he gasped in amazement and could not take his eyes off it' (*The Autobiography of Benvenuto Cellini*, p.291). The work in question was not a painting or a major work of sculpture but a salt-cellar (Plate 65). Clearly, the artist was very gratified by the reaction of the king (Francis I of France, reigned 1515–47), and the salt-cellar certainly is a gorgeous object, of beaten or cast gold enriched with coloured enamel and set on a base of ebony.

Plate 65 Benvenuto Cellini, salt-cellar for King Francis I, 1540–3, gold and enamel, 26 x 33.5 cm, Kunstshistorisches Museum, Vienna.

You may be a bit surprised, though, at the choice of this work as the focus of a case study on the status of the artist. After all, if our definition of art is confined to the 'fine arts' of painting, sculpture, and architecture, a salt-cellar, as goldsmith's work and designed principally for a utilitarian function, would hardly qualify as a work of art at all. Cellini too, although one of the leading Florentine sculptors of the decades after Michelangelo left the city, is not always ranked as one of the truly 'great' artists. However, the very ambiguous position of the work and of its creator highlight a number of determining factors in relation to artistic status that are worth considering. First, there is the nature and function of the work of art itself. Secondly, there is the influence of the patron and the place for which the work was made. The status of the salt-cellar and its creator would certainly be enhanced by the fact that Francis I was a client of the highest stratum of society and that by the mid-sixteenth century his court at Fontainebleau was succeeding Florence as one of the leading centres of artistic excellence. Thirdly, of course, there is the reputation of the artist, which derives partly from his works and partly from his patrons. Our chief evidence for the status achieved, or at least aspired to, by Cellini is his autobiography, written in the last years of his life. We shall look at all three of these aspects of status in relation to the salt-cellar.

The work of art

The salt-cellar had a particular importance in the ceremonial life of sixteenth-century courts. At that time it was the practice for the great to dine in formal state, with their silver and gold plate, the immediate evidence of their wealth and power, displayed on the table or a buffet. Among the regular pieces of plate, the salt-cellar had an especially significant place. It was generally set on the table, and it marked the social distinction between the intimate members of the great man's circle (or those currently in favour), who sat 'above the salt', that is, closer to the host than the salt, and the lesser guests who did not. So, in making a salt-cellar for the king, Cellini was making an object of some significance in terms of royal etiquette. This would undoubtedly have accorded it a special status and would have been one of the reasons why Cellini was keen that the salt-cellar should impress the king.

As a piece of work in gold, the salt-cellar certainly has material value, and in the pre-Renaissance period the value of the materials used was an essential aspect of the status of a work of art. One of the features of the Renaissance, however, was that artistic skill assumed more importance as a criterion of quality, so that material value can hardly be said to establish the salt-cellar as a canonical object, even though it is extremely richly fashioned.

Please look at Plates 66–71. Naturalism and skill in representation of the human form and creative or imaginative input in the design of a work of art were both prominent sixteenth-century artistic preoccupations. Do you consider that there is evidence of these aspects of artistic skill, which would have conferred status on the object?

Plate 66
Benvenuto
Cellini, salt-cellar
for King Francis I,
1540–3, gold and
enamel, 26 x
33.5 cm, view
from behind Sea,
Kunsthistorisches
Museum, Vienna.

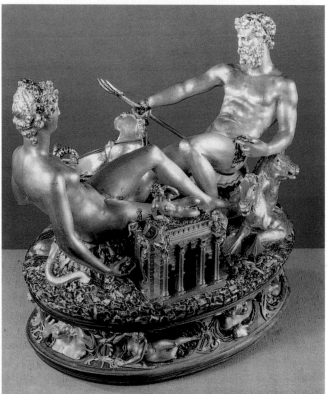

Plate 67
Benvenuto
Cellini, salt-cellar
for King Francis I,
1540–3, gold and
enamel, 26 x
33.5 cm, view
from behind
Land,
Kunsthistorisches
Museum, Vienna.

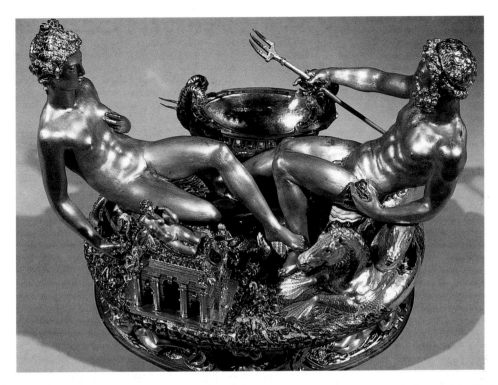

Plate 68 Benvenuto Cellini, salt-cellar for King Francis I, 1540–3, gold and enamel, 26 x 33.5 cm, view from above, Kunsthistorisches Museum, Vienna.

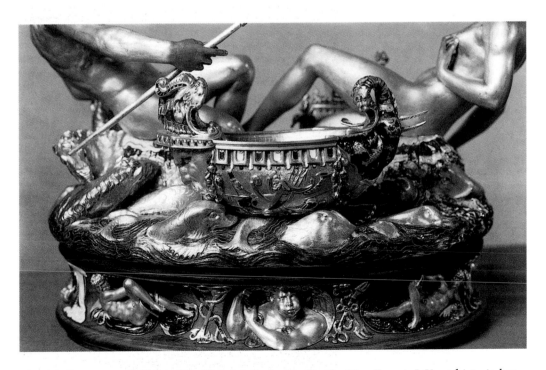

Plate 69 Benvenuto Cellini, salt holder, detail of salt-cellar for King Francis I, Kunsthistorisches Museum, Vienna.

Plate 70
Benvenuto
Cellini, nude
male, detail of
base of salt-cellar
for King Francis I,
Kunsthistorisches
Museum, Vienna.

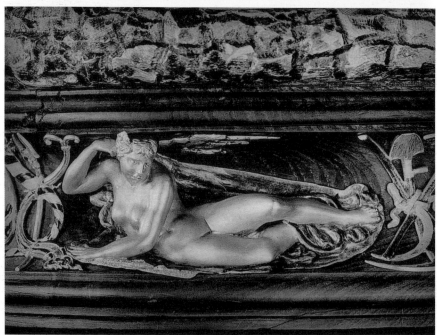

Plate 71
Benvenuto
Cellini, nude
female, detail of
base of salt-cellar
for King Francis I,
Kunsthistorisches
Museum, Vienna.

Discussion

In some respects, for example in their detailed anatomy, the two principal figures seem to be conceived almost as miniature life-like sculptures. The animal and sea life is convincingly represented, even to the extent of using enamel to represent the whites of the horses' eyes, heightening their appearance of wildness and realism. The object as a whole, although quite small, is packed with inventive and decorative detail. (If you like simple forms, you may find this salt-cellar fussy, even vulgar!)

The figures around the base, representing
Night, Day, Twilight, and Dawn, are not origi-
nal conceptions but have been borrowed from
an existing work of sculpture: Michelangelo's
famous allegorical figures for the Medici tombs
in the church of San Lorenzo in Florence
(Plates 72–74). We know from his autobiogra-
phy that Cellini held Michelangelo in high
esteem, so it is no surprise that he should take
inspiration from the master.

Cellini himself has a good deal to say about the
design of the salt-cellar, which it is also
important to consider.

Plate 72 Michelangelo, allegorical figure of Night,
1519–34, marble, over life-size, Medici Chapel, San
Lorenzo, Florence. Photo: Alinari.

Plate 73 Michelangelo, allegorical figure of Day,
1519–34, marble, over life-size, Medici Chapel, San
Lorenzo, Florence. Photo: Alinari.

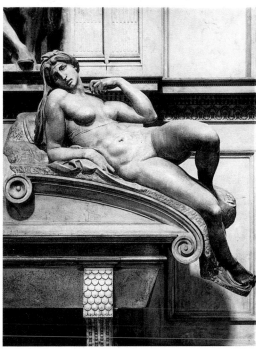

Plate 74 Michelangelo, allegorical figure of
Dawn, 1519–34, marble, over life-size, Medici
Chapel, San Lorenzo, Florence. Photo: Alinari.

Please read the following extract from Cellini's autobiography and look at Plates 66–71 again. What does Cellini seem most proud of?

It was oval in shape, about two-thirds of a cubit high, entirely in gold and chased by means of a chisel. And, as I said when describing the model, I represented the Sea and the Land, both seated, with their legs intertwined just as some branches of the sea run into the land and the land juts into the sea: so, very fittingly, that was the attitude I gave them. I had placed a trident in the right hand of the Sea, and in his left hand, to hold the salt I had put a delicately worked ship. Below the figure were his four sea-horses: the breast and front hooves were like a horse, all the rest, from the middle back, was like a fish; the fishes' tails were interlaced together in a charming way. Dominating the group was the Sea, in an attitude of pride and surrounded by a great variety of fish and other marine creatures. The water was represented with its waves, and then it was beautifully enamelled in its own colour.

The Land I had represented by a very handsome woman, holding her horn of plenty in her hand, and entirely naked like her male partner. In her other hand, the left, I had made a little, very delicately worked, Ionic temple that I intended for the pepper. Beneath this figure I had arranged the most beautiful animals that the earth produces; the rocks of the earth I had partly enamelled and partly left in gold. I had then given the work a foundation, setting it on a black ebony base. It was of the right depth and width and had a small bevel on which I had set four gold figures, executed in more than half relief, and representing Night, Day, Twilight, and Dawn. Besides these there were four other figures of the same size, representing the four chief winds, partly enamelled and finished off as exquisitely as can be imagined.

(*The Autobiography of Benvenuto Cellini*, pp.290–1)

Discussion

Cellini is certainly not modest about the quality he sees in his work, but in phrases such as 'very delicately worked' and 'finished off as exquisitely as can be imagined', he seems to be concerned above all with the richness of the workmanship. By singling out the intertwined legs of Sea and Land and the interlaced fishes' tails, Cellini stresses the combination of imaginative flair and exceptional technical skills evident in the design. He apparently intended the elements of nature to look convincingly real.

◆◆

Evidently Cellini had a complex programme of iconography to establish the meaning of the piece, but if you check his description carefully against the plates you will see that Cellini's words do not match what his hands made. Both the ship for the salt and the 'temple' containing the pepper rest on the base and Land does not hold a horn of plenty. These discrepancies could be because Cellini was recalling a work made some 20 years earlier. Cellini includes another description of the salt-cellar in his *Treatise on Goldsmithing*, written in the 1560s, in which he gives a second allegorical meaning for the figures around the base. It does seem, though, that what Cellini remembered clearly, and what justified the object's status in his eyes, was not the symbolic meaning, nor even the precise composition, but the quality and richness of workmanship.

The patron

Francis I was an important patron of the arts and a great collector, who made a major impact on the development of the collections that now form the core of the Louvre Museum in Paris. He was able to secure the services of a number of artists who had already achieved some prominence in Italy, most famously Leonardo da Vinci from 1517 to his death in 1519, and the architect and architectural theorist Sebastiano Serlio, from 1541 to 1547. For his redevelopment of the Palace of Fontainebleau he employed Rosso Fiorentino (1494–1540) (whom Cellini had known in Rome) and Francesco Primaticcio (c.1504–70) to decorate a long gallery that is often regarded as one of the most important sixteenth-century interiors in France (Plate 75). Such was the lure of the French court that Cellini first travelled to France on his own initiative in 1537. He returned in 1540, summoned by the king himself.

The first commission Cellini obtained from Francis I was for twelve life-size silver statues of gods and goddesses to serve as huge candlesticks to stand around the dining-table. Once again, we might question the status of these art works – on one level they were simply an elaborate lighting system! None the less, Cellini went to some lengths to make models and the Jupiter, the first and only statue to be completed, received from the king the ultimate accolade – that it surpassed classical statuary. The statue is now lost and we can judge the project only by such hints as we get from a maquette[1] and a drawing for the Juno (Plate 76).

Plate 75 Gallery of King Francis I, Palace of Fontainebleau, 1534–7, decorated with paintings and stucco figures by the Florentine artists Rosso and Primaticcio. Photo: Giraudon.

[1] Small model in wax or clay.

Cellini would have us believe that Francis I regarded him with considerable respect, and was relatively sparing in his stipulations regarding the design or funding of works he commissioned. One such work was the sculptural decoration for the Porte Dorée, the principal entrance to the Palace of Fontainebleau, although it was never actually installed. According to Cellini's autobiography, the king had requested a figure representing Fontainebleau. Cellini's design centred around the Nymph of Fontainebleau (Plate 77), a semi-circular bronze relief panel designed to fit over the doorway. Two satyrs of reportedly startling ferocity were to stand in place of columns flanking the doorway and two female figures personifying Victory, executed in low relief, were to fill the spandrels[2] above the main relief. The elongated yet modestly life-like elegance of the Nymph of Fontainebleau herself is perhaps less impressive than the lively detailing of the background. Cellini describes this in detail in his autobiography: the hounds eager for the kill to the right; the boar and deer to the left. All of these recall the imaginative design of the salt-cellar.

Plate 76 Benvenuto Cellini, drawing of Juno, 1540–4, design for one of twelve silver statues for King Francis I, on paper, 247 x 186 cm, Musée du Louvre, Paris, Département des Arts Graphiques. Photo: R.M.N.

Plate 77 Benvenuto Cellini, *The Nymph of Fontainebleau*, c.1542–4, bronze, 205 x 409 cm, relief for the Porte Dorée at the Palace of Fontainebleau, Musée du Louvre, Paris. Photo: R.M.N.

2 Spaces between the curves of arches and the surrounding mouldings.

Cellini went beyond the bounds of the normal patron–artist relationship in embarking on works of art on his own initiative. Finding that there was silver left over from the Jupiter he used it to make a vase without consulting the king. He also prepared without consultation a small-scale model for a huge fountain for Fontainebleau, incorporating a colossal statue of Mars accompanied by personifications of the Arts and Sciences, and delivered the king a lecture to explain its flattering iconographical significance. Initially the king's reaction was favourable:

> Mon ami (that is, my friend), I don't know which is the greater, the pleasure of a prince at having found a man after his own heart, or the pleasure of an artist at having found a prince ready to provide him with all he needs to express his great creative ideas.
>
> I answered that if it was me his Majesty meant then my fortune was by far the greater. He answered with a laugh: 'Let's say that it's equal.' I left him in very high spirits, and went back to my work.
>
> (Cellini, *The Autobiography of Benvenuto Cellini*, p.271)

Later, however, the king's exasperation with Cellini's presumption grew to a pitch that even the sight of the assembled sculpture for the Porte Dorée could not dissipate, and prompted him to one of the most eloquent statements on the patron–artist relationship in the Renaissance:

> There is one very important thing, Benvenuto, that you artists, talented as you are, must understand: you cannot display your talents without help; and your greatness only becomes perceptible because of the opportunities you receive from us. Now you should be a little more obedient and less arrogant and headstrong. I remember giving you express orders to make me twelve silver statues, and that was all I wanted. But you set your mind on making me a salt-cellar, and vases, and busts, and doors, and so many other things that I'm completely dumbfounded when I consider how you've ignored my wishes and set out to satisfy yourself. If you think you can go on like this, I'll show you the way I behave when I want things done my way. So I warn you, make sure you obey my orders: if you persist in your own ideas you'll run your head against a wall.
>
> (Cellini, *The Autobiography of Benvenuto Cellini*, p.302)

In fact, it had been at the king's request that the salt-cellar was made, although it must have been perfectly true that the initiative lay primarily with Cellini in all the works the king cited. When the king expressed a desire for a salt-cellar, Cellini at once showed him a wax model made originally for Ippolito d'Este, the Cardinal of Ferrara, but never executed. Cellini had rejected the designs suggested by the Cardinal's advisors in favour of one of his own devising, which, he claimed, was far superior. Francis's remark, then, provided the ideal opportunity for Cellini to realize what was essentially his own project.

Although the king partially retracted his dressing-down, Cellini returned to Italy offended and never went back to France. So ended Cellini's encounter with one of the greatest of sixteenth-century patrons.

The artist

Cellini acquired his technical expertise through the normal route of apprenticeship and working experience as a journeyman.[3] In the eleven years between beginning his apprenticeship and opening his own shop in 1524 he changed master more than thirteen times, working with leading goldsmiths in Florence, Siena, Pisa, and Rome. Through them he had access to some of the best models and sources. His master in Siena, Francesco Castero, was busy with prestigious commissions for the cathedral. Ulivieri della Chiostra in Pisa helped him to study classical sarcophagi and Santi di Cola in Rome brought him into contact with the pupils of Raphael. It is at least probable that the outstanding technical mastery of many of Cellini's works would have conferred considerable status on both the maker and the individual objects.

We can get some idea of his skill as a goldsmith from a silver medal he designed in 1537 for Pietro Bembo, one of the leading Florentine scholars of the time and from 1538 a cardinal of the church (Plates 78 and 79). The version most likely to be Cellini's own work is cast in silver. The obverse has all the appearance of an accurate portrait, while the Pegasus on the reverse is an imaginative design anticipating the dynamic seahorses of the salt-cellar. Both are described with astounding fidelity through the limited means available: subtle undulations of the surface of the medal, variations in line, and the slight manipulation of the depth of relief, as in the upper edge of the horse's wings. The skill involved is considerable, bearing in mind the small size of the medal.

Plate 78 Benvenuto Cellini, *Cardinal Pietro Bembo*, 1537 (probably modified after 1538), silver medal (obverse), diameter 5.5 cm, Museo Nazionale, Florence. Photo: Alinari.

Plate 79 Benvenuto Cellini, *Pegasus*, 1537 (probably modified after 1538), silver medal (reverse), diameter 5.5 cm, Museo Nazionale, Florence. Photo: Alinari.

[3] Paid employee of a guildmaster. Unlike apprentices, journeymen were fully trained but did not or could not pay the dues to become master craftsmen and open their own workshops. Many journeymen were itinerant, but some stayed in a single workshop for years.

Cellini's most famous large sculpture is the figure of Perseus, which he made for Cosimo I de' Medici in 1545–54 (Plate 80). This was designed to stand in the Loggia dei Lanzi in the central square of Florence (where it remains). The subject, the mythological Greek hero Perseus holding aloft the head of the Gorgon (a sea monster whose glance turned men to stone) which he has just severed, had a symbolic message of the triumph of civilization over demonic powers and the victory of the young hero. This was just the sort of message the new Duke of Florence would have been keen to put across at a time when his city had recently emerged from a period of serious disturbances. Since major works by the canonical Renaissance sculptors Donatello (*c.*1386–1466) and Michelangelo were to be found in the same location, Cellini was faced with the problem of how to compete. He rose to the challenge in part by technical means. It was far from certain that so complicated a figure could ever be cast in one piece. Cellini's success in achieving a near-perfect cast was a source of enormous pride to him, although it almost resulted in the burning down of his studio, and he had to resort to putting pewter tableware into the furnace as an emergency measure to increase the liquidity of the molten metal!

Plate 80 Benvenuto Cellini, *Perseus*, 1545–54, bronze on marble base, height 320 cm without pedestal, Loggia dei Lanzi, Florence. Photo: Alinari.

Unlike the salt-cellar, the *Perseus* automatically had a high status, being a large-scale sculpture and a work of political importance to the state's ruler, designed for a key position in the city. In securing the commission for such a major work, Cellini's recent status as a valued artist at the court of Francis I can have done him nothing but good.

During the earlier part of the Renaissance at least, the definition of an artist was a good deal wider than it is now and there was as yet no clear distinction between the 'fine arts' of large-scale sculpture, painting, and architecture and the 'decorative arts' such as goldsmithing. In 1508, Pope Julius II had established a committee to organize the goldsmiths guild as the Università degli Orefici (University of Goldworkers), so there was increased status for his craft from the start of Cellini's career. The fact that at the end of his career, in the mid-1560s, Cellini wrote a treatise on goldsmithing confirms his continuing esteem for his original vocation. The contents of the treatise reveal the premium he still placed on quality of craftsmanship, for the whole tenor of the text seems to be practical rather than in any way concerned with aesthetic problems.

In his autobiography, Cellini was at pains to stress that he was not, as a goldsmith, a second-class citizen. While in Rome prior to his years in France, he was apparently on good terms with Italian painters such as Rosso (whom he later encountered again in France) and Giulio Romano (*c*.1492–1546). In Mantua in 1527, according to Cellini, Romano declined the request of a north Italian artistocrat, Federico II Gonzaga, to provide Cellini with a design for goldsmith's work, declaring that Cellini 'has no need of drawings by other artists' (Pope Hennessy, *Cellini*, p.44). In other words, Cellini claimed equality with painters in the creative ability to design, not simply to execute. In Florence, he records, he was visited by Michelangelo himself, who expressed admiration for the gold medal he was making. Cellini apparently regarded this as artistic ratification of the highest kind.

Cellini's declared aim in writing his autobiography leaves us in no doubt about his self-evaluation as a man who had achieved great things: 'No matter what sort he is, everyone who has to his credit what are or really seem great achievements, if he cares for truth and goodness, ought to write the story of his own life in his own hand' (*The Autobiography of Benvenuto Cellini*, p.15). Cellini does not attempt to define the scope of these 'great achievements': in the cultural climate of the Renaissance a goldsmith no less than a politician or a man of letters was entitled to cultivate the memory of his own greatness by means of an autobiography.

Please reread the extracts from Cellini's autobiography quoted on page 97. What do they suggest about the status Cellini was claiming for himself?

Discussion

Cellini's account of his relationship with Francis I, even if biased in his own favour, shows clearly his aspiration to artistic independence, whether as a goldsmith producing a salt-cellar or as a sculptor designing a colossal statue of Mars. Despite their differences, both he and Francis I seem to have seen Cellini more as a creative genius giving reign to his imagination than as a skilled craftsman following the detailed instructions of a patron. Cellini takes

care to specify the king's terms of address: 'mon ami' denotes a degree of friendship and respect that elevates the artist far above the level of a mere royal servant. Clearly, Cellini was very ambitious, both in his artistic projects and in his social aspirations.

◆◆

Cellini had a very clear sense of his own importance. He was deeply concerned to be valued for his artistry and to have that artistry seen as the attribute of a gentleman, and was not prepared to be treated in any sense as a servant or minion of his patrons. He was evidently on good terms not only with Francis I but with his Italian patrons, Pope Clement VII, Cardinal Cornaro, Alessandro and Cosimo I de' Medici and Cardinal Ippolito d'Este, who treated him with flattering familiarity and even bailed him out of trouble. He also consorted with scholars, not only Pietro Bembo but also Benedetto Varchi, who composed a sonnet in praise of Cellini's *Perseus* and whom Cellini consulted over his autobiography.

It was against this background that Cellini made his salt-cellar. Not only is it a complex work of goldsmithing, based on the artist's own creative design and requiring the highest levels of craftsmanship, but it was commissioned by the leading monarch of the day, at whose court Cellini was an esteemed guest. Small wonder, then, that Cellini set so high a value on it.

Sources

Ashbee, C.R. (trans.) (1967) *The Treatises of Benvenuto Cellini on Goldsmithing and Sculpture*, New York, Dover (first published London, 1888).

Avery, C. (1970) *Florentine Renaissance Sculpture*, London, John Murray.

Cellini, B. (1956) *The Autobiography of Benvenuto Cellini*, trans. G. Bull, Harmondsworth, Penguin.

Pope Hennessey, J. (1985) *Benvenuto Cellini*, London, Macmillan.

PART 2
NORTHERN EUROPE IN THE
SIXTEENTH CENTURY

Introduction

KIM WOODS

Michelangelo is reported to have spoken slightingly of Netherlandish painting: it would, he said, appeal to women, especially to the very old and the very young, and also to monks and nuns and to certain noblemen who have no sense of true harmony: 'In Flanders they paint with a view to deceiving sensual vision … And all this, though it pleases some persons, is done without reason or art, without symmetry or proportion, without skill, selection or boldness, and, finally, without substance or vigour' (Harbison, *The Art of the Northern Renaissance*, p.155). Whether or not Michelangelo really did utter these words, they provide clear evidence of the way in which Netherlandish artists were judged negatively, in terms of their failure to conform to the ideals of Italian art, rather than assessed by reference to their own concerns and ambitions.

In Part 2 of this book, we will be charting the changing status of the artist in Northern Europe, to see how far the impact of Italian ideas was felt and how far the different artistic environment generated differing ideas and practices. Case Study 4 reveals both similarities with and differences from the situation in Italy. As in Italy, the status of the artist was a topical issue, particularly around the mid-sixteenth century, although individual artists had achieved fame well before this date. By the early part of the century, both the Netherlandish painter Jan Gossaert (fl.1503–*c*.1533) and the German painter and printmaker Albrecht Dürer (1471–1528) were pioneering a new approach in their work, which encompassed some of the learned principles of the Italian Renaissance and with it a claim to higher status. Nevertheless, the northern emphasis on craftsmanship and workshop production was not superseded, and artistic production continued to be regulated as much by the demands of the market as by high-minded ideas about artistic creativity. This is the theme of Case Study 4.

However, a vital sub-text of any consideration of works of art produced for the open market is the impact of the Reformation, which caused many difficulties for artists in Northern Europe. From the 1520s onwards in parts of Switzerland and Germany, from the 1540s in England and the 1560s in the Netherlands, Protestants sought to impose severe restrictions on or even outlaw altogether the use of works of art in churches. The consequent undermining of the ecclesiastical market for works of art in so many areas often forced artists into the service of private collectors if they were to make a living at all. The German artist Hans Holbein (1497/8–1543) produced

Plate 81 (Facing page) Pieter Bruegel the Elder, detail of *The Peasant Wedding* (Plate 134).

religious works as well as portraits in his early career in Basel (Switzerland) before it turned Protestant. In 1532, Holbein moved permanently to England, where he found employment at the court of Henry VIII. Even here, the English Reformation meant that he worked almost exclusively as a portrait painter. Dürer, himself a supporter of Martin Luther, one of the leaders of the Reformation, argued against iconoclasm (the destruction of images): 'God is angry with all destroyers of the works of great mastership, which is only attained by much toil, labour and expenditure of time, and is bestowed by God alone' (Stechow, *Northern Renaissance Art*, p.113).

Out of this turbulent century, two artists emerge as the principal but starkly contrasting exemplars of what is sometimes called the Northern Renaissance: Dürer (Case Study 6) and the Netherlandish painter and print designer Pieter Bruegel the Elder (fl. from 1550; d.1569) (Case Study 7). Of the two, Dürer was to northern theorists what Michelangelo was to those in Italy. Just as Vasari saw the latter as a shining light sent by God, so Van Mander opens his life of Dürer by saying he was the instrument by which Germany 'shed its darkness' (*The Lives of the Illustrious Netherlandish and German Painters*, p.89). Dürer's career provided a model for northern artists, but it is debatable how far his artistic ambitions were typical even by the end of the sixteenth century, so the contrasts and parallels between his career and other artistic activity in the North at the time is revealing. We will devote the remainder of this introduction to a brief survey of Dürer as the Northern Renaissance paradigm.

Vasari concerned himself only with Italian artists, but one of the few northern artists of whom he did approve was Dürer. Nor was he alone in his approval. Like Michelangelo, Dürer was lauded both in his lifetime and after his death. Between 1515 and 1519, he received a stipend from the Holy Roman Emperor Maximilian I. When Dürer travelled to the Netherlands apparently in the hope of securing a stipend from Maximilian's successor Charles V, he was treated with respect wherever he went. The epitaph written after Dürer's sudden death by his friend the humanist Willibald Pirckheimer testifies by implication to his immortal fame: 'Whatever was mortal in Albrecht Dürer lies beneath this mound'. He later received tributes from other distinguished individuals, including the Dutch humanist Desiderius Erasmus (c.1466–1536).

In the Netherlands of the 1560s onwards, the archetypal Renaissance artist Lambert Lombard of Liège (1505–66) and his humanist biographer Domenicus Lampsonius (see Case Study 4) were staunch defenders of Dürer's Renaissance credentials. Abraham Ortelius (1527–98), a Flemish humanist and cartographer, and a friend of Bruegel, was an avid collector of Dürer's prints, and Cardinal Granvelle, one of the officials of Philip II of Spain, owned drawings by him later bought by Emperor Rudolph II of Prague. By the early years of the seventeenth century, Rudolph II also owned some six original Dürer paintings.

Dürer's contemporaries and immediate successors seem to have regarded him firmly as exemplifying the Renaissance in terms of northern art, and with some justification, since he united skilled artistic practice with the rational theory promoted in Italy by Alberti and others from the early fifteenth century. In a letter to Vasari dated 27 April 1565, Lombard, himself an archetypal Renaissance artist, commended Dürer's knowledge of optics, proportion, and geometry, suggesting he fell short only through his ignorance of ancient art! An artist of considerable learning, Dürer associated with humanists in his native Nuremberg and made two journeys to Italy (in 1494

and 1505–7). In order to develop his knowledge of proportion, Dürer studied the writings of Vitruvius, conducted his own experiments, and eventually wrote four books on the subject, which were published posthumously in 1528 (see Case Study 4). He also wrote a treatise on geometry and perspective entitled *Introduction to the Art of Measurement with Compass and Ruler* (1525).

In contrast to Michelangelo, who (as we saw in the historical introduction) was a poet as well as an artist, Dürer was more of a man of science than of letters. Nevertheless, he did have literary tendencies. He engaged, for example, in a lively correspondence with his friend Pirckheimer, kept a copious diary of his Netherlandish journey (although not apparently with publication in mind), and subsequently recorded some biographical details that together anticipate in a rudimentary and very incomplete way the autobiography of Cellini (see Case Study 3).

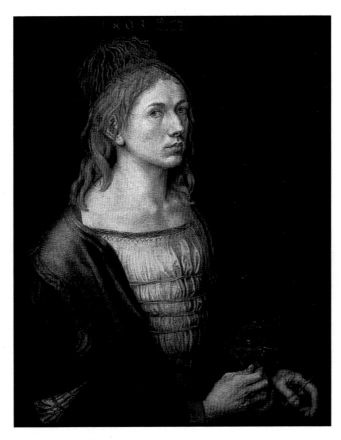

Plate 82 Albrecht Dürer, *Self-portrait*, 1493, painting on parchment, 56.5 x 44.5 cm, Musée du Louvre, Paris. Photo: R.M.N. - Arnaudet.

Although Dürer served a conventional apprenticeship he was atypical of the German artists of his day, not only in his Italian connections and theoretical knowledge, but in his consciousness of his artistic status. In a much-quoted letter written from Venice to Pirckheimer in 1506, he complained: 'Here I am a gentleman, at home only a parasite' (Stechow, *Northern Renaissance Art*, p.91).

Dürer was highly unusual in producing three painted self-portraits, symptomatic of a growing consciousness of his own vocation as an artist (something that he also shared with Michelangelo), which he developed further in the engraving *Melencolia I* (see Case Study 6). The first self-portrait (Plate 82) was painted during Dürer's *Wanderjahr*[1] and bears an inscription in German, which reads in translation: 'My affairs shall go as ordained on high'. In his fine clothes and holding a stem of sea holly, symbol of good luck or marriage, instead of the tools of his trade, Dürer presents himself in a guise more apt for one of his wealthy patrons.

[1] Literally, 'wander-year'. It was customary for a workshop apprentice in Northern Europe, having learned how to emulate the style of his master, to travel in order to gain wider artistic experience.

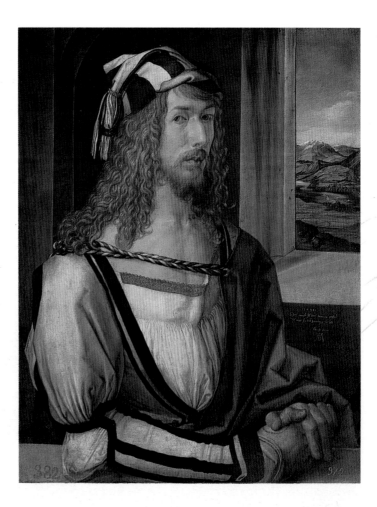

Plate 83
Albrecht
Dürer, *Self-
portrait*, 1498,
oil on panel,
52 x 41 cm,
Museo del
Prado,
Madrid.

The second self-portrait (Plate 83) serves to underline this status as gentleman, for Dürer is even more lavishly and flamboyantly dressed, with gloved hands resting on an illusionistic ledge. The sitter engages the viewer's eye more boldly than in the preceding self-portrait but once again gives no indication of his profession. Dürer's artistic skill is, though, advertised in the German inscription, which reads in translation: 'This I did from my own visage', and is flaunted in the fine detail and striking tonal contrasts of the picture itself. Unlike the first self-portrait, this work has no obvious function beyond self-advertisement.

It is the third and final self-portrait, however, which is the most direct and even shocking in its message (Plate 84). Dürer presents himself facing the viewer, his right hand raised in a pose unmistakably intended to refer to that usually reserved for Christ as *salvator mundi* (saviour of the world). The artist's skills were usually harnessed anonymously in visualizing such pictures of Christ, but Dürer advertises his identity, as if to stress his own God-given capabilities in his profession. His writings contain remarks to this effect. In his third book on proportion, for example, he claims that: 'God therefore and in such and other ways grants great power unto artistic men'. In his earlier notes for a treatise on art he states that 'God is thereby honoured when it is seen that he has bestowed such genius upon one of His creatures in whom

such art dwells!' (Stechow, *Northern Renaissance Art*, pp.112, 110). Interestingly, Van Mander, who saw the painting in Nuremberg town hall in 1577, makes no reference to the *salvator mundi* allusion. To the right of the picture is an inscription, this time in Latin (the language of the church and of scholars), informing the viewer that this is the true likeness of Dürer, painted with 'immortal colours'. While this image may seem to border on blasphemy to us, it is highly unlikely that this was the original intention. Dürer may have chosen the format as an appropriate way of immortalizing his own likeness.

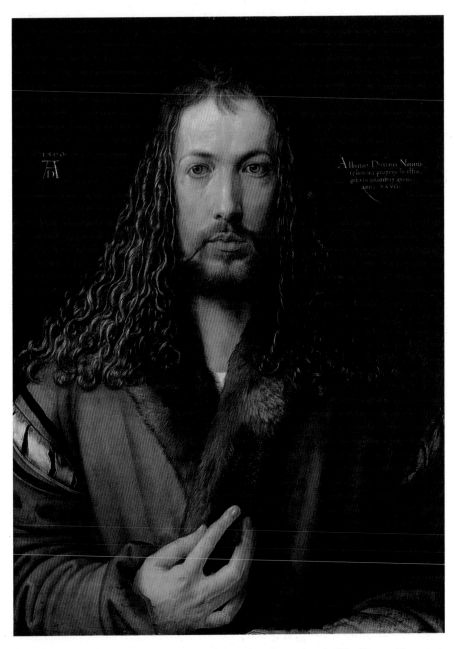

Plate 84 Albrecht Dürer, *Self-portrait*, 1500, oil on lime panel, 67 x 49 cm, Alte Pinakothek, Munich. Photo: Artothek.

Dürer's principal activity was print-making and here his distinctively northern identity asserts itself. Print-making had originated in Northern Europe in the fifteenth century. Although some Italian artists such as Mantegna produced prints, these were never any more than a sideline of their work. Most Italian prints were made by professional engravers or woodcutters, working from the designs – or paintings – of established artists. The European-wide renown achieved by Raphael, for example, rested to a large extent on the prints after his work made by the Italian engraver Marcantonio Raimondi (1487–1539). Some northern prints were produced in the same way. Bruegel, for example, was a prolific designer of prints but never, so far as we know, cut the plates himself. Not so Dürer. While some maintain that he employed a professional woodcutter, there is no doubt that he produced his engravings himself. He conceived of his prints as an independent art form of no less status than painting.

Dürer's innovations as a print-maker cannot be overestimated and not simply in technical terms. He produced his designs as a commercial venture for the market without the supervision of patron, church, or publisher. Some (the woodcuts) were designed for wider consumption than others (the engravings, being more expensive, were probably intended for an élite clientèle). By working on his own initiative, he actively raised the status of the independent print-maker. He broke new ground by producing independently both image and text for a series of woodcuts illustrating the Apocalypse as described in The Revelation of Saint John (c.1496–8). His engraved Passion series, published in 1513, had no text at all and seems to have been produced as much as a collector's item as for instruction. The *Melencolia* engraving was Dürer's own creative invention at a time when it would have been unthinkable for a northern painter to produce a painting of such rarefied subject-matter without a detailed commission.

Dürer, then, succeeded in combining the craft skills that were prized in the northern tradition with the learned approach of the Italian Renaissance (see Case Study 4). The creative originality of his prints forms the very antithesis of the commercial sculpture produced by rote in sixteenth-century Northern Europe (see Case Study 5); nevertheless, they were produced *en masse* on a commercial basis. Dürer confronted the issue of the status of the northern artist both in writing and in his art, and, critically, publicized the views, not of literary theorists but of the artist himself.

References

Harbison, C. (1995) *The Art of the Northern Renaissance*, London, Weidenfeld & Nicolson.

Stechow, W. (1989) *Northern Renaissance Art 1400–1600: Sources and Documents*, Evanston, Northwestern University Press.

Van Mander, K. (1994) *The Lives of the Illustrious Netherlandish and German Painters*, ed., trans., and intro. H. Miedema, Doornspijk, Davaco.

The status of the artist in Northern Europe in the sixteenth century

KIM WOODS

The previous three case studies have explored the status of Italian artists. In this case study we will be attempting to establish the degree to which Northern European sixteenth-century artists took over the norms of their Italian counterparts and the degree to which the northern tradition was distinct and different. Of course, the North was not a homogeneous area in the sixteenth century any more than it is today: ideas on art could vary within a country and from one country to the next, and could change over time. We will be concentrating here on sixteenth-century art in the Netherlands, asking whether art was viewed as a menial craft (a mechanical art) or as an intellectual pursuit (a liberal art).

Today we might well look at exhibition reviews for some idea of how artists, and their work, are regarded. Clearly, this source did not exist in the sixteenth century. What sort of evidence could we explore to establish the status of the artist at that time in the North?

Using what you have read so far, can you think of any visual, documentary, or literary sources that might help us?

Discussion

You may have thought of some of the following sources.

> Treatises on art.
>
> Biographies.
>
> Letters by, to, or about artists.
>
> Poems about artists.
>
> The 'messages' of the works of art themselves.
>
> Records of how artists were trained and organized (for example, guild records).
>
> The tributes paid to artists in epitaphs, on tombs, or on graves.
>
> The presence or absence of artists' signatures on art works.
>
> Documents relating to patronage or specific commissions (for example, contracts).
>
> Evidence concerning artists' wealth (for example, size and grandeur of dwelling place).
>
> Evidence concerning social standing of artists (for example, honorific or civic posts held).

Can you see any problems with this list? Go through it again and think about the possible limitations or failings of each of these sources, bearing in mind that often very little source material survives at all.

Discussion

The following were some of my ideas.

> Writings on art might reflect theory rather than actual practice.
>
> Literary sources may not be representative.
>
> 'Messages' of art works are not necessarily straightforward.
>
> Posthumous reputation might not reflect reputation during an artist's lifetime.
>
> The absence of a signature on a work of art may not mean that it was felt that the artist's identity was not worth publicizing. The identity of the artist could have been well known by other means or the signature could have been lost (signatures on Netherlandish fifteenth-century paintings were commonly applied to the frames, few of which survive).
>
> Wealth is a mark of commercial success, but is it necessarily a mark of status?
>
> Personal rather than artistic qualities might account for high social status.

◆◆◆

Clearly, we need to think quite carefully about the value of different types of evidence and we will have to be selective in the sources we consider to establish how art was perceived.

We are going to look briefly at the evidence embodied in treatises written in the Netherlands and Germany. We will then move on to consider three different sources dating from the 1560s in the Netherlands that have a direct bearing on our theme: a biography, a series of poems, and a series of paintings.

Treatises

The first artistic treatise to be produced in the Netherlands dates from 1604: Van Mander's *Schilderboek*. The treatise is divided into six books, of which only one, the fourth book (which is devoted to the lives of Netherlandish artists), is at all well known today. In fact, the overall project was very ambitious. A theoretical poem on the visual arts made up Book 1, and the lives of ancient artists (Book 2) and Italian artists (Book 3) preceded the Netherlandish lives. Books 5 and 6 were handbooks on ancient mythology and the use of emblems, respectively. *The Penguin Dictionary of Art and Artists* describes the treatise in damning terms as 'a poor imitation of Vasari's "Lives"', but some see it as a self-consciously northern alternative view. We will return to Van Mander's work at the end of this case study, but his treatise cannot form our starting-point for the very good reason that it dates from slightly after the end of the sixteenth century.

In Germany, though, Dürer had produced a series of theoretical writings in the early sixteenth century. Around 1512, he was planning to publish a comprehensive treatise on painting, but this was never completed. A fragmentary introduction survives in manuscript form. Here Dürer maintains the necessity of learning, and evidently conceived of the treatise as meeting the need of German artists for instruction. Nevertheless, he also places value on innate artistic creativity. He stresses the high status of earlier artists,

attributing it to the recognition that their inventiveness was: 'a creating power like God's. For a good painter is inwardly full of figures, and were it possible for him to live forever he would always have from his inward "ideas" whereof Plato writes something new to pour forth by the work of his hand' (Stechow, *Northern Renaissance Art*, p.112). The first book of the treatise was to have included sections on the artist's temperament, his education, and the value of art, and the second book a series of studies on proportion, perspective, light and shade, and colours.

Dürer's *Four Books on Human Proportion*, published posthumously, set out his methods of establishing correct proportions, supplementing Vitruvius' method with data gathered from detailed observation. Interestingly, in his conclusion he admits that more information about the operation of the limbs in the human body would require a knowledge of anatomy that he does not have. Book Three finishes with what is sometimes known as the 'Aesthetic Excursus', in which Dürer reiterates the necessity for both understanding and experience in the production of great art:

> a man may often draw something with his pen on a half-sheet of paper in one day or cut it with his little iron on a small block of wood, and it shall be fuller of art and better than another's great work whereon he has spent a whole year's careful labor, and this gift is wonderful. For God sometimes grants unto one man to learn and to understand how to make something good; the like of whom, in his day, no other can be found.
>
> (Stechow, *Northern Renaissance Art*, p.116)

Dürer certainly advocated theoretical knowledge, but he systematized the visual approach on which German painting was based rather than replacing it. His friend Pirckheimer's sister reported that one of the other nuns in her convent, who was a painter, enjoyed reading his *Introduction to the Art of Measurement with Compass and Ruler*, but could work just as well without it!

Biography: *The Life of Lambert Lombard* (1565) by Domenicus Lampsonius

Lambert Lombard was a painter and architect employed at the episcopal court of the Bishop of Liège in present-day Belgium. He visited Italy and was deeply influenced by Italian art and theory, but his enthusiasm was primarily for ancient art. He remains a shadowy figure and there are no paintings definitely known to be his work, although several signed and sometimes dated drawings survive. In *The Raising of Lazarus* (Plate 85) Lombard treats the biblical subject as an Italian-style *istoria*, a heroic historical drama peopled with numerous figures in classical dress. He makes the most of the musculature of the gravedigger to demonstrate his prowess at anatomy and proportion, and the background shows his knowledge of classical architecture and perspective. Gesture is deliberately used to reveal individual reactions to the event and to clarify the narrative, and the figure to the left gazes out at us as viewers to engage our attention. The result is a very deliberately constructed theatrical rather than devotional scene. The drawing was later engraved, and it was published by Hieronymus Cock, the leading humanist print publisher of Antwerp at the time.

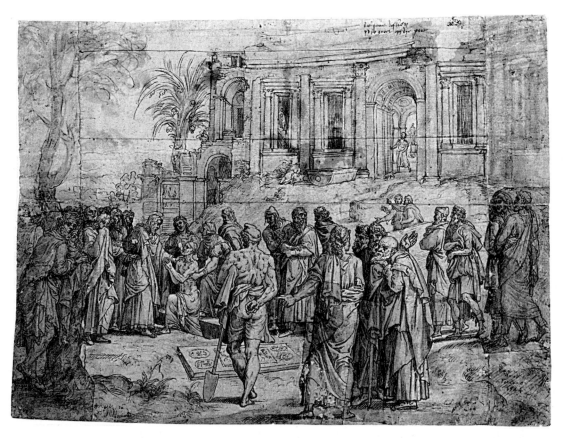

Plate 85 Lambert Lombard, *The Raising of Lazarus*, 1544, pen and ink, 27.6 x 37.9 cm, Kunstmuseum, Düsseldorf im Ehrenhof, Sammlung der Kunstakademie (NRW), inv. no. KA(FP) 4748. Copyright Kunstmuseum Düsseldorf im Ehrenhof. Photo: Landesbildstelle Rheinland. (A small area at the top left of the picture has been retouched following the removal of an archive stamp.)

Lombard's biographer Lampsonius was a humanist poet and minor artist. He uses his *Life of Lambert Lombard* to record his own views on art, which favoured the Italian approach, although he never went to Italy and his knowledge of Italian and ancient art was based entirely on prints and on the writings of Vasari. Lampsonius's emphasis is on idealizing, or 'perfecting', nature, and he draws on an argument that goes back to Horace: that painting is directly comparable in its creative processes to poetry, long accepted as a liberal art. Significantly, however, he also stresses the detailed knowledge of accoutrements, colour, and the natural world needed to produce a 'sincere and truthful' rather than 'vague and approximate' imitation of nature. Here he seems to echo the tradition of realism for which the Netherlands was renowned.

Although the convention in Renaissance art in both North and South was to stress the importance of imitation of nature, this was taken far more seriously in the North. While for Vasari nature was the starting-point for an artist's invention, in the North the faithful representation of the natural world itself is a recurring theme. In a letter to Vasari in 1564, Lampsonius made the startling comment that his modest skills would be adequate for painting nudes, costumes, and portraits, but not the natural world. Vasari would have

judged figure painting pre-eminent. This does not make Lampsonius a nationalist defender of the Netherlandish realist tradition, but nor should he be seen simply as an honorary Italian. He was bitterly critical of some contemporary Netherlandish painting, but he provided the preface and the captions for Cock's series of 23 engraved portraits of famous Netherlandish artists. This was left unfinished on Cock's death, and eventually published in 1572 in Lampsonius's name as the *Pictorum aliquot celebrium Germaniae inferioris effigies* (*Portraits of some Celebrated Artists of the Low Countries*).

Lampsonius was in the service of the Bishop of Liège, so he would have known Lombard. His *Life of Lambert Lombard* was not a straightforward biography, however, so much as an attempt to present Lombard as the archetypal Northern Renaissance artist. Throughout the book, Lombard is commended for his learning. His scholarly interests began with an encounter with the humanist Michael Zagrius, who was secretary of Middleburg. This was one of the towns where Gossaert, who was purported to have been Lombard's teacher, worked. Lampsonius tells us that Zagrius introduced the young painter to the writings of Pliny the Elder, which so fired his imagination that he began to try to learn Latin and Greek. A voyage to Italy with Cardinal Reginald de la Pole in 1537 offered Lombard the opportunity to study ancient art and architecture at first hand as well as the art of Mantegna and Michelangelo, the artists he most admired.

Lampsonius's model for the ideal artist was derived from Pliny's account of ancient Greece, where, he claims, artists were men educated in the liberal arts, unconstrained by material needs and working more for love of art than profit. Lampsonius states that Lombard pursued his studies despite financial hardship, that he spent more time at his books than painting, that although not rich he refused to tout for work, leaving patrons to come to him, and was willing to undertake only work promising great glory (and never for a common client!). Finally, Lampsonius states that Lombard opened a drawing school in his own home, a very different mode of study from apprenticeship to a craft.

As enthusiasts of Italian and ancient art, it is not surprising that Lombard and Lampsonius promoted the concept of art as an intellectual pursuit, but theirs was not necessarily a view shared by many. It is fairly clear that Lampsonius's difficult Latin biography of Lombard had a very limited circulation (Van Mander had evidently been unable to get hold of a copy while researching his book). Printed in Bruges by the printmaker and publisher Hubertus Goltzius (1526–83), it was probably largely restricted to élite, humanist circles: it was dedicated to Ortelius, a friend of Bruegel's (see Case Study 7).

Poetry: an anthology by Lucas de Heere

Netherlandish artists were celebrated in poetry from as early as the first quarter of the sixteenth century. In an unfinished poem written *c.*1504 for Margaret of Austria, later regent of the Netherlands, the French humanist poet Jean Lemaire included a lengthy list of celebrated Netherlandish artists, and referred to Pliny in his appeal that the same respect be paid to them as was paid to artists by the ancients.

An anthology of poetry survives by the Ghent painter and poet Lucas de Heere (1534–after 1584). This was compiled in 1565 and entitled *Den Hof en Boomgaerd der Poesien* (*The Garden and Orchard of Poetry*). Here the status of art and artists is a recurring theme. The anthology concludes with a 'Refereyn' ('Refrain') dedicated to the 'Violieren' of Antwerp, the rhetoricians guild which from 1480 had been incorporated into the artists Guild of Saint Luke. This alliance in itself blurs the divisions between painting and literary activity. By the mid-sixteenth century many of the rhetoricians were also artists, and Cock, publisher of the prints of Lombard and later Bruegel, was a member. In the 'Refrain', de Heere describes an imaginary argument between the Muses over which is pre-eminent among the liberal and mechanical arts. Apollo judges art the clear winner, on the grounds that God personally instructed the artists Bezalel and Oholiab (Exodus 31:1–11), inaugurating and ratifying artistic activity in a unique way. Of the different forms of art, painting is judged to be the most difficult, the best for instructing and proving moral exemplars, and to exceed poetry in eloquence and immediacy. This theological justification is particularly poignant coming as it does so shortly before the great iconoclasm of 1566 when so many Netherlandish religious art works were destroyed in the belief that they were idolatrous.

De Heere also included in his *Orchard and Garden of Poetry* a poem entitled 'An Invective Against a Certain Painter, who Made a Spiteful Attack on the Painters of Antwerp',[1] defending his teacher, the Flemish painter Frans Floris (c.1516–70), against the criticisms of an anonymous painter. This anonymous painter evidently disliked the Italian artistic approach and derided Floris's work as over-adorned *suuckerbeeldekens* (little sugar figures). De Heere retorts that the artist is simply insensitive and incompetent; although he has been to Rome he has evidently learned nothing there; and he does not understand the principles of Roman or ancient art – his painted figures resemble *kaermes poppen* (carnival dolls). This dispute is an important indication that the Italian- and classically inspired tradition represented by de Heere, Lombard, Lampsonius, and Floris did not go unchallenged.

The house of Frans Floris

Let us take a look at the work of the painter de Heere was defending. Floris was a pupil of Lombard and visited Italy in 1541–7. On his return he developed a distinctive style based on Italian art, which made him one of the most wealthy and celebrated painters of his day.

The Feast of the Sea Gods (Plate 86) by Floris and *The Cornharvest* (Plate 87) by his Antwerp contemporary Pieter Bruegel the Elder were both executed for the wealthy Antwerp financier Nicholaes Jonghelinck (1517/18–70) for his country villa of ter Becken. They probably served a similar function as a refined form of leisure and relaxation. The two works are very different, however. Floris's appears very loosely inspired by Raphael's Galatea fresco in the Villa Farnesina in Rome (c.1512). Bruegel's seems to emanate from the Netherlandish tradition of representing seasonal tasks in the calendar section of illuminated Books of Hours.

[1] For a translation of the poem, see Edwards, *Art and its Histories: A Reader*.

Plate 86 Frans Floris, *The Feast of the Sea Gods*, 1561, wood, 126 x 226 cm, National Museum, Stockholm. Photo: Statens Konstmuseer.

Plate 87 Pieter Bruegel the Elder, *The Cornharvest*, 1565, oil on wood, 118.1 x 160.7 cm, Metropolitan Museum of Art, New York. All Rights Reserved. Photo: © The Metropolitan Museum of Art, New York. Rogers Fund, 1919 (19.164).

Compare the two works in terms of:

1 **representation of the natural world**
2 **representation of the human figure**
3 **subject-matter.**

Do they seem to reflect a different approach?

Discussion

1 Floris does not exploit the seascape or atmospheric effects (although some very convincing marine life hangs from the bottom of the sail). His focus is on the figures, as Vasari recommended. Conversely, *The Cornharvest* is primarily a landscape rather than a figure painting, and the natural detail and atmospheric effects are astounding.

2 Floris's figures are ideal physical types, all following a convention of beauty in facial type, size, and physique, the men muscular, the women white skinned and fleshy. (These features, together with the nudity, are indebted to Italian art.) Bruegel's figures all look much the same too, but instead of being idealized they are heavy and somewhat graceless; facial features are hardly described at all – the expression is all in the pose.

3 Floris's scene seems to be a generalized mythological scene, probably without a specific story or literary source. It is far removed from everyday life and must have functioned well as a visual diversion. (The Italian- or classically inspired subject-matter presumably conferred a certain prestige.) Bruegel's work by contrast is rooted in everyday life.

◆◆◆

Antwerp's prosperity rested on sea-trade, and Jonghelinck himself was a collector of sea-tax, so Floris's painting would have held a particular significance for him. Bruegel's seasons reflect the classical custom, reported by Pliny, of decorating country villas with landscape paintings. In exhibiting such a work of art, Jonghelinck, as a good humanist, was following ancient custom.

Different emphases might account for the different subjects but they do not explain the contrast between Floris's idealizing style and Bruegel's down-to-earth realism. However, both seem to have appealed to Jonghelinck.

Adopting Italian style as a matter of fashion, or even artistic conviction, did not necessarily raise the artist's status. In Floris's case, however, we have an important piece of evidence to suggest that this is what he intended: his house. According to Van Mander, Floris earned a huge amount, at least 1000 guilders a year, and spent his fortune on a grand house with classical features. This displayed both his wealth and the reputation from which it derived.

Floris executed paintings on the exterior of his lavish house in the early 1560s, and the scheme is known from a drawing of *c*.1700 and an engraving dated 1576 (Plates 88 and 89). Van Mander says the paintings were in yellow grisaille to imitate copper. The scheme was little less than an advertisement for the status of painting that could be viewed by any Antwerp citizens passing by. To one side of the doorway were placed personifications of Diligentia

Plate 88 Jan van Croes, façade of the house of Frans Floris, *c.*1700, from D. Van Papenbroeck, *Annales Antverenses*, Bibliotheque Royale Albert Ier, Brussels. MS 7921, fols 40 verso and 41 recto.

(Diligence), Usus (Practice), and Poesis (Poetry), and to the other Architectura (Architecture), Labor (Toil), Experientia (Experience), and Industria (Industry) (Plate 88). These seven figures represent an overlapping mixture of virtues and skills deemed necessary for the successful pursuit of art (although, according to Van Mander, Floris himself scored badly on diligence and industry). Over the doorway was a simulated bronze relief with personifications of Painting (lower left) and Sculpture (lower right), and a man drawing (right background). Apollo and a personification of Fame fly overhead and the other standing male figures might represent poets and philosophers. The central figure has been identified variously as a personification of Geometry, Architecture, or *Ars*, the visual arts combined (Plate 89).

Floris's painted house is mentioned in a lawsuit brought against a sculptor by the Antwerp guild of masons and sculptors in 1595. The Guild of Saint Luke included painters and woodcarvers but not stone sculptors, so a sculptor working in stone and wood needed to register himself and his apprentices with both guilds. The sculptor on trial had registered only with the Guild of Saint Luke. In his defence he claimed, first, that according to Michelangelo sculpture was the mother of painting and architecture and, secondly, that Floris had represented both painting and sculpture as liberal arts on his house. His arguments align sculpture with painting, a liberal art, rather than masonry, a manual art (and incidentally overturn de Heere's case for the primacy of painting), but were deemed *absurditeijten* (absurdities) by the masons guild, which was no doubt keen to safeguard its own status and guild dues.

Plate 89 'TG', overdoor, house of Frans Floris, 1576, engraving, Gabinetto Disegni e Stampe, Uffizi, Florence. Photo: by courtesy of the Soprintendenze, Firenze.

Review of these sources

The three sources from the 1560s suggest that at this point in the century some Netherlandish artists promoted the concept of art as an intellectual activity distinct from crafts. Strong evidence for this is provided in each case: by Lampsonius's classically inspired concept of the artist as intellectual creator; by De Heere's Italian-inspired views and claim for the pre-eminence of painting; and by Floris's public visual defence of painting as a liberal art and display of the virtues that sustain it.

What I want to avoid is any suggestion that Lampsonius's and Lombard's 'fine art' position is an improvement on the view of the artist as practitioner of a highly skilled craft. At the time some clearly felt it to be an advance, but in embracing Italian and ancient ideas, the art itself did not necessarily improve. The anonymous painter mentioned earlier obviously thought not and many art historians (including this one) would agree! (Which painting did you find more impressive in the comparison exercise, the one by Floris or the one by Bruegel?)

In order to establish how the 'fine art' position represents a shift in thinking in the Netherlands, we need to look back to evidence from the fifteenth and the first half of the sixteenth century.

Artistic training and organization

At the turn of the sixteenth century, the guilds in the Netherlands were very powerful guardians of collective artistic privilege and technical quality. Admission to the guild depended primarily on payment, and sons of guildmasters were often admitted at reduced rates. Those unable to pay were limited to the status of waged journeyman and usually prohibited from selling their own work except at some annual fairs; their skills were the property of the guildmasters for whom they worked. The system was aimed primarily at guarding the privileges of existing guildsmen. In some cities such as Tournai, guild membership also depended on the submission of a 'masterpiece' specified by the guild. The intention was evidently to ensure that a prospective guildmaster could fulfil the obligations of a contract satisfactorily without bringing the guild into disrepute, rather than to ensure artistic conformity.

These guild restrictions posed some limitations on artistic freedom, but the high technical standards assured the reputation of Netherlandish art works. Guild regulations stress quality of materials and workmanship, relating not to the concept of art as an intellectual pursuit but to the craft tradition. For example, in 1454 the painters, sculptors, and joiners guilds in Brussels inaugurated a system of marks to be applied to carved wooden altarpieces once they had been inspected for quality: the compass mark of the joiner, who made the wooden case; the mallet mark of the carver; and the word 'Bruesel' stamped into the gilding to certify the painting (Plate 90). A similar system of marks was used in Brussels for tapestries, tin and lead work, goldsmith work, barrels, and cloth and was adopted in Antwerp for carved altarpieces in 1470. Hallmarks are used to this day for gold- and silverware.

Plate 90 Brussels craftsmen's marks of the carver, joiner, and painter and polychromer, from 1454. (a) Brussels Hammer mark, detail from Flemish altarpiece, c.1460–80, The Bowes Museum, Barnard Castle, County Durham. (b) Brussels Compasses mark, detail from frame of the Sforza Triptych by the workshop of Rogier van der Weyden, Musées Royaux des Beaux-Arts de Belgique, Brussels. Photo: © KIK-IRPA, Brussels. (c) 'BRVESEL' mark, detail from the Saluces altarpiece. Photo: © KIK-IRPA, Brussels.

There are few grounds for claiming that in the first half of the sixteenth century painting enjoyed the high status accorded it by de Heere, or indeed for making a division between the 'fine arts' and the 'decorative arts'. In most cities the painters guild incorporated a heterogeneous collection of workers in other crafts, such as saddlers, harness-makers, and rope-makers, with no obvious hierarchy of status (although in some major artistic centres such as Antwerp, the artistic guild, the Guild of Saint Luke, appears to have been more of a power in its own right). Nevertheless, the painters sometimes asserted their rights and monopolies. In 1453, Brussels painters claimed the sole right to sell carved and polychromed (painted and gilded) altarpieces on the open market, leaving the woodcarvers as subcontractors. The ruling was revised in 1454, although still leaving the carvers at a disadvantage. In the 1480 Tournai guild regulations, manuscript illuminators were strictly barred from producing large paintings on wood or cloth even though they might have served their two-year apprenticeships with painters; to be a painter it was necessary to have served four years. With a few exceptions, in Tournai all who needed to learn to draw for whatever craft had to learn it with a painter. In Brussels in 1476, the painters asserted the sole right to provide tapestry cartoons, while the tapestry weavers themselves were allowed only to embellish them.

Tapestries and illuminated manuscripts were highly prized, luxury items and usually fetched higher prices than painting. The fact that painters, according to the Brussels and Tournai guild regulations, seem to have asserted superiority shows some discrimination between crafts and suggests that lengthy training and jealously guarded specialized skills constituted a better claim to status than high-cost materials and labour-intensive production.

Lampsonius's concept of an artist-genius, working in isolation for an aristocratic protector, did not correspond to fifteenth- and sixteenth-century working practices. Almost all artists, whether in the North or elsewhere, had workshops, but in the North, because of the high proportion of ready-made art works to be sold on the open market or exported, painters or carvers would use the labour of journeymen and apprentices to establish a sort of production line in which they might themselves have participated very little. A very large proportion of surviving Netherlandish painting and sculpture is the product of this sort of collaboration to a lesser or greater extent, even works by artists associated with the new Italian-inspired ideas on art. Van Mander says of Floris, for example:

> Frans set his journeymen to do the dead colouring[2] after he had indicated to them his intention somewhat with chalk, letting them get on with it, after having said: Put in these or those heads; for he always had a good few of those to hand on panels [as designs to be copied].
>
> (*The Lives of the Illustrious Netherlandish and German Painters*, p.229)

Were guildmasters more like workshop managers than individual creative geniuses, then? It seems that many probably were, but that is not to say that they did not participate in, and probably dominate, the production of high-status commissions, as documents sometimes show.

[2] Underpainting in one or a limited range of colours to set the tonal values and layout of the composition.

In a letter of 1508 to his patron, the Frankfurt merchant Jacob Heller, Dürer agreed to paint the central panel of a lost altarpiece of the Assumption of the Virgin without workshop help: 'And noone shall paint a stroke on it except myself, wherefore I shall spend much time on it' (Stechow, *Northern Renaissance Art*, p.92). In 1520, the Bruges painter Aelbrecht Cornelis appeared before the city magistrates for allegedly subcontracting the painting of an altarpiece of Nine Choirs of Angels when he had agreed to paint the nudes and principal parts of the picture himself (Campbell, 'The early Netherlandish painters', p.51).

The contract for a lost carved altarpiece for the brewers guild of Louvain in 1506 stipulated unusually that the figures should be *vander hant* (by the hand) of the Brussels carver Jan Borman (fl.1479–*c*.1520), implying 'by his hand and none other'. In 1509, the Confraternity of the Holy Sacrament of Turnhout also specified that the carved sections of its new altarpiece were to be carved by Borman or his son. Borman signed one carved altarpiece, the altarpiece of Saint George (Plate 91), but of scores of other surviving altarpieces carved in his style, his own hand has been indisputably recognized in none. Perhaps the Louvain and Turnhout patrons were wise to make the provisions that they did.

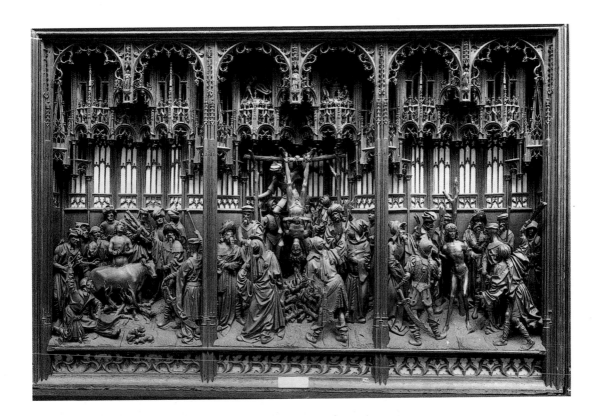

Plate 91 Jan Borman, carved altarpiece of Saint George, 1493, oak, 163.5 x 248.5 x 30.5 cm, Musées Royaux d'Art et d'Histoire, Brussels. Photo: © KIK-IRPA, Brussels. The plate shows the central section of the altarpiece, on either side of which are carved wings.

Individual reputations

Some fifteenth-century Netherlandish guildmasters built up legendary reputations clearly based on individual artistic prowess and important civic or court patronage. Among them is Rogier van der Weyden (1399–1464), a native of Tournai who became painter to the city of Brussels in about 1435, an office probably created specifically for him to secure his services (Plate 92). In 1453, the German philosopher Cardinal Nicholas Cusa (1401–64) described Van der Weyden as the 'best painter' and in 1460 the Duchess of Milan sent her own court painter to study with Van der Weyden in Brussels. In the field of sculpture, though, reputations are harder to uncover. Borman was described as the 'best carver' in the royal accounts in 1511, but this sort of comment is unusual in documents. Since Van Mander and his forbears recorded the lives only of painters, the reputations of most fifteenth- and early sixteenth-century sculptors remain obscure and most surviving sculpture is anonymous.

The office of court painter existed in many Northern European countries and often brought with it exemption from guild control. Although the patronage of a royal client could confer prestige, it did not automatically imply the

Plate 92 Rogier van der Weyden, *The Descent from the Cross, c.*1440, oil on wood, 220 x 262 cm, Museo del Prado, Madrid.

highest artistic status. Indeed, court painters were not always the most prominent artists of the day, and the work they were required to undertake was sometimes mundane. Artists enjoying court or aristocratic patronage continued to accept commissions from other patrons, and they, like guild artists, had to respond to a client's requirements. True artistic freedom did not exist in the Netherlands in the fifteenth and sixteenth centuries.

Perhaps the most renowned of all Netherlandish fifteenth-century painters, Jan van Eyck (fl. from 1422; d.1441), was painter to Philip the Good, Duke of Burgundy, from 1425 until Van Eyck's death. The fact that Philip was godfather to Van Eyck's child suggests his status at court was high; he undertook secret diplomatic missions on Philip's behalf and his posthumous reputation was considerable. The exact nature of his artistic duties remains uncertain, but a document of 1435, in which Philip defended his controversial decision to grant Van Eyck a life pension, mentions 'certain great works' with which he was to be occupied and also states that Philip would 'never find his like more to our taste, one so excellent in his art and science' (Stechow, *Northern Renaissance Art*, p.4). It seems likely that the financial security of a royal pension offered Van Eyck a certain artistic freedom, but all his surviving works, including the famous Ghent altarpiece (Plate 93), were done for other, private patrons.

Plate 93 Jan van Eyck, Ghent altarpiece, 1432, oil on panel, each panel 146.2 x 51.4 cm, Cathedral of Saint Bavo, Ghent. Photo: Giraudon.

Gossaert, who was trained in Antwerp, was employed from 1508 by Admiral Philip of Burgundy, an illegitimate son of Philip the Good. When Philip travelled to Rome in 1508 for papal negotiations, he took Gossaert with him to record Roman antiquities. Some of Gossaert's drawings survive. According to Van Mander (*Lives*, p.161), Gossaert was the first artist to bring to the Netherlands the 'right manner of composing and constructing stories with naked figures and all kinds of allegorical representations' (in other words, satisfactory *istorie*). While not attaining the renown of Van der Weyden or Van Eyck, he continued to enjoy Philip's patronage, if spasmodically, at Philip's castles of Souburg and Wijk bij Duurstede, and it seems that this offered him unusual opportunities.

Hercules and Deianira (Plate 94) is very likely to have been painted for Wijk bij Duurstede after Philip's appointment as Bishop of Utrecht in 1517. The prestige of the painting lies in the mythological subject-matter (Hercules was a mythological Greek hero and Deianira was his second wife; Hercules slew Cacus for stealing cattle from him). The classical-style architectural

background, with its ram or ox skulls above the figures, and the simulated marble relief of Hercules and Cacus on the bench below would have appealed to Philip's interest in ancient art rather than his status as a bishop. Although the nudity of Hercules and Deianira follows classical practice, the anatomy is unorthodox, which would indicate that neither artist nor patron was much concerned with the 'rules' of classical figure construction. The focus is more on the skilled execution of the poses of the intertwined figures. This is an expressive, close-up painting suitable for an intimate domestic and humanist setting.

A diptych, or painting on two panels, done by Gossaert in the same year for another cleric, Jean Carondelet, Provost of Saint Donatian's, Bruges and Chancellor of Flanders, provides a dramatic contrast (Plate 95). Here the cleric pays his devotions to the adjacent Virgin and Child in a pious and conventional formula that harks

Plate 94 Jan Gossaert, *Hercules and Deianira*, 1517, oil on panel, 36.8 x 26.6 cm, The Barber Institute of Fine Arts, University of Birmingham. Bridgeman Art Library, London/New York.

back to the work of Van der Weyden. The diptych offers Gossaert very different possibilities from the mythological work. He is able to show off his prowess in recording a specific human face, imitating nature with the realism for which northern artists were renowned.

Both paintings share high standards of craftsmanship in the enamel-like quality of the paint, created by meticulous brushwork and a careful building up of the paint layers. Surface textures such as fur and marble are convincingly represented. This seems to show the guild tradition of quality alive and well, whoever the patron.

The question remains as to whether these artists consciously sought artistic status. Unlike most of his contemporaries, Van Eyck made a habit of signing his paintings and sometimes, with an almost aristocratic touch, he even added his personal motto – 'Als ich kan' (As I am able) – styled in pseudo-Greek letters. The fact that he did so on what is thought to be his self-portrait (Plate 96), and indeed the very concept of painting a self-portrait, may suggest a degree of status-consciousness and ostentation. Gossaert also signed many of his works, some with the latinized name Joannes Malbodius. This, together with the fact that he was deeply influenced by Van Eyck and worked for a humanist patron, may indicate that he saw himself as a 'famous man' related to Italian humanist ideals and classical literature. It was perhaps his approach that inspired Lombard.

Finally, let us look at the status of the artist in the Netherlands at the end of the sixteenth century.

Plate 95 Jan Gossaert, diptych for Jean Carondelet, 1517, oil on wood, each panel 47 x 27 cm, Musée du Louvre, Paris. Photo: R.M.N. - Jean Schormans.

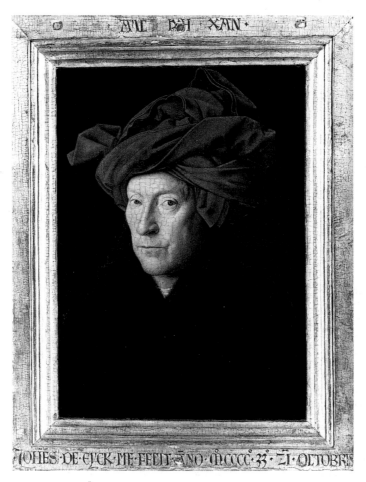

Plate 96 Jan van Eyck, *Portrait of a Man* (*Self-portrait?*), 1433, wood, 33.3 x 25.8 cm, National Gallery, London. Reproduced by permission of the Trustees of the National Gallery.

The end of the century: Van Mander

Sixteenth-century Netherlandish painters held their fifteenth-century predecessors in high regard and fully recognized the staggering quality of their work, even though it was produced within very different frames of reference from their own. According to Van Mander, his teacher de Heere wrote a series of lives of Netherlandish artists in poetic form, but the book was lost even in Van Mander's day. De Heere also owned Van Eyck's apparently unfinished painting *Saint Barbara* (Plate 97).

Van Mander, writing at the very end of the century, spent less time on abstract arguments about the status of art than on artistic skills and on identifying the assets of the Netherlandish tradition. Nevertheless, the title of the first book of his treatise – *The Noble and Free Art of Painting* – takes the status of painting as a liberal art for granted. The first edition of the treatise sold out almost at once, and its popularity suggests it should be seen as far more representative than *The Life of Lambert Lombard*.

In Book 1, the poetic advice to young artists, Van Mander recommends a visit to Italy and draws many of his ideas from Italian theorists such as Alberti and Leonardo, but introduces important modifications. In contrast to Lampsonius, he stresses the standards of craftsmanship of his fifteenth-

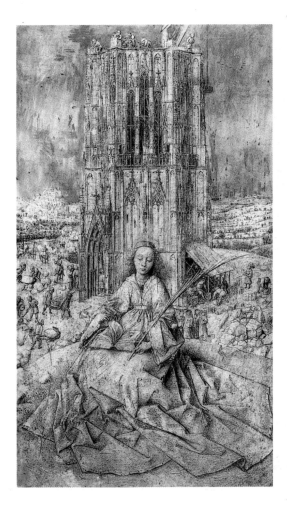

Plate 97 Jan van Eyck, *Saint Barbara*, 1437, brush drawing, Koninklijke Museen voor Schone Kunsten, Antwerp. Photo: © KIK-IRPA, Brussels.

century predecessors and the value of training, experience, and hard work above genius and scholarship. Indeed, the fifth and sixth books may be seen as nothing less than cribs 'for my young painters in order that they, without any special learning, can depict matters of significant meaning' (Book 6, quoted in Stechow, *Northern Renaissance Art*, p.71).

Two distinctively northern principles are implied, although not stated, in Book 1. First, the priority given to a fairly literal imitation of nature in terms of natural effects and landscape, in which Van Mander claims Netherlandish reputation lies. He says of Bruegel, for example:

> As if we were [with him] in the cliffs and rocks of the Alps, he teaches us to paint, without too much trouble, how one looks down into dizzy abysses, at steep crags, cloud-kissing pine trees, vast distances, and rushing streams.
>
> (Book 8, quoted in Stechow, *Northern Renaissance Art*, p.65)

(Conversely, in Book 1 he reveals that in Italy the received opinion was that 'the Flemings cannot paint figures'.) Secondly, Van Mander affirms the canonical status of the traditional Netherlandish technique: Van Eyck's scrupulous craftsmanship involving manipulating a thin paint layer with great skill. He discards the model of the creative painter working directly from a mental idea as unsuitable for many, and recommends the laborious

process of assembling a design from the stock of workshop drawings, the detailed underpainting, and thin paint layer used in the fifteenth and early sixteenth centuries rather than the broader, thicker painting of Van Mander's own day.

It would be simplistic to suggest that Van Mander provides a synthesis of Italian-based and northern values, of art as an intellectual activity and as a skill-based craft, but there appears to be evidence of both attitudes in his work. His approach seems much less prescriptive than that found in *The Life of Lambert Lombard*. Although he stresses craft skills, this is no manual treatise. He tells aspiring artists what they should be doing and where to look for examples to learn from, but not actually how to work.

Conclusion

From the mid-sixteenth century the status of the artist seems to have been an issue that was debated in Northern Europe, drawing on ideas gleaned from the Italian Renaissance. This probably represents a shift from the technically based ideas of quality promoted by the guild system in the fifteenth century. We need to be careful, however, for the guild system was not superseded until after 1600 and certain fifteenth-century artists, among them Van Eyck and Van der Weyden, enjoyed a very high status in the fifteenth century without the benefit of any artistic theories to underpin them. In the sixteenth century, a conscious effort seems to have been made to preserve the memory of these artists for posterity, for example in biographies (de Heere) and engravings (Lampsonius). To a great extent this may have been a northern response to Vasari's *Lives*, but it does show northern artists and writers evaluating their own traditions and insisting on a status that in the past may have been hard won and uncertain.

Sources

Campbell, L. (1981) 'The early Netherlandish painters and their workshops', in *Le Problème Maître de Flémalle – Van der Weyden*, ed. D. Hollanders-Favart and R. van Schoute, Louvain-la-Neuve, pp.44–61.

Dawn of the Golden Age: North Netherlandish Art 1580–1620, exhibition catalogue 1993–4, Rijksmuseum, Amsterdam, especially H. Miedema: 'The appreciation of painting around 1600', pp.122–35.

Edwards, S. (ed.) (1999) *Art and its Histories: A Reader*, New Haven and London, Yale University Press.

Harbison, C. (1995) *The Art of the Northern Renaissance*, London, Everyman Art Library.

Melion, W.S. (1991) *Shaping the Netherlandish Canon: Karel van Mander's Schilder-boeck*, Chicago and London, University of Chicago Press.

Murray, P. and L. (eds) (1978) *The Penguin Dictionary of Art and Artists*, Harmondsworth, Penguin (first published 1959).

Stechow, W. (1989) *Northern Renaissance Art 1400–1600: Sources and Documents*, Evanston, Northwestern University Press.

Van Mander, K. (1994) *The Lives of the Illustrious Netherlandish and German Painters*, ed., trans., and intro. H. Miedema, Doornspijk, Davaco.

Zaremba Filipczak, Z. (1987) *Picturing Art in Antwerp 1550–1700*, Princeton University Press.

Commercial sculpture

KIM WOODS

In his *Life of Lambert Lombard*, Lampsonius condemned in no uncertain terms artists who worked primarily for commercial gain:

> It must be said, furthermore, that one sees many of this profession and condition these days who, devoid of good and fine culture, end up discrediting the profession of painting, the most beautiful of all, and if in these present times painting passes for a liberal art, at the same time it is also seen as a vulgar art.
>
> (Hubaux and Puraye, 'Dominique Lampson', p.63, trans. K. Woods)

This 'vulgar' commercial art gives rise to an alternative measure of the status of the artist, which does not depend on literary fame and individual creative genius but on the popularity and material quality of the objects produced. A commercial artist needed to fulfil fairly fixed, popularly oriented demands rather than the specifications of an educated, élite patron. The result was not original creations but standard types, which allowed only limited creativity within strict conformity.

Lampsonius judged painting 'the most beautiful of all' artistic professions. As we have seen, the question of whether painting or sculpture was superior was a subject debated in the sixteenth century. Sculpture certainly had its champions, notably Michelangelo and Cellini, but there were no 'Lives' of Netherlandish or German sculptors and no early sixteenth-century northern theorists on sculpture to rival Dürer on painting. For much of the sixteenth century, sculptural production was geared largely to the commercial market for religious artefacts. We are going to look at three sorts of commercial religious sculpture in this case study: Netherlandish carved altarpieces, German statues of the Virgin and Child, and English alabaster tombs.

Netherlandish carved altarpieces

Netherlandish carved altarpieces were produced in large numbers, principally in Brussels and Antwerp, in the fifteenth and the first half of the sixteenth centuries, both for the home market and for export. Any altarpiece to be installed in a church, whether in Italy or in the North, needed to satisfy ecclesiastical requirements and be acceptable to the viewing public, whether lay or religious. For this reason, even privately commissioned works do not necessarily vary substantially in response to the specific requirements of patrons. The carved altarpieces produced in Brussels and Antwerp are unusual in that the entire altarpieces could be produced ready made for the commercial market. We rarely know the names of the craftsmen who produced these.

The value placed on Netherlandish carved altarpieces is attested to by the fact that hundreds were exported throughout Europe and beyond. Dozens are to be found in the Rhineland, some in France, and a few, now lost, were even exported to England. No fewer than 38 Netherlandish carved altarpieces survive in Sweden alone. Until the end of the fifteenth century, the Swedish

market was dominated by imported Lübeck altarpieces, reflecting the
traditional links between the Baltic countries. Around the turn of the sixteenth
century, though, the balance shifted towards importing from the Netherlands,
perhaps as a result of the changing political and commercial scene, but perhaps
also because the Netherlands could provide a more competitive commercial
product. Plate 98 shows a Lübeck altarpiece formerly on the high altar of the
church of Saint Nicholas, Stockholm (now Stockholm Cathedral). This has a
central narrative Crucifixion with standing saints placed under intricately
carved canopies in the wings to either side. It is an impressive work, lavishly
painted and gilded and with two sets of shutters, the inner ones carved, the
outer ones painted. When open it measures some six metres wide.
Nevertheless, on closer scrutiny the figure carving appears stiff and poorly
articulated, the drapery tends to subside into a formula of unnatural ridge-

Plate 98 Carved wooden altarpiece of the Passion of Christ, 1468, Lübeck work, 210 x 299 cm closed,
Stockholm Museum, formerly in Saint Nicholas, Stockholm. Courtesy, Antikvarisk-topografiska arkivet,
Stockholm.

like folds and the illusion of space in the Crucifixion is rudimentary. For a century where faithfulness to nature increasingly constituted artistic excellence, this cannot be rated very highly. Significantly, the altarpiece bears an inscription recording the date of completion (1468) and the names of the churchwardens (added later). While the sculptor is not mentioned, the fact that the altarpiece was made in Lübeck is, which suggests that the prestige value of the work lay in the quality of the product type rather than the artist responsible.

This Lübeck altarpiece format had been current in the Netherlands as early as the end of the fourteenth century, and by the second half of the fifteenth century designs had changed. The huge carved altarpiece showing the Passion in the Cathedral of Strängnäs, Sweden (Plates 99 and 100) was commissioned from a Brussels workshop, probably that of Borman (see Case Study 4), about fifteen years after the Saint Nicholas altarpiece. It is believed to have been paid for by the Bishop of Strängnäs, Conrad Rogge. With its elaborate carved shutters and massive scale it bears a superficial similarity to the Lübeck altarpiece, but there are important differences. There are no statues. Instead, there are seven large, narrative scenes, in which the sloping ground, three-dimensional architectural canopies, and tiered arrangement of figures create a plausible illusion of space. The well-proportioned and expressive figures make the less adept Lübeck reliefs look clumsy and unconvincing. It is not difficult to see why as early as the mid-fifteenth century Netherlandish carved altarpieces were famed at home and abroad.

Plate 99 Attributed to Jan Borman, *Strängnäs I*, carved wooden altarpiece of the Passion of Christ, *c*.1480–5, Brussels work, 259 x 691 cm open, Strängnäs Cathedral. Courtesy, Antikvarisk-topografiska arkivet, Stockholm. Photo: G. Hildebrand.

Plate 100
Attributed to Jan Borman, *Pietà*, detail of carved wooden altarpiece of the Passion of Christ (Plate 99). Courtesy, Antikvarisk-topografiska arkivet, Stockholm. Photo: G. Hildebrand.

In 1460, a purpose-built art market known as the Onser–Liever–Vrouwen Pand was constructed by the Church of Our Lady, Antwerp (from 1559 Antwerp Cathedral) for the sale of books, paintings, prints, and carvings during the two Antwerp annual fairs, the Pentecost fair and Saint Bavo's fair, both of which lasted about six weeks. Artists and dealers hired places, just as one would rent a market stall today. The period of transactions was gradually extended beyond the fairs and from *c.*1540 the Pand operated on a permanent basis until its demolition in 1560. At this very early art market a client could purchase works of art ready made – even carved altarpieces. The sculptor no longer travelled to the client in order to execute a commission; the client came to the Pand to buy and his purchase was transported ready made to its destination.

Faced with the task of refurnishing its church following a fire, the Abbey of Averbode in the Netherlands resorted to the Antwerp Pand. In 1524, the Abbey purchased from the Antwerp carver Laureys Keldermans an altarpiece 'which

Plate 101 Jacob van Cothem, Lamentation altarpiece, 1513–14, oak, Vleeshuis, Antwerp. Photo: © KIK-IRPA, Brussels.

stood in Onser–Liever–Vrouwen Pand' (Jacobs, 'The commissioning of early Netherlandish carved altarpieces', p.105). Judging from the Abbey records, an earlier altarpiece of the Passion of Christ purchased from Keldermans in 1511 and three altarpieces purchased from the Antwerp carver Jacob van Cothem in 1513–14 may also have been ready made. One of the latter, a small altarpiece for the altar of the confessor saints, may be the Lamentation altarpiece that bears the arms of the Abbey and is now in the Vleeshuis, Antwerp (Plate 101). The 1514 altarpiece for the Sacraments altar, now in the Musée de Cluny, Paris (Plate 102), was specifically commissioned from the Antwerp carver Jan de Molder in 1513. The three narrative scenes on Molder's Sacraments altarpiece – the Meeting of Abraham and Melchisedek, the Mass of Saint Gregory, and the Last Supper – have a Eucharistic significance appropriate for its setting. This sort of unusual iconography would need to have been specifically commissioned, while the more universal subject-matter of the Infancy or Passion of Christ was prime material for a ready-made work. When de Molder was commissioned to make a second altarpiece in 1518, the old stone altarpiece it was to replace was sold at the Antwerp Pand.

Although ready-made altarpieces could be cheaper, Kelderman's 1524 altarpiece, which was definitely bought ready made, was only marginally less expensive than de Molder's commissioned Sacraments altarpiece. Size may have played a part in the pricing of altarpieces, for Kelderman's 1511 Passion altarpiece, bought for a very high price indeed, was a large work. Nevertheless, valuation was not simply decided by the yard. De Molder's 1518 altarpiece was inspected by the Guild of Saint Luke for the quality of the wood, the polychromy (painting and gilding), and the painting on the shutters, in order to check for 'defects' and 'fraud', before the price was ratified.

Plate 102 Jan de Molder, Sacraments altarpiece, from L'Abbaye des Prémontrés at Averbode, 1514, oak, Musée National du Moyen Age, Thermes et Hôtel de Cluny. Photo: R.M.N. - Gérard Blot. The altarpiece had painted wings, which are now lost.

The Abbey of Averbode, it seems, did not look down on ready-made altarpieces. What was important in altarpiece production was not creative genius or originality of design, but a standard, quality product to satisfy the liturgical and devotional functions of an altarpiece. It was surely to advertise such standards that in 1470 the Antwerp Guild of Saint Luke followed the earlier example of Brussels and introduced craftsmen's marks as guarantees of quality. The Antwerp 'hand' signifying quality of carving was applied clearly and visibly to the heads of the figures and the base of the compartments, and the 'castle' mark guaranteeing polychromy was applied to the case (Plate 103); at a glance a client could check that the altarpiece had passed the guild inspection.

The production of a carved altarpiece was a collaborative venture involving carvers and joiners to make the case, and painters to provide the painted shutters and polychrome the carved scenes. This involved a high degree of cooperation, particularly in Brussels, where painters and carvers belonged to different guilds. Workshop production employed the techniques of mass production in order to meet demand. De Molder, for example, was required

Plate 103 Antwerp 'hand' and 'castle' mark, in use from 1470, from the Bocholt altarpiece. Photo: © KIK-IRPA, Brussels.

to produce the Sacraments altarpiece within only about six months. A workshop often employed apprentices, but the variation in style within most carved altarpieces makes it quite clear that several skilled carvers, probably journeymen, were at work. The muscular swagger of the figures in the 'Ecce Homo'[1] of the Strängnäs altarpiece (see Plate 99, the scene on the left) are indeed typical of Borman's style, but other more pensive, expressive figures are reminiscent of an earlier tradition, and at least two different styles are to be found in the Pietà scene alone (see Plate 100). Clearly, more than one carver has worked on this altarpiece. This would have been something of a necessity in a work of this size if it were to be delivered in less than a lifetime! It is even possible that more than one workshop collaborated in its production.

The shifting workforce of carvers' workshops and the anonymity of master carvers create difficulties in attribution that are compounded by the widespread borrowing of designs and the adoption of successful and marketable styles, like the muscular, colourful Borman style with its wealth of surface detail. Innovations, rather than being jealously guarded, were quickly assimilated and disseminated. There is even one documented instance of an Antwerp altarpiece design being purchased for the manufacture of an altarpiece in Louvain in 1504. Commercial production involved reproducing stock types, designs, and even entire altarpieces. The early sixteenth-century Brussels altar pieces in Västerås Cathedral and the Church of Villberga in Sweden are virtually identical in the major scenes of Christ carrying the Cross, the Crucifixion, and the Pietà (Plates 104 and 105). Both altarpieces display the Borman style and designs and are sometimes attributed to the Borman workshop itself: the three scenes duplicate ones in the huge 1522 Passion altarpiece in the Church of Güstrow in northern Germany, which is a signed Borman work (Plate 106). Even more common is the reuse of individual figure designs. Of course, clients would not necessarily know that their altarpiece was virtually identical to several others, or that designs had been derived from other works, but they

[1] Literally, 'Behold the Man': the biblical scene showing Christ displayed before the people by Pilate (John 19:14).

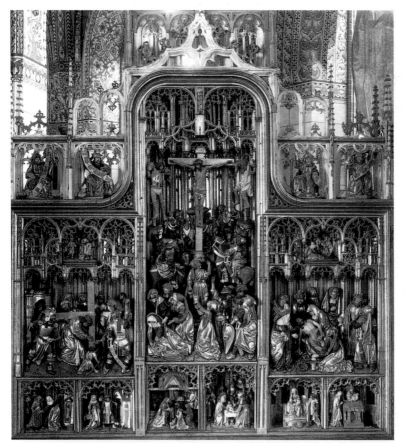

Plate 104 Carved wooden altarpiece of the Passion of Christ, *c.*1520, Brussels work, Västerås Cathedral. Courtesy, Antikvarisk-topografiska arkivet, Stockholm.

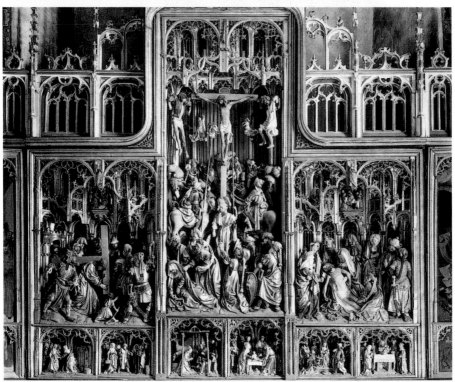

Plate 105 Carved wooden altarpiece of the Passion of Christ, *c.*1520, Brussels work, Villberga Church. Courtesy, Antikvarisk-topografiska arkivet, Stockholm. Photo: H. Hultgren.

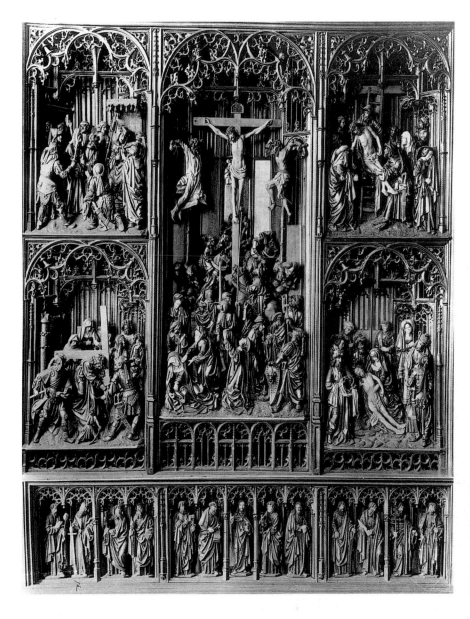

Plate 106 Jan Borman the Younger, Passion altarpiece, 1522, oak, 405 x 536 cm (open), Güstrow Parish Church. Photo: Bildarchiv Foto Marburg.

probably would not have minded. A contract for a commissioned carved altarpiece would frequently state that the altarpiece should resemble another with which the patrons were familiar. Clients commissioning an altarpiece rather than buying one ready made could, of course, make stipulations, but these might amount to no more than customizing a standard type, for example through the choice of the saints depicted on the altarpiece shutters.

These lavish and highly decorative illusionistic works suggest that their prestige lay not in the name of the artist responsible (for there was no one artist responsible), nor in a tailor-made and original design produced in response to specialized demands (for most altarpieces followed a formula), nor in the power of a patron (for most patrons of these works were corporate bodies rather than individuals). It seems more likely that Netherlandish carved altarpieces were sought after as prestigious works in their own right: first, for highly skilled, illusionistic carving and polychromy that brought

religious events alive in an accessible and popular way, appealing primarily to the imagination rather than to the intellect; and secondly, for high-quality materials and craftsmanship, guaranteed through the Antwerp or Brussels marks. These were the features that established the status of Antwerp and Brussels carvers and brought clients from far and wide.

As with any product, the demand for Netherlandish carved altarpieces was subject to the vagaries of fashion, and even allowing for the negative effect of the Reformation on the manufacture of religious imagery there is some evidence that production was slackening by the mid-sixteenth century. Carvers kept abreast with Renaissance styles, producing ever more Italian-inspired figure types, but the most prestigious commissions were increasingly for Renaissance-style alabaster (a marble substitute) altarpieces such as the one carved in 1533 by Jean Mone, sculptor to Emperor Charles V, for Saint Martin's, Halle (Plate 107). Carved wooden altarpieces were never very popular with the Netherlandish aristocracy, and may also have fallen victim to an increasing preference for painting. A parallel shift has been charted in the collecting patterns of the English aristocracy. Perhaps, too, carvers had saturated the market, as sometimes happens with commercial products.

Plate 107 Jean Mone, altarpiece, 1533, alabaster, Saint Martin's, Halle. Photo: Bildarchiv Foto Marburg.

German statues of the Virgin and Child

Statues of the Virgin and Child were in constant demand before the Reformation and by the Catholic church after the Reformation, and so invited commercial production. There was no organized art market in Germany to compare with the one in Antwerp, but carvers could sell their wares through their workshops or at fairs, for example those of Cologne and Frankfurt. The Nuremberg sculptor Veit Stoss (fl. from 1477; d.1533) is documented as having visited the Frankfurt fair in 1506 to sell his works, probably smaller-scale portable works like statues. This was at a time when Stoss had fallen from favour in Nuremberg following conviction for fraud, so he was perhaps plying the commercial market to recoup financial losses.

Stoss is not thought to have had a huge commercial workshop, so the sculpture he sold at the Frankfurt fair was probably largely his own work, although sold on a purely commercial basis. By contrast, the prominent Würzburg carver Tilmann Riemenschneider (fl. from 1478/9; d.1531) ran a large commercial workshop. Riemenschneider was a man of some local standing, who from 1504 until 1525 held a variety of civic offices including that of Burgomeister (mayor). These civic responsibilities are sometimes cited as one reason for the particularly evolved system of delegation in his workshop. Unlike Michelangelo, who carried out his commissions with very little aid from assistants, Riemenschneider is recorded as having taken on no fewer than twelve apprentices from 1501, and would also have employed journeymen (according to one estimate, at times as many as 40!). This busy workshop produced commissioned and largely autograph[2] carvings as well as mass-produced works, which were probably based on models by the master but executed wholly by assistants. For example, a small statue of the Virgin and Child by Riemenschneider (Plate 108) has been proposed as the model for the Virgin and Child in a rosary which is largely the product of workshop assistants (Plate 109). In the latter version, the Christ Child is more conventionally represented, nude, rather than wearing a Netherlands-style shift. The stiffer, more upright stance and less naturalistic hands of the Virgin are marks of workshop craftsmanship. It is also possible, however, that the statue of the Virgin and Child is not so much a model for a single product as a workshop pattern, which was used to train journeymen in the workshop style so that they could work on commissions without any intervention from Riemenschneider.

In medieval workshop practice, a master was responsible for designs and an assistant was required to match his master's style in producing them. The Renaissance concept of the creative artist as designer and originator of a composition was not very different, and the print was an acceptable means of reproducing designs. Riemenschneider resembles the Renaissance designer rather than the Netherlandish carvers, who would appropriate designs from almost anywhere. His distinctive 'look' was translated into a successful commercial style: the austere, pensive, Netherlandish-derived figure types, the beauty of surfaces, and the decorative crispness of hair and drapery.

Statues of the Virgin and Child had not only an ecclesiastical function but also a domestic one. Small devotional statues might be found in wealthy houses or domestic chapels, and *Hausmadonna*, or statues of the Virgin set on

2 Original work by the artist himself.

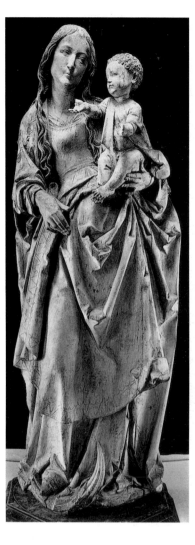

Plate 108
Tilmann
Riemenschneider,
Virgin and Child,
*c.*1521–4,
limewood,
height 95.2 cm,
Dumbarton Oaks
Research Library
and Collections,
Washington, D.C.
(37.06).

Plate 109 Workshop of Tilmann
Riemenschneider, *Virgin and Child* in a
rosary, 1521–2, limewood, height
171 cm, Pilgrimage Church, Kirchberg bei
Volkach. Photo: Conway Library, Courtauld
Institute of Art, University of London.

the exterior corners of houses, were a tradition in certain areas of Germany
from the fourteenth century. The point of these *Hausmadonnas* was not so
much to exhibit artistic excellence or originality as to afford protection and
blessing for the house and neighbourhood, and they formed a set type that
could be produced by rote. As with Netherlandish carved altarpieces the
scope for customization was limited and the degree of participation of the
master could be minimal. Riemenschneider's sandstone *Virgin and Child* from
the exterior of a canon's house in Wurzburg (Plate 110), formerly
polychromed, is an example of a high-quality commission by the master
himself. A *Hausmadonna* by Stoss in limewood is particularly interesting, since
it came from his own house on the corner of the Wunderburggasse in
Nuremberg and so combines a traditional religious function with that most
commercial of tactics, self-advertisement (Plate 111).

The Protestant Reformation saw the demise of religious sculpture. Many
Protestant reformers regarded religious images as at best inessential and at
worst idolatrous, and sculptors in affected territories were forced to adapt.
Statues of the Virgin and Child were a more versatile genre than altarpieces

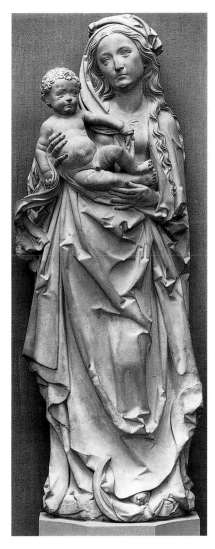

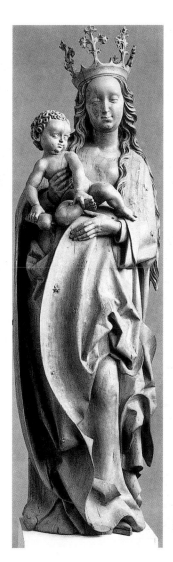

Plate 110 Tilmann
Riemenschneider, *Virgin and Child*,
c.1516–22, sandstone, traces of
polychromy and gilding, height
156.5 cm, Städtische Galerie
Liebighaus, Frankfurt.

Plate 111 Veit Stoss, *Virgin and
Child*, *c*.1500–10, limewood,
formerly polychromed, height
159 cm, Germanisches National
Museum, Nuremberg.

and could survive changes in taste and religious practices more successfully.
Because they were produced at lower cost, they were not such a capital risk
for craftsman as large-scale altarpieces. In addition, it was possible for smaller
statues to be carved by individual 'creative' craftsmen and thus acquire the
prestige of collectors' pieces for élite clients, valued not for their function but
for their aesthetic appeal. Stoss's small boxwood *Virgin and Child* (Plate 112)
may be a forerunner of such work. It is a happy, intimate work, carved with
panache. Gilding, of which traces remain, would have lightened the mood
still further. The conventional central drapery flourish is treated with
particular flair, which is apparent also in the Virgin's headdress. Carved in
the round, it was evidently designed to be examined from all viewpoints
rather than placed in a niche, and is small enough to be held in the hand.

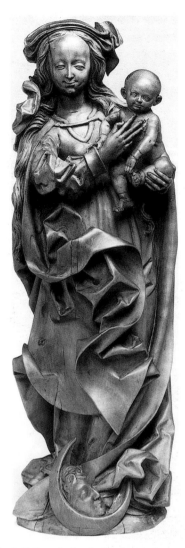

Plate 112 Veit Stoss, *Virgin and Child*, c.1510–20, boxwood, height 20 cm, Victoria and Albert Museum, London. Photo: © The Board of Trustees of the Victoria and Albert Museum, London.

Boxwood statues of a secular nature are mentioned in the inventories of an early connoisseur and collector, Margaret of Austria, regent of the Netherlands. For carvers suffering the effects of the Reformation, this sort of collector's item was certainly one alternative form of output, although quite different from the commercially produced statues of the Virgin and Child from the workshop of Riemenschneider. The collector's piece has more in common with Cellini's salt-cellar (see Case Study 3) and, indeed, depended on an élite clientèle who could afford such works.

English alabaster tombs

When the demand for religious sculpture in Protestant areas plummeted in the second half of the sixteenth century tombs were one form of sculpture that did survive. Since tombs were commissioned for particular clients, we might expect them to be individually designed to suit the patron's requirements. In England, however, alabaster tombs were produced on a commercial basis, particularly in Burton-on-Trent, from the end of the Middle Ages. The industry survived when the Reformation helped to undermine the market for alabaster altarpieces and devotional sculpture for which the Midlands had also been famous. About 90 tombs have been connected with the Burton-on-Trent workshop of one sculptor alone, Richard Royley (d. by 1589). Far less is known about the commercial basis of the Midlands tomb industry than about Netherlandish carved altarpiece production, but judging by the large numbers of such tombs surviving, it thrived until *c*.1580, when the competition provided by Netherlandish refugee sculptors settled in Southwark, London[3] signalled the demise of the industry.

The Earls of Rutland commissioned works from both centres. The tomb of Thomas Manners, First Earl of Rutland (Plate 113), cost £24 and was a standard product of Burton-on-Trent by one of the few sculptors from this region whose names are known (Richard Parker, d. before 1570). A later tomb for the same family and church, that of the Fourth Earl of Rutland (Plate 114) and costing £100, is by Gerard Johnson (d.1611), one of the Southwark Netherlandish refugees.

[3] When Philip II of Spain succeeded to the sovereignty of the Netherlands in 1555, he began the rigorous imposition of the authority of the Catholic church in the face of the growing strength of Protestantism. Opposition to Spanish rule erupted in the form of mob violence and iconoclasm in 1566, and continuing unrest over the next twenty years resulted in increasing numbers of Protestant refugees fleeing abroad.

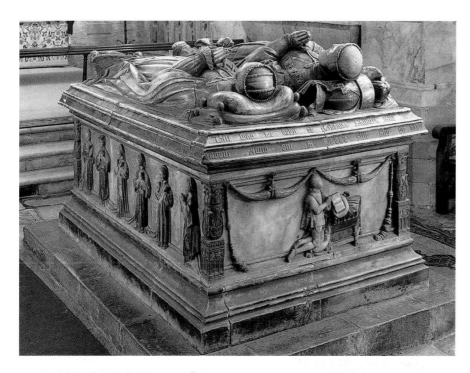

Plate 113
Richard Parker,
tomb of Thomas
Manners, First
Earl of Rutland,
1544, alabaster,
Saint Mary's,
Bottesford. Photo:
James Austin.

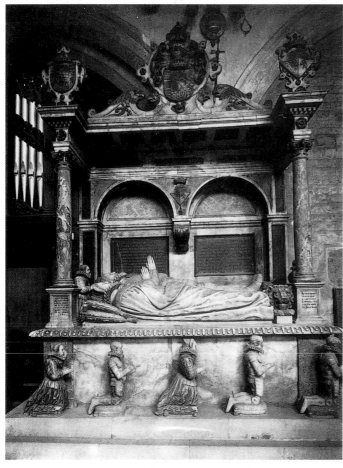

Plate 114
Gerard
Johnson, tomb
of the Fourth
Earl of
Rutland, 1591,
alabaster and
black marble,
Saint Mary's,
Bottesford.
Photo:
National
Monuments
Record,
RCHME, ©
Crown
Copyright.

By careful comparison of the two tombs please try to decide which of the features of tomb design seem to be standard. How does Johnson improve on the commercial formula?

Discussion

Both tombs have finely dressed recumbent effigies in an attitude of prayer, their heads placed on cushions, and family members around the tomb chest. Inscriptions, around the rim of the tomb chest in the earlier work and behind the effigies in the later one, presumably identify the deceased. It looks to me as if an emphasis on wealth and dynasty was more important than artistic creativity in the design of tombs.

Parker includes a little Renaissance-style decoration in the foliated corner pilasters[4] and the swags at the end of the tomb chest, and he does try to vary the poses of the children carved in relief around the chest (Burton-on-Trent tombs can appear a lot more boring than this one!), but his work looks very plain in comparison with that of Johnson. In Johnson's tomb the family members are carved in three dimensions as if in prayer around the tomb, with one kneeling at the head of the effigies. He also includes a huge pseudo-Renaissance architectural canopy, which greatly adds to the grandeur of the work and the prestige of the client, for included in the canopy are prominent coats of arms. Johnson uses black marble for detailing as well as alabaster.

◆◆◆

Both tombs attempt to individualize the faces of the effigies, but again, of the two, the Johnson heads are more convincing. It is not difficult to see why the Southwark product might be preferred.

Of course, the Southwark school developed a repertoire of designs and formulae, but there is greater imagination in its tombs and higher quality carving. Ordering a Burton-on-Trent tomb might seem a little like ordering a conventional headstone today, while a Southwark school product, although still employing many of the conventions of Midlands tomb design, offered the client a more customized, high-quality product, rather than merely a commercial type.

Conclusion

The workshop method is inherent in large-scale sculpture, but the commercial approach, in which genres of work were mass produced for sale, is not. The capital outlay involved in producing Netherlandish carved altarpieces, which could be justified by the popularity of the product and the importance of Antwerp as an international trading centre, means that as commercial products they are in a class of their own. Commercial sculpture was not, however, limited to the North: stucco and terracotta reliefs were mass produced in Italy. Even Donatello, the archetypal fifteenth-century Renaissance innovator and creative genius, may have flirted with mass

4 Square columns partly built into and partly projecting from a wall.

production; the back of the bronze relief of the Virgin and Child made for his physician, Giovanni Chellini, is in effect a mould from which casts could be taken.

Commercial ventures depend on the existence of a certain market, and with the Reformation the market for sculpture was much reduced. The corporate patronage of churches and guilds was replaced in many areas by private patronage, which meant sculptors had to adapt or starve. The fashion was for high-cost materials, such as the bronze or marble used in highly esteemed Italian Renaissance sculpture, which meant that it was too expensive for an individual to produce these sorts of work for sale.

This does not, however, mean that the perception of value shifted irrevocably from quality product to revered artist, or from function to aesthetic appeal. Commercial art works – and artists – did not disappear under pressure from the Italian Renaissance concept of the creative artist-genius but continued to provide a competitive alternative and challenge, of which English alabaster tombs are but one example.

Sources

Baxandall, M. (1980) *The Limewood Sculptors of Renaissance Germany*, New Haven and London, Yale University Press.

Ewing, D. (1990) 'Marketing art in Antwerp 1460–1560: Our Lady's Pand', *Art Bulletin*, vol.72, pp.558–84, 788–800.

Hubaux, J. and Puraye, J. (1949) 'Dominique Lampson: Lamberti Lombardi … vita. Traduction et notes', *Revue Belge d'Historie de l'Art*, vol.18, p.63.

Jacobs, L. (1994) 'The commissioning of early Netherlandish carved altarpieces: some documentary evidence', in *A Tribute to Robert A Koch*, Studies in the Northern Renaissance, Princeton University Press.

Jacobs, L. (1998) *Early Netherlandish Carved Altarpieces 1380–1550: Medieval Tastes and Mass Marketing*, Cambridge.

Osten, G. and Vey, H. (1969) *Painting and Sculpture in Germany and the Netherlands: 1500–1600*, The Pelican History of Art, Harmondsworth, Penguin.

Whinney, M.D. (1988) *Sculpture in Britain 1530–1830*, 2nd edn, revised J. Physick, The Pelican History of Art, Harmondsworth, Penguin, chapters 2 and 3.

Woods, K.W. (1996) 'Five Netherlandish altar-pieces in England and the Brussels school of carving c.1470–1520', *Burlington Magazine*, vol.CXXXVIII, pp.788–800.

Genius and melancholy: the art of Dürer

PAUL WOOD

Introduction

People have been discussing Albrecht Dürer's engraving *Melencolia I* for nearly 500 years (Plate 115). One recent essay began with a quotation from another commentator to the effect that everything there was to be said about Dürer's picture had been said, and proceeded to add 10,000 words to the mountain of text accumulated since the engraving was made in 1514 (Balus, 'Dürer's *Melencolia I*'). It seems to be a condition, a definition even, of a canonical work that it is able to stimulate extensive critical reflection; it has somehow to be able to present different facets to succeeding generations without becoming exhausted. The web of interpretation is particularly densely woven around *Melencolia*. During the flurry of exhibitions held to mark the fifth centenary of Dürer's birth in Nuremberg in 1471, one catalogue called it 'the most discussed and interpreted engraving in all art literature'.

Melencolia, then, is nothing if not canonical. Yet it is a relatively small image, and even lacks one of the most important characteristics of pictorial art: colour. *Melencolia* is an engraving, printed from a copper plate. It is not, however, one of the types of work we usually associate with small scale, such as an intense portrait, a concentrated still life, or a deeply felt lyrical poem. It is not personal, at least not in the sense of being intimate. Its title, which it bears within itself on a kind of banner, points to a general, even abstract, content. *Melencolia* is a strange mixture, small in size, epic in scale. It is as if we half understand it at a glance, without being able to feel we have got to the bottom of it. It may, arguably, be this enigmatic quality that has underwritten the engraving's perennial fascination.

In the present case study we will concentrate on this one work by Dürer. We are going to discuss the meaning, or meanings, of the *Melencolia* engraving as they have been investigated by art historians writing from different points of view. And we are going to do so with the aim of revealing how the meaning of Dürer's picture is bound up with changing ideas of what it was to be an artist during the period when he lived and worked. This was the time, at the end of the fifteenth century and the beginning of the sixteenth, when new ideas from Italy about the status of artists and intellectuals were filtering through into Northern Europe: ideas that continue to be fundamental to modern conceptions of the artist.

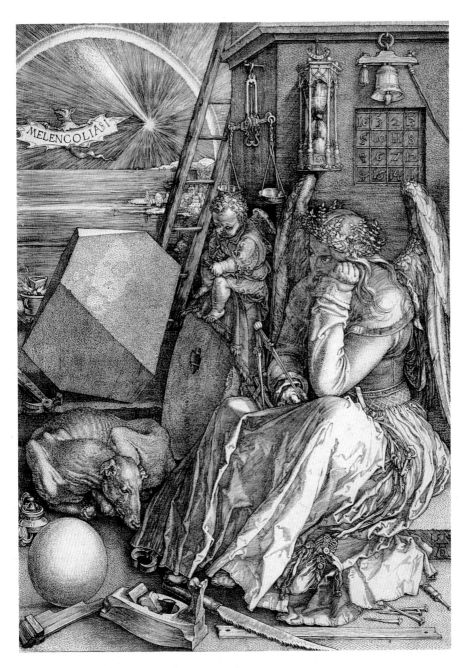

Plate 115
Albrecht Dürer, *Melencolia I*, 1514, engraving, 23.9 x 16.8 cm, British Museum, London. © The British Museum, London.

Melancholy and depression

The *Oxford English Dictionary* offers nearly 50 different inflections to the meaning of 'melancholy' and related words. A cluster of key features is apparent, however, concentrated around the idea of 'a mental disease characterized by gloomy thoughtfulness, ill-grounded fears, and general depression of mind' and the melancholic as 'one who is affected with mental depression or sadness'. For S.W. Jackson, in his study of *Melancholia and Depression* from the ancient world to modern times, the melancholy that was seen as madness in earlier times is 'clearly a close kin' to the depressions that have come to be regarded as 'cardinal forms of mental disorder' today. The

very persistence of these categories means that the experiences they are used to name are 'at the very heart of being human' (p.3). We use the word 'melancholy' to describe a subjective mood, which may be passing or prolonged and which, if extreme, will begin to count as a form of mental illness, characterized by feelings of hopelessness, worthlessness, and consequent inactivity. Yet these depressive states, with their completely negative connotations of dejection or even capitulation, do not quite seem to match what we see of the winged figure in Dürer's print. She has a powerful body, the wings are like those of an eagle, and her glare is not as defeated as our sense of melancholy and depression requires. The figure seems rather closer to a phrase used by the *Encyclopaedia Britannica* to capture a different aspect of neurotic depression: 'a frozen state of rage'.

An important question, then, is whether the word 'melancholy' had the same kind of meaning in the sixteenth century as it does now. Would an artist produce such a complex image of a form of illness? Also, would an image of illness exert such a compelling fascination as Dürer's engraving? Earlier images of illnesses of this type, for example the illustrations to medieval medical treatises, are devoid of psychology. However curious they may be, they feel archaic and remote from us (Plate 116). On the other hand, certain later images, for example the paintings by the French artist Théodore Géricault (1791–1824) of what he called 'monomaniacs' (Plate 117), impress us because of the empathy they reveal with an individual's suffering.[1] This is achieved through an intensity of observation that gains its power from the exclusion of all else. There are no compasses, hour-glasses, or geometrical solids in Géricault's ruthlessly concentrated physiognomies. By contrast, it is the *mixture* of psychology and allegory that gives Dürer's work its enigmatic character.

Plate 116 Anonymous, *The Melancholic*, cauterization diagram, thirteenth century, MS Amplon, Q.185, fol. 247 verso, Wissenschaftliche Bibliothek, Erfurt.

[1] The *Cyclopedia of Practical Medicine* of 1833 noted that the term 'monomania' 'has been adapted of late times instead of melancholia'.

Plate 117 Théodore Géricault, *Gambling Mania*, *c*.1822, 77 x 61.5 cm, Musée du Louvre, Paris. Photo: R.M.N.

Encountering *Melencolia*

In our culture, saturated as it is with imagery, a picture often receives only a distracted glance (a photograph in a newspaper, for example). So when we start to enumerate elements in *Melencolia*, we are already doing something a little out of the ordinary. It is, therefore, worth asking a basic question.

What do you, a modern viewer coming across Dürer's print for the first time, actually see? Before you try to describe the picture in detail, I would like you to consider another point. How does the fact that you are looking at a reproduction in a book affect your perception of a work of art, and is this the same in all cases?

Discussion

The size of the reproduction and the closeness of the colours to the original may influence your assessment of a work such as a painting. *Melencolia*, however, does not lose impact from being reproduced in a book to the same extent as a painting, because its effect is not diminished through being drastically reduced. It is meant to be encountered in approximately this way, so size is not a major issue. Nor, as a black and white image, does it perhaps suffer so much from photographic reproduction as a painting would.

When we come to the image itself, even on first inspection various elements stand out. Most obvious is the winged woman sitting on a low step, elbow on knee, head in hand, staring somewhere into the middle of the picture. She sits in front of a building, against which a ladder is propped. Numerous objects are strewn around in no particular order: an incongruous geometrical solid with a small flaming crucible behind it, a sphere, various carpenter's tools, a large thin dog rather like a greyhound, apparently asleep. Perched next to the woman on a draped millstone, a winged child is writing. Behind her on the wall of the building are some scales, an hour-glass, a bell, and a kind of plaque covered in numbers. To the left, the view gives on to a distant seascape. In the sky there is a blazing star, or comet, but also a rainbow. In the space between the foreground objects and the celestial elements, flying over the sea, there is a grimacing, bat-like creature across whose wings appears the legend 'Melencolia I'.

◆◆

From a verbal description like this, however, we cannot pick up the 'mood', or effect, of a picture in the way that we can when we look at it.

1 **What effect does the lighting of Dürer's print have on the mood of the picture?**

2 **Can you identify how the mood is affected by the way you – as the viewer – are positioned in relation to the depicted scene?**

Discussion

1 Dürer's image is rather dark overall, but this effect is not absolutely consistent. (This is to do with the way light is distributed in the picture. Light is crucial to the effect of pictorial illusion, and producing a believable illusion is largely a question of successfully imitating on a flat surface the way light falls on objects in three-dimensional space.) Highlights are scattered, but mostly occur in the foreground, as if light was spreading from a lamp placed low down and to the viewer's right. Yet the shadow of the hour-glass appears to be cast by a light placed facing, but rather higher up than, the viewer. There is also the star in the top left distance, which lights the top plane of the geometrical block as well as illuminating the dark surface of the water, rather like moonlight. It may therefore be a twilight scene, but this is somewhat contradicted by the rainbow, and there are no unequivocal signs to tell us whether day is turning into night, or night into day. The fact that the light source is not settled or consistent, coupled with the lack of colour which contributes to the sense of the image being rather dark, helps to produce a gloomy and rather unsettled feeling.

2 The unsettled feeling is reinforced by our imaginary position relative to the things depicted in the scene. As viewers we are situated low down, more or less on a level with the seated woman. The scale of the principal objects, that is their size relative to the whole picture, is large. The lack of space between the hem of the woman's dress and the bottom border of the picture, coupled with the fact that her head extends above half the picture's height gives a feeling of being pressed up close to the scene, almost tripping over the jumble of nails, saw, straightedge, and plane.

◆◆◆

This jumbled feel could be a mistake. But it isn't. Dürer was a master of composition and perspective. He has deliberately produced an incoherent effect by 'tuning' pictorial space, or, to continue the musical analogy, by making it somewhat 'discordant'. The creation of an effect or mood of tension and unease is the result of the formal, compositional devices he has employed.

Canons of interpretation: formalism and iconography

There are, of course, many methods in art history, many ways of interpreting and explaining works of art. Two in particular are important to note here: formalism and iconography. The first tends to concern itself with the visual aspects of a work, considering the work as a more or less independent arrangement of forms, lines, colours, and so on, relatively unconcerned with what objects those colours and forms might be being used to depict, or what stories they might be being used to tell. This approach often involves questions of aesthetics, of judgements of the success or failure of the work in purely visual terms. The second approach tends to investigate how a work of art comes to be as it is by attempting to read meanings out of the objects depicted. This approach can open out the investigation to social, political, and intellectual factors on which the artist draws, either consciously or unconsciously, when producing the work. To put the difference quite dramatically, we could say the first approach is concerned with art's *effects*, the second with its *causes*.

One of the first to write in a modern way about Dürer was the German art historian Heinrich Wölfflin (1864–1945), in his monograph *The Art of Albrecht Dürer*, published in 1905. In attempting to imagine and describe a first encounter with *Melencolia*, we were following Wölffin's formalist approach. In his discussion of *Melencolia*, Wölfflin does to a certain extent draw upon the method of iconography, but in general, for him, the 'meaning' of stone blocks, carpenter's tools, and numbered squares is a secondary matter. He says that these are 'superficial aspects' and that what matters is 'how Dürer has used all possible formal means to convey the mood of melancholy'. In his analysis, Wölfflin noted the lack of a 'predominant line', the way in which the light is 'not concentrated but broken up' with the highlights 'set very low', and the way 'objects are juxtaposed harshly and chaotically' in a manner that contributes to 'the chaos of the whole'. The result of all this is 'an unpleasant effect'. Wölfflin's principal claim is that 'the disturbed mental state is mirrored in the disturbed composition' (Wölfflin, *Dürer*, p.204).

Wölfflin is saying here that the spectator is made to *feel* something of the melancholia felt by the picture's principal figure, and that he or she is prompted to feel this, first and foremost, by the way Dürer has disposed his pictorial elements. For Wölfflin, the main force of the engraving's effect is produced by the picture's design itself, rather than by what the objects in it might mean in terms of sixteenth-century ideas of, for example, geometry, philosophy, or alchemy.

Yet the range of possible questions about meaning surely is an aspect of the picture's enigma, that which makes us want to keep on looking at it and thinking about it. We have not so far determined anything precise about the 'meaning' of the work. To explore this aspect of the picture, we need not only an alertness to pictorial organization and detail as we *look* at the work itself, but also a range of cultural knowledge that we can only acquire from *reading* about historical ideas and beliefs. As the art historian Joseph Koerner has remarked, Dürer's idea of melancholy 'depends on notions of self and image that remain radically alien to us today' (Koerner, *The Moment of Self-Portraiture*, p.21). Perhaps this is a point that needs briefly to be emphasized: our modern conceptions of self and identity are historically specific. Not just artists and writers but all of us experience what it is to be human in ways that have changed over time. In his classic study *Sources of the Self*, Charles Taylor writes that 'The moral world of moderns is significantly different from that of previous civilizations' (p.11). Dürer's *Melencolia* was produced at a time when modern ideas of the self, of individual responsibility, of a shrinking sense of divine control over human existence, and, not least, of the identity of the artist, were first beginning to appear in their modern form, out of a cluster of other ideas that now seem quite remote from our sense of ourselves.

No name in the discipline of art history is more closely associated with Dürer's *Melencolia* than that of the art historian Erwin Panofsky (1892–1968), who published *The Life and Art of Albrecht Dürer*, in exile from his native Germany, in the United States in 1943. This was followed in 1964 by an encyclopaedic study (written jointly with Fritz Saxl and Raymond Klibansky) of the concept of melancholy from antiquity to the fifteenth century. Perhaps the most surprising claim to emerge from Panofsky's iconographic investigation of *Melencolia* is that the engraving may have functioned as an allegorical self-portrait. This does not, of course, mean that the figure in the engraving is an actual self-portrait, although Dürer *was* among the first to produce such self-portraits at the time when modern ideas of subjectivity and individuality were beginning to emerge in Europe (see Plates 13 and 82–84). Panofsky's suggestion is that the engraving represents a *generic* portrait of the artist, that is, of the 'new' kind of artist Dürer believed himself to be. It is this claim that we will now go on to explore.

We may admit, and to this extent we would be at one with Wölfflin, that however complicated or profound the 'hidden' meanings in a picture are, if the way they are embodied is not made to work visually, then in some sense the picture will not be successful. The meanings will seem to be stuck on to it from outside (as with the medieval medical illustration shown in Plate 116). But we might also want to say – and here we would be at one with Panofsky – that to look on a work such as *Melencolia* as no more than an arrangement of pictorial forms, even though they are powerfully expressive forms, would be severely to truncate its significance. What is lost is the historical dimension,

the range of meanings animating the work of art at the moment of its production. We need to follow Panofsky's analysis if we are to come to an understanding of how the *Melencolia* engraving produces an image of 'the artist' at a crucial point in the history of art: when the modern meanings associated with the term were emerging.

The doctrine of the humours

Panofsky's interpretation involves the doctrine of the humours: a notion that has been largely dispelled by modern medicine in the last two or three hundred years, but which held sway before that for upwards of two millennia from Greece in the fifth century BCE up to the seventeenth and eighteenth centuries of our own epoch. It was a complex system of ideas linking humankind into the natural world. We should, though, bear in mind that what we are here calling the 'natural world' was considered at the time to include two elements – not merely 'nature' as we would now understand it. On the one hand was the earth and the realm of material things and on the other the celestial sphere and the world of the spirit.

In very early Greek mystical mathematics, the number four was venerated, and categories of four things therefore tended to be highly esteemed. These ideas had grown out of earlier Babylonian and Sumerian thinking in ways that are neither clear to us nor directly relevant to Dürer. None the less, out of these beliefs there gradually stabilized a doctrine of the universe as being comprised of four basic elements: earth, air, fire, and water. The human body itself could not be said to be made out of these elements as such, but the food we eat *is* more directly of the earth and its elements. Food came to be seen as being transformed by the organs of the body (the stomach and the liver being important) into four life-giving fluids: blood, phlegm, yellow bile, and black bile. The elements were connected to these fluids through a system of linking qualities: hot (or warm), dry, cold, and wet (or moist). These building-blocks and their interconnected relations formed the basis of a belief system which integrated the human organism into a cosmic order of being. This order included, most importantly, the stars and planets, and time. The latter was viewed both in terms of the four seasons (spring, summer, autumn, winter) and the four ages of man (childhood, youth, maturity, old age, or, alternatively, youth up to 20, prime up to 40, decline up to 60, and old age over 60). The importance of this for our study of Dürer's engraving is that the four bodily fluids and their attendant qualities gave rise to four character types or temperaments: the phlegmatic, the choleric, the sanguine, and the melancholic. It is possible to render this system in the form of a table to show the interrelations (Table 1).

Table 1 The doctrine of the humours

Fluid	Quality	Temperament	Planet	Season	Age
Blood	Hot/Wet	Sanguine	Jupiter	Spring	Childhood (or *c*.20)
Yellow bile	Hot/Dry	Choleric	Mars	Summer	Youth (or *c*.20–40)
Black bile	Cold/Dry	Melancholic	Saturn	Autumn	Maturity (or *c*.40–60)
Phlegm	Cold/Wet	Phlegmatic	Moon/Venus	Winter	Old age (or over 60)

The melancholy humour and the notion of creativity

The idea of melancholy was not static, and the transformations it underwent are particularly important for Panofsky's account of Dürer's engraving. In the very earliest formulations in the fifth and fourth centuries BCE, and also for the long period from the dawn of the Christian era and later antiquity through to the Florentine Renaissance of the fifteenth century, a dominance of black bile and a consequent melancholy humour was seen as a negative attribute. Melancholy, associated with the gloomy star of Saturn, was a curse.[2] Indeed, in Christian belief melancholy was linked directly to the Fall (the expulsion of humankind from Paradise). Melancholy, it was believed, came to haunt human life as a direct consequence of Original Sin. The dominant view of the melancholic in both classical and Christian ideology corresponds to what we have already discovered from present-day dictionaries and encyclopaedias. Just as today the condition that modern psychology calls 'depression' is seen as undesirable, so, for most of two millennia, to be afflicted with melancholy was to be out of sorts with yourself and your fellow creatures.

There was also, however, an extraordinary reversal of this norm. In the earliest Greek myths, the gods punished heroes with madness for their presumption in trying to reach beyond the merely human. Thus, a precedent was established in which madness became linked with, so to speak, a deviation 'upwards' from the human norm. The philosopher Plato (c.429–347 BCE) developed this notion of spiritual exaltation as a divine gift, taking the form of 'frenzy'. By contrast, and most importantly for our purposes, another Greek philosopher, Aristotle (384–322 BCE), and his followers suggested that, rather than being divinely induced, such exaltation and madness could be accounted for in human terms. They did this by regarding creative exaltation, or inspiration, as part of the system of temperaments: linking it to 'melancholy', which had up to then been a solely medical concept. A key question is posed in Aristotle's *Problemata physica* (long thought to be by Aristotle himself, but now assumed to be the work of a follower): 'Why is it that all those who have become eminent in philosophy or politics or poetry or the arts are clearly melancholics?' The passage in which this is discussed concludes: 'all melancholy persons are out of the ordinary, not owing to illness, but from their natural constitutions' (Panofsky *et al., Saturn and Melancholia*, pp.18, 29). The ground was thus laid for a radically different, positive assessment of the melancholy temperament, although this positive potential remained fraught with danger. To be endowed with the positive effects of the melancholic temperament – powers of concentration and reflection, capacity for solitary study and creative thinking – was simultaneously to be haunted by a life led in *tension*.

These ideas, then, represented an alternative view of melancholia in the ancient world. In post-Aristotelian classical thought, as well as in subsequent Christian doctrine, the concept's negative connotations came once again to the fore. But, from the point of view of an understanding of Dürer's engraving, the crucial factor is that it was precisely this Aristotelian conception of melancholy that was recovered and extended by humanist thinkers in Florence in the second half of the fifteenth century, most notably in consort with a

2 In ancient mythology, the god Saturn (or Chronos) is often pictured devouring his own children as a metaphor for the way in which time (*chronos*) destroys all living things.

newly developed idea: that of the creative genius. In his pioneering study of 1924, the German writer Walter Benjamin wrote of the Renaissance as the time 'when the re-interpretation of saturnine melancholy as a theory of genius was carried out with a radicalism unequalled even in the thought of antiquity' (*The Origin of German Tragic Drama*, pp.150–1).

The identity of the artist

Before the Renaissance, the ability to create was essentially attributable only to God. Thus, for the philosopher and theologian Saint Thomas Aquinas (1225–74), and before him Saint Augustine (354–430), human creativity was limited to the rearrangement of what God had already created. In the fifteenth century, however, this was changing. It has been argued that at this time 'qualities that we would now subsume under the general heading of "creativity"' began to be applied to artists, and the image emerged of 'a somewhat eccentric figure, characterised mainly by its nature and temperament' (Barasch, *Theories of Art*, p.181). This notion of eccentricity has become so overworked in the modern period that the portrayal of the misunderstood artist, forced into incomprehensibility by a creative urge he barely controls, has descended into cliché. Nonetheless, when it first emerged, the concept of 'genius' was principally characterized by a heightened form of self-consciousness, which could be intensely uncomfortable rather than merely self-indulgent. The relevance of this to the present discussion is that at the extremity of self-consciousness is the recognition of one's own mortality. A connection therefore opens up between genius and the condition of melancholy. What in the medieval world were the often linked sins of sloth (or acedia) and dementia (and as such obvious forerunners of the modern sense of a 'manic-depressive' condition) were transformed in Renaissance humanism into the idea of a melancholic, but creative, genius.

In this summary of Panofsky's attempt to unravel the complex meanings behind Dürer's *Melencolia* engraving, one more step needs to be taken. The ideas we have been tracing were brought into the main current of European thought in the writings of the Florentine humanist philosopher Marsilio Ficino (1433–99), whose book *De vita triplici* was published between 1482 and 1489. According to Panofsky, its arguments arose out of a new understanding of life, in which the striving for moral and intellectual independence formed the key features. The acquisition of a new sense of freedom was, however, indivisibly linked to a tragic sense of the human condition. Human freedom cannot be experienced without a significant undermining of the idea of God's omnipotence. As soon as that happens, the seeds are sown for a tragic view of human life as finite, separate from God, and thus in some deep sense alone. From a precarious conjunction of medieval and early modern conceptions of human subjectivity, Ficino reinstated melancholy as the shadow of creative achievement, and established Saturn – the astrological companion of melancholy – as the principal astral influence on the mind.

The only stumbling block here is that Ficino did not think that artists were the stuff of genius. He thought people like himself were: that is, humanist intellectuals. For him, creative melancholia was an attribute of contemplation, not imagination. The contemplative intellectual thought abstractly, and was thus in a sense elevated out of the material world. The imagination was considered to be the more restricted province of those who thought in terms

B ILIBALDI · PIRKEYMHERI · EFFIGIES
· AETATIS · SVAE · ANNO · L · iii ·
VIVITVR · INGENIO · CAETERA · MORTIS ·
· ERVNT ·
· M · D · X X · iv ·

Plate 118 Albrecht Dürer, *Willibald Pirckheimer*, 1524, engraving, 18.1 x 11.5 cm, British Museum, London. © The British Museum, London.

of images and figures. What we now need is to see how the humanist idea of the melancholy genius-as-intellectual became available for Dürer as an image of the artist.

One of the key figures in the reception and dissemination of the new Italian ideas north of the Alps was the German occultist philosopher Agrippa of Nettesheim (1456–1535). Like many others exploring new conceptions of human nature at the time, Agrippa seems to transgress the distinction between our modern sense of science and of mysticism. His *De occulta philosophia* was published in 1533, nearly 20 years after Dürer engraved his *Melencolia*, but was almost certainly available in about 1510 to the humanist circle around the intellectual and diplomat Willibald Pirckheimer, who was not only Dürer's life-long friend and correspondent but also the subject of one of his most psychologically compelling portraits (Plate 118). The point of this for our present account is that Agrippa developed Ficino's theory, expanding the idea of melancholy, which was thought to exist at two levels, to incorporate an additional level, that of the imagination. The belief was that when the soul was concentrated at what both Ficino and Agrippa regarded as the highest level, the *mens*, it could attain knowledge of things divine. When the

soul was concentrated at the level of reason, it could attain knowledge of human and natural affairs. But Agrippa specifically argued that the 'humor melancholicus' could also be found in the imagination: and here it received from the dæmons of inspiration 'wonderful instruction in the manual arts' (cited in Panofsky *et al.*, *Saturn and Melancholy*, pp.356–7). The imagination thus came to constitute the first, or lowest, level of the new concept of the melancholy genius. Hence, it would appear, the legend displayed by Dürer's distressed bat, 'Melencolia *I*'.

The picture's iconography

The *Melencolia* engraving was often sold by Dürer with another print, *Saint Jerome in his Study* (Plate 119), which can thus be regarded as a companion piece. Taken together, the two images may be seen to contrast the lives of the

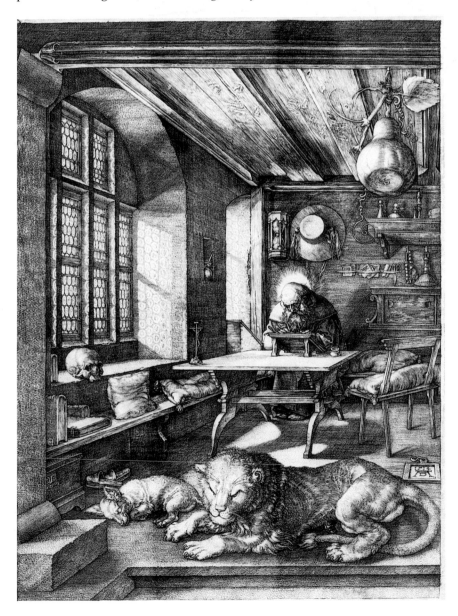

Plate 119
Albrecht Dürer, *Saint Jerome in his Study*, 1514, engraving, 24.7 x 18.8 cm, British Museum, London. © The British Museum, London.

contemplative scholar and the imaginative artist. In Panofsky's words, they represent, on the one hand, 'the life of the Saint in the spiritual world of sacred contemplation', and on the other, 'the life of the secular genius in the rational and imaginative worlds of science and art' (Panofsky, *Dürer*, p.151). In other words, the pairing suggests that the artist should be placed on the highest levels of learning and imagination. In order to understand the logic of the juxtaposition more fully, let us look again at Dürer's engraving.

Can you single out what features of *Melencolia* remain puzzling?

Discussion

In some ways it is quite easy to list puzzling features: the strange-shaped stone is the most obvious. After that perhaps the most inexplicable features remain the instruments on the wall behind the seated figure. Beyond that, despite all we have done to uncover the picture's general meaning, there is a sense in which everything remains more than a little unclear. What is the child doing? And the dog? Why is the main figure in that particular pose? And so on.

◆◆◆

Bearing in mind what we have discussed about the deeper meanings of the picture, how might these features relate to the overall meaning?

Discussion

On the basis of non-specialist knowledge, it remains difficult to attach precise significance to the main features of the picture. But from what we have learned we might be able to make general connections. Thus, it is likely that the imagery may concern the liberal arts, and it could be that there are references to scientific, or quasi-scientific, forms of knowledge: perhaps alchemy or astrology. To progress beyond that, we will have to turn again to specialized historical investigation.

◆◆◆

Art historians have traced the principal iconographic roots of Dürer's composition into three traditions. The first of these is indeed representations of the liberal arts. Panofsky himself makes a compelling case for the stone block, the sphere, the dividers, and other tools constituting a reference to geometry (Plate 120). Others, though, have seen the female figure as a personification of Astronomy or as a kind of composite representation of the quadrivium, the higher division of the liberal arts, which comprises arithmetic and music as well as geometry and astronomy. Whichever of these may be true in detail, the conclusion would seem to be that, insofar as the engraving is meant to be a generic self-portrait of the creative artist, for Dürer such an artist has also to be a scholar, master of the liberal arts as well as of the manual arts involved in producing the image itself.

The second tradition is the cycles of the four temperaments (Plate 121). We have already seen how, in humorological theory, the temperaments were related to the four ages of man, and also to the four seasons. Images of both could be found in situations as diverse as medieval calendars and cathedrals. For our present purposes, it is particularly relevant that to represent the

temperaments medieval artists used the same allegorical figures that were used to represent the virtues (such as faith and justice) and the vices (such as pride and envy). Panofsky points out that, when the fifteenth-century artist sought models for representing the temperaments, outside of medical treatises 'he had nothing to turn to except the traditional types of the Vices' (Panofsky, *Dürer*, p.159). Thus, the vice of acedia or sloth appears to provide the basic pose of the seated, sleeping, or distracted figure, with head in hand (Plate 122).

Plate 120 Anonymous, *Typus Geometriae*, woodcut from Gregorius Reisch, 'Margita Philosophica', Strasbourg, 1504. Photo: Ann Ronan at Image Select, London.

Plate 121 Anonymous, *The Four Humours* (left to right: sanguine, choleric, phlegmatic, melancholic), third quarter of fifteenth century, German woodcut, reproduced in Erwin Panofsky, *The Life and Art of Albrecht Dürer*, Princeton University Press, 1955, plate 214. Copyright © 1955 by Princeton University Press, reprinted by permission of Princeton University Press.

Plate 122 Anonymous, *Acedia*, detail of woodcut, *c*.1490, reproduced in Erwin Panofsky, *The Life and Art of Albrecht Dürer*, Princeton University Press, 1955, plate 210. Copyright © 1955 by Princeton University Press, reprinted by permission of Princeton University Press.

The third tradition is astrology. An important dimension of humorological theory was the links of the components of the belief system linking to the planets, and consequently the importance of conventions for representing them. This is an area beyond our present scope, but it is relevant that Saturn took on a greater significance in Italian humanism than he had enjoyed previously. One of the key sites of what Panofsky called the 'humanistic rehabilitation of Saturn' (Panofsky *et al.*, *Saturn and Melancholy*, p.209) was Venice, visited by Dürer in the mid-1490s. Important features of this reassessment of Saturn included the representation of him as classically robed, often with head propped in hand (Plate 123), and not infrequently with accoutrements such as wings and an hour-glass. Other astrological features of the *Melencolia* engraving include the dog, the bat, and the numbered square on the wall. This is a 'magic square'. It has the sum of 34: that is to say, the numbers in the rows add up to 34 whichever direction they are added up in, horizontally, vertically, or diagonally. That square, however, is a symbol not of the gloomy Saturn but of the jollier god Jupiter. It thus seems to function as a counterbalance to melancholy as also perhaps does the wreath of water-plants around the principal figure's head (given that melancholy is a dry, earth-oriented temperament). It should be underlined that, while speculative, such claims regarding the influence of astrology on the content of the engraving are not without foundation. A reputedly ancient text, known as the *Horappolo* text, which was thought to decode Egyptian hieroglyphics, identified the dog as a symbol of spleen, linking it to scholars and prophets, as it also did with the bat. This text was not merely in general circulation in German humanist circles: it was actually translated from the Greek by Pirckheimer, and, moreover, illustrated by Dürer in 1512, only two years before *Melencolia* was produced.

Plate 123 Anonymous, *The Children of Saturn* (two melancholics in the upper corners), third quarter of fifteenth century, German miniature, reproduced in Erwin Panofsky, *The Life and Art of Albrecht Dürer*, Princeton University Press, 1955, plate 213. Copyright © 1955 by Princeton University Press, reprinted by permission of Princeton University Press.

In general, Dürer seems to have taken particular interest in the power of supernatural phenomena at various points in his career. It is as if the supernatural dimension, be it in Christian or astrological guise, counterbalanced the emphasis on naturalism which is such a powerful basis for his work (Plate 124). Dürer's powers of observation, and his ability to translate these into extraordinarily naturalistic depictions, were the other side of his immersion in an all-embracing, mystical-religious world-view: a kind of homage to the detail of God's design. These two aspects of his outlook seem fused in the *Melencolia*. In Dürer's time, science and mysticism were not as differentiated as they subsequently became, and elements in his work

that seem strange or archaic to us were a relatively normal part of daily life and learning for the people of Dürer's epoch. It was a widespread perception around 1500 that people were living in the 'End Times', and the process of the Protestant Reformation in the second and third decades of the sixteenth century did nothing to dispel belief in an imminent apocalypse. Late in his life, in May 1525, Dürer made a water-colour of a dream he had of the Deluge, in which columns of water fell from heaven and struck the earth with thunderous noise. Thirty years earlier, one of the major projects that established his career was a series of woodcuts of the Apocalypse based on the Book of Revelation. Following the biblical text, several of these contain imagery of blazing stars falling to earth. Also in the 1490s, on the reverse of a small oil painting of *Saint Jerome*, he painted a striking vision of a fiery star not dissimilar to that shown in *Melencolia* (Plate 125).

Plate 124 Albrecht Dürer, *Muzzle of an Ox* (view from the front), 1503, watercolour, 19.7 x 15.8 cm, British Museum, London. © The British Museum, London.

Plate 125 Albrecht Dürer, *A Heavenly Body* (reverse of *Saint Jerome*), *c*.1496, oil on pearwood, 23.1 x 17.4 cm, National Gallery, London. Reproduced by courtesy of the Trustees of the National Gallery.

It seems, then, that the entire structure of the *Melencolia* engraving, from the significance of the various elements to the pose of the figures, is steeped in a range of antecedent pictorial and intellectual traditions. Yet simultaneously it represents a reflection upon key transformations in those traditions, particularly as they bear upon the identity of the artist. This artist is – of course – responsible for making the picture in the first place, and hence for those meanings it disseminates about changing conceptions of what it is to be an artist. To that extent, *Melencolia* represents not just an argument about a change in the status of artists, but evidence *of* it. It does not just *say* being an artist has changed; it *shows* it.

The status of the artist and the question of media

The concept of the artist was changing in Dürer's time in more ways than one. We have discussed at some length the intellectual and theoretical transformations, but these were accompanied by, and mutually interacted with, social and institutional changes in status. In particular, these involved painting becoming seen as one of the humanist liberal arts, rather than an artisanal craft skill. Thus, when Dürer wrote during his second visit to Venice in 1504 to his humanist friend Pirckheimer that in Italy he was rubbing shoulders with 'men of sense and knowledge' who showed him 'humour and friendship' (Conway, *The Writings of Albrecht Dürer*, p.48), this was more than an expression of personal success. It was a registration of the uneven transition from the medieval to the Renaissance (and ultimately to the modern) status of the artist. Part of what we mean by the term 'Renaissance' concerns not merely the rebirth of classical learning but also the emergence of that sense of independent human capacity associated with the rise of humanism. The status of the artist did not, of course, change overnight from anonymous artisan to divinely creative independent genius, but over a period a change did take place. Through his friendship with Pirckheimer, who had himself studied in Italy for seven years, Dürer became part of a circle of humanist intellectuals. In the second decade of the sixteenth century (the time of his work on *Melencolia*), these humanists became an influential part of the culture of the court of the Holy Roman Emperor, Maximilian I (Plate 126). Considered in this perspective, Dürer's second visit to Italy, after ten years of established practice as the master of his own workshop in Nuremberg, appears to be a conscious attempt to refresh his engagement with Italian humanism, and to vitalize its assimilation into the arts north of the Alps.

In his theoretical writings, Dürer advanced a conception of the artist in terms of originality and individual creativity. These were published after his death but the ideas were based on his own practice. In surviving notes from the period around 1512, that is approximately the time of his work on the *Melencolia* and *Saint Jerome* engravings, he is already writing of the painter as 'inwardly full of figures' and imbued with the capacity 'to pour forth something new'. By the 1520s, he famously observed that one man 'may often draw something with his pen on a half sheet of paper in one day', and yet this apparently hasty or improvised sketch may be 'fuller of art and better than another's great work whereon he has spent a whole year's careful labour' (Stechow, *Northern Renaissance Art*, p.116).

This is a long way from the conception of the artist as incorporated guild member. As Joachim Camerarius, Professor of Greek and Latin at the University of Nuremberg, wrote in a commentary on Dürer's treatise, his 'singular skill and genius as an artist and man' resulted in his being 'exalted and honoured with undying glory' (Moore, *Durer*, p.188). Conventional hyperbole aside, this still adds up to singular praise for the practitioner of a trade who not long before might have been carrying out designs for banners and playing cards. Perhaps the last word in this celebration of the new artist can be left with none other than Erasmus of Rotterdam, arguably the pre-eminent scholar in Northern Europe. In his estimation, Dürer did not merely rate high: he outdid the ancients, emulation of whom was in many respects the driving force of the entire conception of 'Renaissance'. Erasmus wrote: 'I

Imperator Caeſar Diuus Maximilianus Pius Felix Auguſtus

Johann Kramer.

Plate 126
Albrecht Dürer,
*Emperor
Maximilian I*,
1518, woodcut,
41.4 x 31.9 cm,
British Museum,
London. © The
British Museum,
London.

have known Dürer's name for a long time as that of the first celebrity in the art of painting. Some call him the Apelles of our time. But I think that did Apelles live now, he, as an honourable man, would give the palm to Dürer' (Moore, *Durer*, p.185).

Having established these points about the changing status of the artist, we do none the less have to exercise caution in attempting to apply the general trend to the particular instance. It is not a simple matter of celebrating the 'freeing' of the fine arts from craft constraints – as if the modernist conception of the artist represented an unproblematic culmination of earlier developments. Part of 'questioning the canon' *is* to question just such assumptions. In the present case, for one thing, Dürer most certainly did not scorn craft skill. For another, there were no guilds as such in Nuremberg. Nuremberg at the end of the fifteenth century was a city that depended for its wealth in no small part on trade in the crafts. Instead of being subect to guild control, therefore, they were overseen by the city council itself. This meant that in Nuremberg painting and sculpture, as part of the system of craft production, were already conceived as 'free arts' (Bartrum, *German Renaissance Prints*, p.9). 'Freedom', that is to say, is a relative concept in the historical practice of the arts.

Dürer initially studied as a goldsmith under his father, where he learned engraving techniques, before turning to painting at the age of fifteen. Once he had completed his apprenticeship in the workshop of the painter Michael Wolgemut during the late 1480s, and then spent four years in the early 1490s gaining experience as a journeyman in Colmar, Strasbourg, and Basle, he was free to set up his own workshop. For Dürer, mastery of technique was the prerequisite for being able to represent the new ideas. It is the relationship between the two that is crucial, with the skills serving, rather than determining, the impulse towards 'making something in his heart' (Barasch, *Theories of Art*, p.188). To us such individualism is a commonplace of the *fine* arts, but Dürer stands at a point where new ideas of creativity were intertwined both with earlier craft-based practices and with media (such as woodcuts and engravings) that have subsequently been marginalized by the elevation of painting as the paradigmatic visual 'fine art'.

Melencolia, as we have seen, is an engraving on copper. To produce an engraving the artist painstakingly incises the metal plate with a chisel-like instrument, the burin. Each line has to be cut with a combination of commitment and accuracy to ensure the desired effect is achieved first time, since mistakes are difficult to rectify. Dürer's technical mastery was exceptional, and formed the basis for the intellectually and psychologically complex meanings that his prints disseminate. *Melencolia* was, in a sense, an instance of new technology: it advanced available techniques beyond existing examples, and, by fusing this with the medium's reproducibility, permitted the circulation of high-quality, intellectually complex imagery to a wider audience than was possible even with portable oil paintings on canvas.

Although printing had a long prehistory, the key developments that laid the basis for modern print technology were made in Germany only a few decades before Dürer began to practise as an artist. Johannes Gutenberg (1400–68) brought together the two innovations that underpin modern printing – the use of a press for multiple impressions and the design of dies to make reusable type – only in about 1450. His Bible was printed in Mainz between 1453 and 1456. Woodcuts on paper, notably for playing cards, had appeared in the early fifteenth century, but engraving on metal plates (based on crafts such as gold- and silversmithing) only developed in the second half of the century. The first engraver actually to sign his work was Martin Schongauer (1450–91), in Colmar, and it was to Schongauer's workshop that Dürer travelled as part of his journeyman's experience. Schongauer in fact died a few months before Dürer's arrival, but the techniques Dürer observed in Colmar, allied to the work he did in book production in Basle, equipped him with a knowledge of the latest print technology, which he was able to employ when setting up his own workshop in 1495. He was further helped in this direction by the fact that his uncle was a leading book publisher and provided a supply of commissions for illustrations in the print media of both woodcuts and metal engravings.

Dürer tended to reserve the woodcut medium for relatively popular subjects, based, for example, on the Bible. The audience for works like *Melencolia*, one of Dürer's principal markets, was drawn from the kinds of educated circle in which he himself was an eminent figure: 'the burgeoning class of professional men with a university education in classical languages and history (the humanist curriculum) who served or profited from the newly powerful and

wealthy states of the early sixteenth century' (Bartrum, *German Renaissance Prints*, p.8). Mechanical reproducibility was central to Dürer's practice as an artist. Wide distribution on both sides of the Alps fostered both his fame and his commercial success. Far from woodcuts and engravings being adjuncts to a 'fine art' practice centred on painting, Dürer once complained that he would have been a richer man if he had dropped painting altogether for the benefits conferred by this early phase of art in the age of mechanical reproduction.

Conclusion: learning about art and learning from art

In conclusion, perhaps we can see that Dürer's example looks forward as well as backwards. Not only does it challenge medieval norms, it also challenges subsequent ideas of the hierarchy of the 'fine arts'. This may be one reason why it continues to be interesting today. Dürer lived at a time when ideas about artists and art practice, and, indeed, ideas about human subjectivity in general, were changing. So do we. In this case study we have discussed two art-historical approaches to *Melencolia*: the formalist and the iconographic. We concentrated on the latter because it enabled us to see how Dürer's print represented fundamental changes in the concept of what it was to be an artist.

Both of these approaches have become part of the history of art history, and twentieth-century historians have sought in turn to contextualize *them*. Forms of explanation of works of art are, of course, always inflected to some extent by the interests of those doing the explaining. When Dürer was 'rediscovered' by the Romantics at the beginning of the nineteenth century, it was as a German 'master' – a citizen of Nuremberg, Protestant and Gothic. As such his work was contrasted with the classically based Italian style of art and, of course, with the French and their academic tradition. This served at the time to articulate a sense of national cultural identity in the face of Napoleon's invading armies. Today, the American historian Keith Moxey has argued that Panofsky's estimation of Dürer as a northern equivalent to the canonical masters of the Italian Renaissance was bound up with the political crisis of the mid-twentieth century and Panofsky's need to clarify his own identity as a German–Jewish intellectual.

This is not, of course, to say that Panofsky's history is somehow compromised or 'wrong', but it does reflect the prevailing intellectual climate at the present time. This is one of relativism, that is, a questioning of received claims to status and authority, including an uncertainty about the value of canonical works of art and the way we have conceived the role of the artist. Thus, for the twentieth-century Polish author Wojciech Balus (whose essay was referred to at the beginning of this case study), the point of the various and sometimes conflicting views generated by *Melencolia* is that they do *not* add up. His claim is that Dürer's print actually frustrates attempts to locate its definitive meaning. Such a view is, of course, deeply symptomatic of the preoccupations of the period in which it is written.

We have seen, then, how Dürer's work represents changes in the idea of 'the artist', and how forms of art-historical explanation themselves change. The

underlying point of examining this work of art, however, has to be to discover the relevance of the work and its meaning to the situation we are in. As the English Jacobean author Robert Burton wrote to his readers at the head of his monumental *Anatomy of Melancholy* in 1624: 'Thou thyself art the subject of my discourse'. If the extent to which we as historians can shed light on the work is not balanced by some sense of the way in which the work can speak to our present historical circumstance, then we are on a scholastic merry-go-round. The various interpretations we have encountered all make their claim on our attention. They tell us something about the value of the artist-as-genius, and the cost of that freedom in terms of uncertainty and self-consciousness; we learn from this what we can about ourselves, as our 'selves' are constructed at any one historical juncture. There is one thing, however, of which we may be certain. The critical point of Dürer's *Melencolia* is that he, as author, as artist, overcame that moment when everything stopped. The evidence is in the art. The print *represents* the new kind of artist as melancholic, or more to the point, it represents the price of 'free creativity' as experienced in periods, fleeting or prolonged, of disabling melancholia. What it *exemplifies*, by its very existence, is their overcoming.

References

Balus, W. (1994) 'Dürer's *Melencolia I*: melancholy and the undecidable', *Artibus et Historiae*, vol.30, pp.9–21.

Barasch, M. (1985) *Theories of Art from Plato to Winckelmann*, New York University Press.

Bartrum, G. (1995) *German Renaissance Prints 1490–1550*, London, British Museum.

Benjamin, W. (1985) *The Origin of German Tragic Drama*, London, Verso (first published 1924–5).

Burton, R. (1927) *The Anatomy of Melancholy* (1624), New York, Tudor.

Conway, W.M. (ed.) (1958) *The Writings of Albrecht Dürer*, London, Peter Owen.

Jackson, S.W. (1986) *Melancholia and Depression: From Hippocratic Times to Modern Times*, New Haven and London, Yale University Press.

Koerner, J.L. (1993) *The Moment of Self-Portraiture in German Renaissance Art*, Chicago and London, University of Chicago Press.

Moore, T. Sturge (1911) *Albert Durer*, London, Duckworth (first published 1905).

Moxey, K. (1994) *The Practice of Theory*, Ithaca, Cornell University Press.

Panofsky, E. (1955) *The Life and Art of Albrecht Dürer*, Princeton University Press (first published 1943).

Panofsky, E., Klibansky, R., and Saxl, F. (1964) *Saturn and Melancholy*, London, Nelson.

Taylor, C. (1989) *Sources of the Self: The Making of the Modern Identity*, Cambridge University Press.

Wölfflin, H. (1971) *The Art of Albrecht Dürer*, London, Phaidon (first published 1905).

Pieter Bruegel the Elder and the northern canon

KIM WOODS

Introduction

Pieter Bruegel the Elder was probably born around the time that Dürer died, and he worked not in Germany but in the Netherlands (present-day Belgium), but the two northern artists form an interesting comparison. Both were working in turbulent times. Dürer was active during the Protestant Reformation, Bruegel during the political and religious troubles of the Netherlands in the 1550s and 1560s.[1] Both were renowned for their graphic work as well as painting, but whereas Dürer was famous for his skill as an engraver, particularly of religious subjects and portraits, Bruegel produced only designs for engravings, and relied on professional engravers to make the prints of peasant pictures and landscapes for which he was famous. Both artists had humanist contacts: Dürer with Pirckheimer, Bruegel with Ortelius. Bruegel's reputation was not obviously based on the prestige of the ancient, however; his unidealized, unclassical peasants show little of Dürer's Renaissance preoccupation with the proportions of the human figure. Like Dürer, Bruegel travelled to Italy early in his career (1552–3). He was not as exempt from Italian influence as art historians once thought, but his work does not include the fashionable figures, motifs, or subjects in the style of Italian art that are apparent in the work of contemporary artists, such as Floris.

Bruegel's reputation as an artist was based on his skills as a painter of peasant scenes and as a landscapist. As such he may appear, unlike Dürer perhaps, to be an artist particularly inseparable from the times in which he lived, but his work was far from being a simple record of the everyday world. Both his peasant paintings and his landscapes are deliberately constructed and often full of meaning. Whilst Dürer's ideas can be perceived to some extent from his theoretical writings, letters, and diaries, Bruegel left none. In this case study, we shall be trying to examine the basis of his reputation, using a mixture of sources: primary, secondary, and visual.[2]

Reputation and interpretation

Bruegel wrote no treatises, but a drawing by him of an artist at work provides some direct if cryptic evidence about his own views on the status of the artist. *Artist and Connoisseur* (Plate 127) shows a prospective client, clutching his money bag and peering through thick glasses at a picture on an easel. The artist painting the picture is portrayed as an unkempt peasant in old-fashioned dress.

[1] See footnote 3 in Case Study 5 on page 142.

[2] Primary sources are sources of information contemporary with a particular historical period. These may include written comments and descriptions as well as visual representations dating from the period. Secondary sources are comments on the period, or on sources contemporary with it, produced by later authors.

Plate 127 Pieter Bruegel the Elder, *Artist and Connoisseur*, 1560s, pen and ink, 25.5 x 21.5 cm, Graphische Sammlung Albertina, Vienna.

What does Bruegel seem to be saying in Plate 127 about both artist and client? The picture is meant to be funny. Does this affect the way we interpret it?

Discussion

The artist has the advantage over the client because he is not the object of such obvious satire. True, he looks morose, but then he is concentrating on his painting and, we might infer, thus ignoring any potentially troublesome customers. His rough appearance makes him look more like a craftsman than a scholar-creator or a man of culture (see Case Study 4). Bruegel calls into question the artistic understanding and discrimination of the client by making him look stupid, an object of ridicule. He is shown holding his money and gloating over his prospective purchase, but how much can he really see through those thick glasses? We are led to believe he pretends to connoisseurship rather than qualifying as the connoisseur in the drawing's title. This humorous picture is probably not intended to be taken too literally, but as with many good jokes there is no doubt an element of truth in it.

This drawing seems to comment more on the consumption of art than on the artist himself, but in satirizing the philistinism of the customer Bruegel seems subtly to uphold the status of the artist. A traditional saying that has been related to the drawing – 'Art and wisdom have no closer enemy than the ignorant' – implies that art involves a degree of knowledge and discrimination that can elude the consumer. We do not know whether the drawing was done to be engraved or formed the design for a painting, and hence whether its humour was intended for wider enjoyment. If it was conceived simply as an independent drawing, its circulation would have been very limited, and it may have functioned more as a satire for an élite audience. It was evidently appreciated by artists who saw it or made copies of it (as many as four survive).

A second drawing, *The Artist at his Easel*, exists in three versions, none of which has definitely been attributed to Bruegel himself. The assumption is that they reproduce an original design by Bruegel. The best version (Plate 128) has been attributed to Bruegel's son, Pieter Bruegel the Younger, who was a skilled imitator of his father's work. Nevertheless, since even this drawing cannot be proved to reflect a lost original work by Bruegel the Elder, we should probably be wary of giving too much weight to the evidence it provides.

Plate 128
After Pieter Bruegel the Elder, *The Artist at his Easel*, late sixteenth century, pen and ink, 26.5 x 20 cm, Musée du Louvre, Paris.

1 **What are the obvious differences in subject-matter between this drawing and the *Artist and Connoisseur*?**

2 **How does the message concerning the status of the artist differ from that of the *Artist and Connoisseur*?**

Discussion

1 You probably noticed the following points in relation to *The Artist at his Easel*.

The focus is wholly on the artist.

The picture that the artist is working on is included in the drawing, and the subject-matter is partially visible although indecipherable.

The artist seems to be more smartly dressed (in fact, he wears a rather impractical, expensive, fur-trimmed robe).

A second figure, perhaps a second artist or an apprentice, is shown sketching in the lower left of the picture.

2 At first glance the first drawing seems to reflect the craft tradition, whilst the rich robes of the artist in the second suggest higher status, perhaps highlighting painting as a liberal rather than a mechanical art. On the other hand, if the implication of the first drawing is that art is something that needs to be understood, then both reflect the status of the artist as a person of more than just technical skill.

◆◆

One of the other versions of the second drawing bears an inscription in Latin, the language of scholars: 'Nulla dies abeat quin linea ducta supersit' (No day passes without a line drawn). This is a paraphrase of a saying attributed to Apelles by Pliny (*The Elder Pliny's Chapters*, p.119) and it presumably applies to the apprentice diligently practising his drawing. The artist here seems to be deliberately presented as the cultivated artist as championed by Lampsonius and others (see Case Study 4), a figure comparable, perhaps, to the revered artists of ancient Greece and Rome. The inscription, however, may not reflect Bruegel's intentions, if indeed he was the originator of the design.

Bruegel's own reputation has fluctuated considerably. He was praised towards the end of his lifetime by the Italian historian Ludovico Guicciardini (1523–89) in his *History of the Low Countries* (1567) and by Vasari in his *Lives of the Artists* (1568). It may have been his moralizing prints and landscapes (published by Cock, who was also singled out by Guicciardini and Vasari) that established his reputation, by virtue of their lower price and wider circulation, as much as his paintings. As a painter he enjoyed the patronage of important and wealthy clients such as Jonghelinck (see Case Study 4) and Cardinal Granvelle. At the time of his death he was employed by the city of Brussels to execute a series of paintings commemorating the excavation of the canal between Brussels and Antwerp. Three years later, Cardinal Granvelle, then in Naples, was informed in a letter from his administrator in the Netherlands that Bruegel's works were selling for even more exorbitant prices than during his lifetime. His works were widely imitated: there are two versions of *The Fall of Icarus*, which we will be looking at later, for example. At the end of the century, his paintings were owned by such elevated figures as Archduke Ernst, governor of the Netherlands from 1593 to 1595, and Emperor Rudolph II of Prague, who also owned several works by Dürer.

Bruegel's reputation did not last. From the seventeenth to the nineteenth centuries, he was known only as a burlesque painter of peasants, 'Pieter den Drol' (Pieter the comic), and was not highly regarded. He was rediscovered in the late nineteenth century. On the one hand, he came to be viewed in a nationalist spirit as a Flemish artist recording his native traditions in resistance to Italian influence. On the other hand, the significance of his trip to Italy and of his circle of humanist friends was recognized and people began to reappraise his work. The different views of Bruegel's status as an artist depend partly on cultural viewpoint and partly on the sources of information selected. We will now look at three different sources and interpretations.

The artist and the canon

During the twentieth century, Bruegel has often been considered as an isolated phenomenon, a truly original artist without precedent. In his own day, however, he was sometimes seen as a successor to the enigmatic Netherlandish painter Hieronymus Bosch (fl.*c*.1480; d.1516). In his book on Netherlandish artists published in 1572, just three years after Bruegel's death, Lampsonius hailed him as a second Bosch. This reputation is echoed by Van Mander.

Bosch's painting *The Haywain* (Plate 129) belonged, along with other works by the artist, to the orthodox Catholic ruler Philip II of Spain; in the same way, Habsburg dukes later owned works by Bruegel. The work is a triptych

Plate 129 Hieronymus Bosch, *The Haywain*, 1490–1500, oil on panel, wings 134.9 x 45.1 cm, centre 134.9 x 100 cm, Museo del Prado, Madrid.

(painting on three panels). The left wing shows four scenes: *The Creation of Eve* (background), *The Fall* (middle ground), *The Expulsion from Paradise* (foreground), and *The Fall of the Rebel Angels* (top); the centre shows *The Haywaggon*; and the right wing shows a scene of hell. The picture is in part a compilation of small incidents, forming visual puzzles to be unravelled, but the overall theme seems to be a moral one. (These characteristics recur in Bruegel's work.) It depicts the avarice affecting all stratas of society, perhaps reflecting the proverb 'The world is a waggon of hay, everyone grabs what he can'.

Bosch's moralizing and religious paintings contain bizarre creatures and images, the significance of which it is often difficult to decipher. Although his work may seem unconventional and even heretical today, it was not marginal in his own day. It was popularized through prints and widely imitated by other artists. In following Bosch, therefore, Bruegel was adhering to an alternative canon to that of artists favouring the Italian style of art, such as Floris.

It seems that Bruegel was employed by Cock in the 1550s as a sort of imitator of Bosch. Bruegel's drawing *Big Fish Eat Little Fish* (Plate 130) appeared as an engraving under the name of Bosch. This was perhaps a clever marketing ploy on the part of Cock, for Bosch's work would probably have sold more

Plate 130 Pieter Bruegel the Elder, *Big Fish Eat Little Fish*, 1556, pen and ink, 22.6 x 29.7 cm, Graphische Sammlung Albertina, Vienna.

readily than that of the young and lesser known Bruegel. Three main features relate the drawing and the engraving to Bosch's work: first, the nightmarish repertory of images; secondly, the use of popular proverbs as the basis of art (below the engraving, the proverb is written in both Latin and Flemish); thirdly, the didactic, moralizing intention, which is made explicit by the father in the rowing boat in the foreground pointing out the moral to his small child, with, in the engraving, the word 'Ecce' (Behold) inscribed by the boy's head.

Bruegel's *Fall of the Rebel Angels* (Plate 131) is so like Bosch's work in its pictorial language that before Bruegel's signature was uncovered it was at one time attributed to Bosch. The rebel angels are represented as nightmarish monsters, but this effect is relieved by the brilliant colour and intensely naturalistic details such as their wings. It differs fundamentally from Floris's painting of the same subject, which hung on public view in Antwerp Cathedral (Plate 132). Floris flattered his patrons, the swordsmens guild, by emphasizing the Italian-style musculature of the sword-wielding angels, in marked contrast to Bruegel's insubstantial figures robed traditionally in monastic or liturgical-style dress. It is clear that here we encounter utterly different pictorial conventions and traditions.

Plate 131 Pieter Bruegel the Elder, *The Fall of the Rebel Angels*, 1562, panel, 116.8 x 161.9 cm, Musées des Beaux-Arts, Brussels.

Plate 132 Frans Floris, *The Fall of the Rebel Angels*, 1554, oil on panel, 303 x 220 cm, Koninklijk Museum voor Schone Kunsten, Koninklijke, Antwerp.

The painter of everyday life

According to Van Mander's 'Life of Bruegel', one of our main sources of information, Bruegel was renowned first and foremost as a painter of peasant scenes. Van Mander recounts that Bruegel used to frequent peasant festivities in the company of a merchant friend called Hans Franckert, and so was able to observe peasant customs and hence record faithfully peasant costume and activities in his paintings. Although Van Mander's assertion that Bruegel came from peasant stock himself has been dismissed as a writer's convention bearing little relation to the truth, plenty of country folk did migrate to the towns in the sixteenth century. In the 1550s and 1560s, Bruegel probably enjoyed the status of a well-to-do townsman, but his paintings bear witness to close knowledge of peasant customs, whether from family background or deliberate observation or both. His work is far from documentary in its approach, however. Until the mid-1970s, considerable numbers of peasant studies inscribed 'naar het leven' (done from life) and executed largely in pen and ink were ascribed to Bruegel, apparently proving a detached interest in peasant life. Most have now been reattributed to the Dutch artist Roelant Savery and dated to *c*.1600. Similarly, a series of small landscape engravings published by Cock in 1559–61, which record most faithfully and dispassionately the village landscapes of the Netherlands, are no longer assigned to Bruegel.

Bruegel's *Kermis at Hoboken* (Plate 133) represents the celebration of a church festival (kermis) in the village of Hoboken not far from Antwerp. It was engraved by Frans Hogenberg and the engraving would have reached a much

Plate 133 Pieter Bruegel the Elder, *Kermis at Hoboken*, 1559, pen and ink, 29.8 x 40.8 cm, The Courtauld Gallery, London.

wider audience than Bruegel's paintings (which seem to have been almost entirely private rather than public commissions). The inscription on the engraving, written not in Latin but in the more accessible Flemish, reads in translation: 'The peasants rejoice at such festivals to dance, jump and drink themselves drunk as beasts. They must have their kermises even if they fast and die of cold'. Both Guicciardini and Erasmus had cited the penchant for festivities as a characteristic of Netherlandish rural life. There is some evidence that Hoboken served as a sort of leisure retreat for Antwerp citizens – the beer was cheap and tourism at kermis time was common. It has been suggested that *Kermis at Hoboken* formed part of a campaign to persuade the new overlord, who took over in the year it was produced, to secure the continuation of the Hoboken kermises in the face of moral and legal objections. (In 1559, Philip II reissued an edict that tried to limit local kermises in order to cut down on tourism and reduce disorder.)

1 **Try to identify the various small figure groups or incidents that make up *Kermis at Hoboken*. Can they tell us whether Bruegel took a positive, neutral, or negative view of peasant festivities?**

2 **Can you think of reasons why Bruegel might have wished to represent peasant festivities and why people would have wanted to buy these representations?**

Discussion

1 You may have noticed some of the following groupings.

The religious procession in the left background, people entering the church or kneeling at the shrine outside it.

Archers (left foreground).

Dancing and musicians (right).

People performing a play (back left).

Figures carousing around the inn (left foreground).

The driver of the horse and cart drinking out of a jar.

Lovers (in the cart, behind the tree immediately behind the horse and cart).

Men urinating or defecating (against the inn, against the church wall, in the right background).

You probably had some difficulty in deciding whether these things indicate a positive or a negative view for, of course, this depends entirely upon your viewpoint. How then do we uncover Bruegel's own view?

2 You may have thought of some of the following reasons.

Vicarious enjoyment of a kermis.

Nostalgia on the part of townsfolk for country life.

Nationalist feeling whereby popular culture is a thing to be preserved and recorded.

Moral condemnation of popular behaviour.

City folk wishing to assert the superiority of urban culture by laughing at uncouth peasant customs and manners.

◆◆◆

The viewpoint we select radically affects the sort of artist we take Bruegel to be: someone who simply enjoyed having a good time; an artist harking back to his (possible) peasant origins; a political activist; a moralizer; a townsman with a superiority complex. Perhaps the viewpoint we feel least comfortable with today is that of the superior town dweller making fun of the peasants. The inclusion of urinating or defecating peasants might indeed be intended to show uncouth behaviour as an object of ridicule. On the other hand, Bruegel could, like other contemporary artists, have poked fun much more obviously by exaggeration, distortion of figures, and multiplying distasteful incidents such as vomiting and brawling, but he does not do so.

Uncouth behaviour is even less in evidence in a later painting by Bruegel, *The Peasant Wedding* (Plate 134). Nothing is known about the original patron, but the painting later formed part of the Austrian royal collection. Bruegel's pictorial tactics are very different here. The viewpoint is much lower, and the focus is on fewer, larger figures presented more as a single, coherent group as opposed to the compilation of small groups characterizing the *Kermis at Hoboken*. Rather than conveying a correspondingly more obvious, unified meaning, problems in interpretation once more abound.

The wedding banquet is set in a barn partly filled with hay. The guests, seated around a trestle table, are served bowls of food from a door used as a huge tray. Ale is drunk directly from large jugs, several of which are being filled in the lower left of the picture. The bride seems to be the woman sitting smugly in front of an improvised cloth of honour, which is attached to the wall of

Plate 134 Pieter Bruegel the Elder, *The Peasant Wedding*, c.1568, oil on oak panel, 114 x 164 cm, Kunsthistorisches Museum, Vienna.

hay with a pitchfork. It is not at all clear who her husband is, but the elderly couple seated to her left (our right) may be her parents. If so, this is interesting, for the man wears a rich gown with a fur collar. The guests, although obviously peasants, do not seem impoverished; there are texts and illustrations printed on paper attached to the back of the bench, for example. The man in black at the extreme right of the painting seems better dressed and carries a sword instead of a knife; he has sometimes been taken to be Bruegel's self-portrait. The adjacent monk is presumably also of higher social status. Peasant customs seem to be represented in the two last harvest sheaves hung on the wall and the paper crowns hung above the bride. The waiter in blue has laces in his hat, a reference to the traditional wedding game in which young men stole laces from the women. The steward dispensing wine in the lower left of the picture, conversely, is very reminiscent of artistic representations of a biblical theme, the Marriage at Cana (John 2:1–11).

How are we to understand this Bruegel painting? As a simple record of traditional peasant festivities? As an exercise in moral censure (bagpipes are often used as a symbol of lust and the peacock feather in the child's hat can signify pride)? More than anything it is Bruegel's humour, what may be described as his 'comic mode', that discourages such straightforward interpretations. Van Mander says of Bruegel that one sees few pictures by him which a spectator can contemplate seriously and without laughing, but such humour was not necessarily intended simply to mock. Sixteenth-century humanists revived the classical concept of satire designed not simply to amuse but also to educate. Bruegel's fellow countryman Erasmus resorted to much the same device in literature. So should Bruegel's work be taken as a humanist and humorous comment on human behaviour?

The artist as humanist intellectual

In the 1930s, the art historian A.E. Popham noticed that an obituary to Bruegel was to be found in the so-called *Album amicorum* (*Album of Friends*; now in Pembroke College, Cambridge) of Ortelius. Ortelius's circle included Cock and another famous humanist printer, Christophe Plantin (1514–89), who sometimes sold Cock's prints. Other humanists registered in the *Album amicorum* may have been known to Bruegel. This represents a very different artistic status from that of the painter of peasant origins described by Van Mander. The obituary, which is divided into three parts, is worth quoting in full:

> That Pieter Bruegel was the most perfect painter of his century noone, except a man who is envious, jealous or ignorant of that art, will ever deny. He was snatched away from us in the flower of his age. Whether I should attribute this to Death who may have thought him older than he was on account of his supreme skill in art, or rather to Nature who feared that his genius for dextrous imitation would bring her into contempt, I cannot easily say.

> Abraham Ortelius dedicated [these lines] in grief to the memory of his friend.

> The painter Eupompus,[3] it is reported, when asked which of his predecessors he followed, pointed to a crowd of people and said it was Nature herself, not an artist, whom one ought to imitate. This applies also to our friend Bruegel, of whose works I used to speak as hardly of works of art, but as of works of Nature. Nor should I call him the best of painters but rather the very nature [and substance] of painters. He is thus worthy, I claim, of being imitated by all of them.

3 See the historical introduction, page 17.

Bruegel depicted many things that cannot be depicted, as Pliny says [likewise] of Apelles.[4] In all his works more is always implied than is depicted. This was also said [by Pliny] of Timanthes.[5] Eunapius in the Life of Iamblichus.[6] Painters who are painting handsome youths in their bloom and wish to add to the painting some ornament and charm of their own thereby destroy the whole character of the likeness, so that they fail to achieve the resemblance at which they aim, as well as true beauty. Of such a blemish our friend Bruegel was perfectly free.

(Stechow, *Northern Renaissance Art*, pp.37–8)

This epitaph draws on ancient writers to present the artist as a creator to rival nature itself. Ortelius seems at pains, however, to stress that Bruegel's approach involves not the idealized beauty associated with Italian Renaissance theory, but a realistic attention to nature. This view is echoed in Van Mander's preamble to his 'Life of Bruegel': 'Nature found and struck lucky wonderfully well with her man – only to be struck by him in turn in a grand way.' He later remarks that during his travels in the Alps Bruegel 'swallowed all those mountains and rocks which, upon returning home, he spat out again onto canvases and panels, so faithfully was he able, in this respect and others, to follow nature' (*Lives*, pp.190–4). Ortelius refers not simply to landscape, however – the obvious convergence of interest between Bruegel and his own activities as a mapmaker – but to figure painting as well. Ortelius champions his friend using the classical sources beloved of humanists, thereby emphasizing Bruegel's humanist credentials, apparently against all odds: Bruegel's figures may lack the classical proportions associated with ancient art, but they still gain classical sanction by virtue of their realism.

Bruegel's known contacts with humanists have led to the speculation that his artistic approach was conditioned by the same classical sources that inspired his friends. Reasonable as this suggestion appears, it should not necessarily be accepted without question. We do not know for sure how well Bruegel knew Latin (the Latin captions on some of his prints were almost certainly added by the publisher rather than Bruegel himself) and might question how much time he, as a busy artist, would have had to comb through erudite classical texts.

The Fall of Icarus (Plate 135) is one of very few surviving classical subjects painted by Bruegel, although the picture is heavily restored and some do not believe that Bruegel painted it at all. The story recounted is drawn from Ovid's *Metamorphoses*, one of the more popular classical texts, and tells of the tragic end of Icarus when he flew too close to the sun on artificial wings bound together with wax. Part of Ovid's account corresponds so closely with Bruegel's painting that it may be taken as evidence that Bruegel read the actual text in formulating his work:

Some fisher, perhaps, plying his quivering rod, some shepherd leaning on his staff, or a peasant bent over his plough handle caught sight of them as they flew past and stood stock still in astonishment, believing that these creatures who could fly through the air must be gods.

(Ovid, *Metamorphoses*, p.185)

4 *The Elder Pliny's Chapters*, p.133.

5 *The Elder Pliny's Chapters*, p.117.

6 Eunapius' *Lives of the Philosophers and Sophists* was published by Ortelius's friend Hadrianus Junius in Antwerp in 1568.

Plate 135
Pieter
Bruegel the
Elder, *The
Fall of Icarus,*
*c.*1558, oil on
canvas, 73.5
x 112 cm,
Musées
Royaux,
Brussels.

Although the fisherman, shepherd, and ploughman are duly included, they take no notice whatever of Icarus falling into the sea. The obvious message here is that great events pass unnoticed, echoed in the popular proverb 'No plough is stopped for a dying man', but both Erasmus and *Ovid Moralisé*[7] take the story to be a warning against ambition. As such, the fisherman, shepherd, and ploughman become exemplars of humility, keeping their station in life in contrast to the vainglorious Icarus. Either way, Bruegel unites a classical text, peasant subject-matter, and perhaps oral proverb to a moralizing end, which is consistent with classical writers such as Seneca, who was most favoured by northern humanists.

Children's Games (Plate 136) is a compendium of games and imitative play in which the associations appear contemporary rather than classical. An unusually obvious reference to the Italian Renaissance is included in the sweeping perspectival construction. This resembles an illustration from Serlio's treatise on Italian architecture, which was translated in 1553 by Pieter Coecke, whom Van Mander names, rather dubiously, as Bruegel's teacher. *Kinderspel* (children's games) was a derogatory term in Flemish literature, and the proverb 'As the old sing, so pipe the young' might suggest once again a moral message, that children learn their bad behaviour from their parents.

Northern humanists were fascinated by the moral wisdom of their classical forebears, and one manifestation of this fascination was the publication of proverb collections in which classical and contemporary sayings were considered in tandem. The most famous such compilation was the *Adages*, first published in 1500 by Erasmus, to introduce classical wisdom in an accessible way. Bruegel's *Netherlandish Proverbs* (Plate 137) seem more obviously derived from oral than written classical sources, but are otherwise conceived with a wit and didacticism very much in the spirit of Erasmus.

[7] A popular didactic version of Ovid's *Metamorphoses* dating from the fourteenth century, which expounds the moral lessons of the various stories.

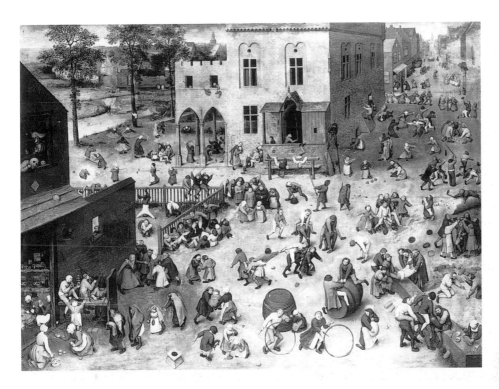

Plate 136 Pieter Bruegel the Elder, *Children's Games*, 1560, oil on oak panel, 118 x 161 cm, Kunsthistorisches Museum, Vienna.

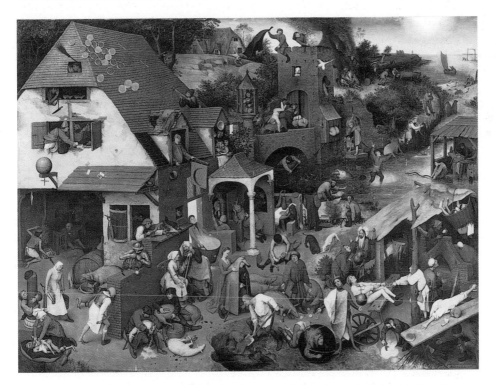

Plate 137 Pieter Bruegel the Elder, *Netherlandish Proverbs*, 1559, panel, 116.8 x 162.9 cm, Gemäldegalerie, Staatliche Museen zu Berlin Preussischer Kulturbesitz. Photo: Jörg P. Anders.

Both these paintings seem designed as amusing visual puzzles, which are consistent with the classically inspired didactic and, most significantly, ironic approach of northern humanists, if less directly with specific classical sources.

Conclusion

The meanings of Bruegel's paintings are notoriously difficult to uncover. The discovery of Bruegel's humanist contacts makes it tempting to classify him as a humanist intellectual. Nevertheless, it seems to me a great mistake to see Bruegel, a relatively prolific artist during his brief career, as spending more time at his books than his painting, as Lombard is said to have done. We should probably not look too hard for erudite scholarly references in his work. To his humanist friends at least he was an artistic creator worthy to be compared with the great classical painters so well known from the writings of Pliny. Nevertheless, the absence of classical references and the use of primarily oral rather than classical proverbs suggest that his humanism must have been one of attitude rather than form.

The elevated view of art that was proposed in *The Life of Lambert Lombard* (see Case Study 4) seems poles apart from Bruegel's peasant artist in the *Artist and Connoisseur* or his peasant paintings, but interestingly *The Life of Lambert Lombard* was dedicated to Ortelius, who wrote the classically inspired obituary to his friend Bruegel (see page 180). Lampsonius was also a friend of Cock, publisher of Bruegel's prints, and it was he who wrote an elegy on Cock's death in 1572. Perhaps this, and the fact that Jonghelinck hung work by both Floris and Bruegel in his country home, suggest complementary rather than opposing humanist approaches.

We also need to ask what kind of market Bruegel was catering for in his prints and paintings. There is every reason to believe that Jonghelinck, Cardinal Granvelle, and Ortelius, all of whom owned works by Bruegel, would relish a humanist viewpoint, but were those buying his prints necessarily so well versed in the classics? According to one estimate, the range of prices fetched by prints was very similar to that fetched by published books. At the very least, then, Bruegel's customers were modestly affluent and educated – the Latin or Flemish captions on his prints also suggest as much. Whilst not necessarily excessively wealthy, some of his customers might well have been scholarly. After all, a guildsman could decide to spend his money on one of Plantin's editions of the classics, and the occupations of some of the friends listed in Ortelius's *Album amicorum* suggest that guildsmen did just that. Bruegel's audience was probably rather mixed, then, more middle class than aristocratic, and urban rather than rural, eminently capable of appreciating the wit and meaning of a work of art although less certainly any classical allusions.

For us to see what Bruegel's contemporaries saw in his paintings and prints, we need to find out about the varied mind sets of the time – humour, class-consciousness, morality, political affiliation, what was a common and what was an obscure visual or literary reference. It is precisely the elusiveness of meaning, and the fascination it engenders, together with Bruegel's consummate skill as a painter, that secures his place in the canon today.

Sources

Carroll, M. (1987) 'Peasant festivity and political identity in the sixteenth century', *Art History*, vol.10, no.3, pp.289–302.

Freedberg, D. (1989), 'Allusion and topicality in the work of Pieter Bruegel: the implications of a forgotten polemic', in D. Freedberg, *The Prints of Pieter Bruegel the Elder*, exhibition catalogue, Ishibashi Museum of Art, Japan, pp.53–65.

Grossman, F. (1973) *Pieter Bruegel*, London, Phaidon.

Gibson, W. (1991) 'Bruegel and the peasants: a problem of interpretation', *Pieter Bruegel the Elder: Two Studies*, Franklin D. Murphy Lectures XI, Kansas, pp.11–52.

Hindman, S. (1981) 'Pieter Bruegel's *Children's Games*: folly and chance', *Art Bulletin*, pp.447–75.

Moxey, K. (1989) 'Pieter Bruegel and popular culture', in D. Freedberg, *The Prints of Pieter Bruegel the Elder*, exhibition catalogue, Ishibashi Museum of Art, Japan, pp.42–52.

Ovid (1995) *Metamorphoses*, trans. and intro. M.M. Innes, Harmondsworth, Penguin.

Riggs, T.A. (1977) *Hieronymus Cock (1510–1570): Printmaker and Publisher in Antwerp at the Sign of the Four Winds*, PhD thesis, Yale University, 1971, Ann Arbor series, New York.

Stechow, W. (1989) *Northern Renaissance Art 1400–1600: Sources and Documents*, Evanston, Northwestern University Press.

Sullivan, M. (1991) 'Bruegel's proverbs: art and audience in the Northern Renaissance', *Art Bulletin*, pp.431–66.

Sullivan, M. (1994) *Bruegel's Festive Peasants: Art and Audience in the Northern Renaissance*, Cambridge University Press.

The Elder Pliny's Chapters on the History of Art (1896) ed. E. Sellers and trans. K. Jex-Blake, London (reprinted Chicago, 1968, 1977).

Van Mander, K. (1994) *The Lives of the Illustrious Netherlandish and German Painters*, ed., trans., and intro. H. Miedema, Doornspijk, Davaco.

PART 3
CHANGING INTERPRETATIONS

Introduction

EMMA BARKER

So far, we have been exclusively concerned with the status of artists in the sixteenth century and earlier. In Part 3, we will explore the shifting reputations of two artists of a slightly later period. At first sight, it might seem that our examples have almost nothing in common with each other. The mid-seventeenth-century Dutch artist Johannes Vermeer is renowned for his quiet, domestic interiors usually depicting only one or two figures, whilst the early eighteenth-century French artist Jean-Antoine Watteau's most distinctive achievement is the *fête galante*, a type of painting that characteristically depicts a large number of people enjoying themselves in a landscape. As the following case studies reveal, however, the paintings of Vermeer and Watteau have certain features in common. Both, for example, often depict figures who look away from the viewer, making it difficult to read their expressions. These parallels can partly be explained by a shared artistic tradition. Watteau was Flemish in origin and also very familiar with Dutch painting (the Netherlands had become divided in the later sixteenth century when the more northern provinces broke off to form a new nation, generally known as Holland).

These points of contact have important ramifications for the two artists' status. Although both Vermeer and Watteau achieved a certain success in their own lifetimes, they were excluded from the highest honours of their profession, since neither was a history painter. As we saw in Case Study 4, the idea that history painting (that is, the expressive, classically inspired *istoria* on the Italian model) represented the highest pinnacle of art was already well established in the Netherlands by the early seventeenth century. By the end of the seventeenth century, the implied inferiority of every other type of painting had been reinforced by art theorists associated with the French Royal Academy of Painting and Sculpture (the Académie royale de peinture et de sculpture, founded in 1648).[1] Thus, Watteau's friend Comte de Caylus could not help but judge his work as deficient by academic standards (see Case Study 9). Watteau paid no attention, Caylus explained, to the 'qualities of arrangement, composition and expression in the works of the great history painters' ('Life of Watteau', reprinted in Goncourt, *French Eighteenth-Century Painters*, p.24).

[1] On the foundation of the French Academy, see Linda Walsh, 'Charles Le Brun, "art dictator of France"', in Perry and Cunningham, *Academies, Museums and Canons of Art* (Book 1 in this series).

Plate 138 (Facing page) Jean-Antoine Watteau, detail of *Venetian Festivities* (Plate 180).

What accounts for the distinctive artistic practice of both Vermeer and Watteau is not so much the legacy of an alternative, craft-based tradition as the demands of an increasingly competitive market. These conditions encouraged seventeenth-century Dutch painters to specialize in a particular genre (for example, portraiture, still life, or landscape) so that they had a readily identifiable and easily marketable product. As we will see in Case Study 8, Vermeer seems to have enjoyed greater financial security than many artists, but conformed to standard practice in concentrating on domestic scenes. These and other scenes of everyday life (what has subsequently come to be described simply as 'genre painting') were produced in large quantities during this period. Similarly, the genre of the *fête galante* was shaped by Watteau's immersion in the highly commercial culture of hack artists, decorative painters, and picture sellers, described in Case Study 9. The integration of art into the market in early eighteenth-century Paris is vividly evoked by the shop sign that Watteau painted for the art dealer Edmé Gersaint, which depicts an elegant clientèle examining works of art on sale. Although designed as an advertisement, it apparently only hung outside Gersaint's shop for a short while (Plate 139).

As well as having a significant impact on artistic practice, the rise of the art market also served in the long run to modify conceptions of aesthetic value. Dealers such as Gersaint catered to the taste of wealthy collectors who increasingly preferred to have appealing northern genre paintings hanging on their walls rather than high-minded history paintings of the Italian school. By the 1770s, seventeenth-century Dutch paintings had become the most sought after and expensive works of art on the market. The prices paid for Watteau's paintings had also undergone massive inflation over the previous

Plate 139 Jean-Antoine Watteau, *Gersaint's Shopsign*, 1721, oil on canvas, 182 x 307 cm, Nationalgalerie, Staatliche Museen Preussischer Kulturbesitz, Schloss Charlottenburg, Berlin. Photo: Jörg P. Anders.

50 years (see Case Studies 8 and 9). Clever promotion by dealers reinforced a shift away from the scholarly approach of an old-style collector like Caylus to a new set of concerns associated with this vogue for Dutch genre and recent French painting. Instead of assuming that the beauty of a particular painting was what mattered most, the art market foregrounded attribution as its principal concern. The ability of the dealer to identify the 'hand' or 'touch' of different masters became crucial once collectors started to 'buy names, instead of works' as one such dealer-connoisseur wrote in 1764 (quoted in Pomian, *Collectors and Curiosities*, p.154). The emergence of this market-based expertise provided the necessary precondition for the 'rediscovery' of the hitherto little-known Vermeer (see Case Study 8).

It is often argued that the idea of the artist-genius is bound up with the emergence of an open market in works of art, which liberates artists from the requirements of patrons. More specifically, we can identify a preoccupation with the unique 'touch' of the artist as the point of connection between commercial realities and the mythology of the artist. There is a curious slippage between the question of authenticity in the sense of the correct attribution of a work of art to a particular 'hand' and that of authenticity in the sense of the artist's sincerity in expressing himself in his work. This can be most clearly demonstrated by reference to another seventeenth-century Dutch artist, Rembrandt van Rijn (1606–69), who came to be regarded in the nineteenth century as the quintessential artist-genius (for example, by the critic Théophile Thoré, who is discussed in Case Study 8). He continues to be revered as a great artist and a man of profound humanity. This perception of Rembrandt depends fundamentally on his characteristically loose handling of paint, which seems utterly individual and thus powerfully evokes the artist's human presence (Plate 140).[2] However, the aesthetic and even spiritual value that we accord to the brushmark testifying to the 'man behind the work' is inextricably bound up with crude monetary value: the huge price of an 'authentic' Rembrandt.

In the following case studies, we explore the difficulties associated with interpreting an artist's work as the expression of his personality. As was noted in the historical introduction, such an approach fails to take account of other factors that can contribute to the shaping of works of art. As in the case of the biography of Watteau by Edmond and Jules de Goncourt, it can also involve simplification and distortion in order to create a perfect fit between the life and the work (see Case Study 9). In other cases, such as Lawrence Gowing's study of Vermeer, the conception of art as self-expression may give rise to the invention of a wholly fictitious personality for an artist (see Case Study 8). In fact, Gowing's withdrawn, yearning Vermeer is really quite similar to the aloof, morose Watteau evoked by the Goncourts: both texts can be said to perpetuate the Romantic stereotype of the melancholy, isolated artist. As this suggests, it is possible that 'the artist' may be less a historical individual with a distinct personality than a standard construct produced by traditional forms of art-historical writing in order to 'explain' works of art.

[2] By the same criterion, the smooth, highly finished surfaces of paintings in the academic tradition has come to be criticized for its impersonality and dismissed as inauthentic; on this point, see Emma Barker, 'Academic into modern: Turner and Leighton', in Perry and Cunningham, *Academies, Museums and Canons of Art* (Book 1 in this series).

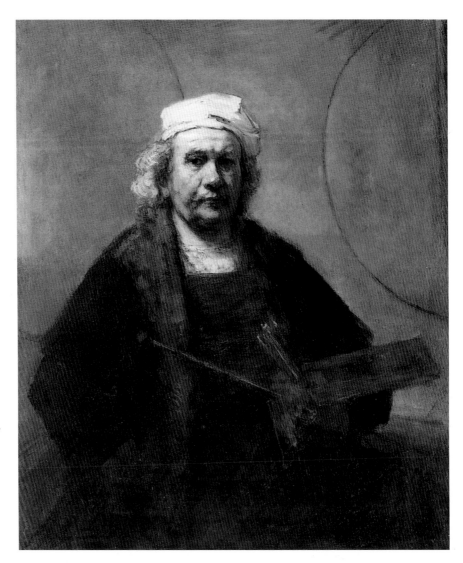

Plate 140
Rembrandt van
Rijn, *Self-portrait*,
c.1665, oil on
canvas,
114 x 94 cm,
Kenwood,
London, The
Iveagh Bequest.
Photo: English
Heritage Photo
Library.

Ultimately, it can be suggested that this theory of art as self-expression serves
to empower the art critic or historian who claims a special insight into the
mind of the artist and expounds what is supposedly the true meaning of his
work. As the French writer Roland Barthes (1915–80) argues in his essay 'The
death of the author', the identification of the personality of the author as the
work's point of origin closes off the possibility of any readings apart from
those proposed by an interpreter who assumes a position of authority on
this subject (the implications of this critique of authorship for art-historical
practice are discussed in Case Study 9). In the case of Watteau, the Goncourts
not only asserted their authority over the interpretation of his work but also
succeeded in imposing a particular view of eighteenth-century French art as
a whole, one that continues to have wide currency. Ignoring the continuing
high status of history painting, they claimed that 'Watteau was the dominant
master to whose style, taste and vision the whole of eighteenth-century
painting was in thrall' (*French Eighteenth-Century Painters*, p.53). This
promotion of Watteau needs to be understood with reference to their nostalgia

for the aristocratic society of pre-Revolutionary France, which they found evoked in the *fête galante*. Their conservative views shaped their taste in painting, just as Thoré's interest in seventeenth-century Dutch art and consequent 'rediscovery' of Vermeer was a function of his progressive outlook. Today, it seems inconceivable that either artist's reputation should ever again be subject to the vagaries of taste and ideological differences, but this perhaps says as much about our culturally relative, time-bound perspective as it does about their aesthetic merit.

References

Barthes, R. (1977) 'The death of the author', in *Image – Music – Text*, London, Fontana, pp.142–8.

Goncourt, E. and J. de (1948) *French Eighteenth-Century Painters*, London, Phaidon.

Perry, G. and Cunningham, C. (eds) (1999) *Academies, Museums and Canons of Art*, New Haven and London, Yale University Press.

Pomian, K. (1990) *Collectors and Curiosities: Paris and Venice, 1500–1800*, London, Polity Press.

The making of a canonical artist: Vermeer

EMMA BARKER

Johannes Vermeer of Delft (1632–75) is now generally agreed to rank among the very greatest of artists. His paintings are some of the most highly valued and admired works of art in the world. However, Vermeer presents many problems for the art historian. The main puzzle, according to Svetlana Alpers, is how these paintings, 'mostly concerned with domestic life in the 1660s in a city of 25,000 in the province of Holland, became a central value to European and … American culture. How is it that Vermeer's interests and skills attract so many and seem so valid in a world so different from his own?' ('The strangeness of Vermeer', p.64). Those who take the greatness of Vermeer for granted are faced with a slightly different question: how can it be that he did not enter the canon until some 200 years after his death?

Vermeer's modern reputation was established only at the end of the nineteenth century. Even in the middle of the century he remained very little known; for example, no figure of Vermeer appears in the frieze of famous artists on the Albert Memorial in London.[1] In fact, the frieze omitted all Dutch artists other than Rembrandt. As we will see, the new appreciation of Vermeer was closely bound up with that of Dutch painting as a whole. Since the nineteenth century, his work has often been discussed not just in the context of Dutch art but with reference to celebrated artists of every time and place. This tendency was exemplified by 'In the Light of Vermeer', an exhibition that took place in Paris and The Hague in 1966. It brought together paintings from the fifteenth century to the twentieth, ranging from the work of Giovanni Bellini (c.1435–1516) to that of Paul Cézanne (1839–1906) and beyond, on the grounds that they all had something in common with Vermeer. Evidently, as Alpers observes, modern esteem for Vermeer has very little to do with the original context in which he worked.

Various explanations have been put forward to account for the new interest in Vermeer that emerged during the second half of the nineteenth century. It is sometimes said, for example, that the invention of photography made it easier to appreciate some of the distinctive effects in his paintings (this argument is based on the belief that he made use of a mechanism called the camera obscura[2]). It has also been claimed that we owe Vermeer's 'rediscovery' to new developments in mid-nineteenth-century French painting, Realism and Impressionism, for which his work seemed to provide a precedent. This case study will take a critical look at Vermeer's reputation as an artist, especially in the centuries since his death, with the aim of assessing exactly how and why he came to attain his current status as one of the greatest artists of all time. To start with, however, we need to establish the ways in which his work is valued today.

[1] See Colin Cunningham, 'The Albert Memorial', in Perry and Cunningham, *Academies, Museums and Canons of Art* (Book 1 in this series).

[2] The camera obscura is a box with a hole at one end, with a lens mounted over it, which admits light and allows an image to be projected onto a semi-transparent screen at the opposite end; it produces distinctive optical effects, which are not visible to the naked eye, such as the blurring of highlights. An artist could trace the image and use the resulting drawing as the basis of a composition.

Viewing Vermeer

Among the works of Vermeer rediscovered in the late nineteenth century was his *Girl with a Pearl Earring* (Plate 141). It first appeared at a sale in The Hague in 1881, where it was bought for a modest sum by a private collector who, on his death in 1902, left his collection to the Royal Cabinet of Paintings at the Mauritshuis. The *Girl with a Pearl Earring* soon become renowned as the 'Dutch Mona Lisa' and has since remained perhaps the single most

Plate 141 Johannes Vermeer, *Girl with a Pearl Earring*, 1665,[3] oil on canvas, 44.5 x 39 cm, Royal Cabinet of Paintings, Mauritshuis, The Hague.

[3] The dates given in the plate captions in this case study are estimates made by art historians and reflect the conception of the development of an artist's style referred to in the historical introduction rather than documentary fact.

popular painting by Vermeer. Its appeal depends on the way that the girl seems to interact with the viewer. Set against a blank black background and illuminated by light falling from the left, her face stands out with startling clarity. Her big eyes (notice the highlights on her pupils) and half-open mouth, the sense that she has been caught in the act of turning her head, make her seem extraordinarily vivid and alive. We can almost believe that she is looking back at us.

I now want us to look at the *Woman in Blue Reading a Letter* (Plate 142), which in 1885 became the first Vermeer to enter the Rijksmuseum in Amsterdam. It is in fact far more typical of the artist than the *Girl with a Pearl Earring*.

Please compare the two paintings, noting the compositional differences between them and how (if at all) the *Woman in Blue* relates to you, the viewer. Where is the light coming from? What kind of letter do you think the woman is reading? Do you notice anything about her figure? Finally, cover over the dimensions given in the caption and make a rough guess as to the size of the painting (big or small?).

Discussion

The most fundamental difference is that, whereas in the *Girl with a Pearl Earring*, we see only the head and shoulders, the *Woman in Blue* is shown almost in her entirety, with only her feet concealed from view. Unlike the girl, moreover, she is located in a well-defined domestic interior, furnished with a table and chairs. Although the figure here appears against a white wall rather than a plain ground, she is again lit from the left, in this case, we assume from an unseen window. Instead of standing out, the woman's head almost seems to merge with the soft brown of the map hanging on the wall behind her. Also, she does not face us but is set at a right-angle to the picture plane, so that we see her only in profile and cannot easily read her expression. Her eyes are lowered so that she does not relate to us but rather to whoever wrote the letter, perhaps her husband or lover. Her rapt attention certainly indicates a love letter. Her bulky shape may have suggested to you that she is pregnant. You probably guessed that the painting is quite large but it is actually rather small, hardly bigger than the *Girl with a Pearl Earring*.

◆◆

It is in fact a common experience for gallery visitors to find that a painting by Vermeer is much smaller than photographs had led them to expect. The characteristic broad, simplified outlines of his figures create a grand, even monumental effect which can be deceptive. The massive solidity of the *Woman in Blue* is a case in point. This painting also exemplifies Vermeer's mastery of subtle effects of light, as you can see by observing the tonal variation at the right where the wall is partly shadowed and where it reflects the blue of the woman's jacket and the chair on the left. The overall impression is one of perfect order and calm. Everything seems absolutely in the right place, as if no movement is possible. Notice that the woman's hands are exactly on a level with the black rod at the bottom of the map. She forms the central axis of a framework of vertical and horizontal lines. The painting is in fact composed almost entirely of roughly rectangular blocks of white, blue, and

Plate 142 Johannes Vermeer, *Woman in Blue Reading a Letter*, 1664, oil on canvas, 46.5 x 39 cm, Rijksmuseum, Amsterdam.

yellow. It is stripped-down and controlled even by Vermeer's standards. The formal discipline of his work has sometimes been compared to the grid compositions of another Dutch artist, Piet Mondrian (1872–1944) (Plate 143). In this respect, Vermeer can be celebrated for being a kind of abstract artist without knowing it.

However, the *Woman in Blue* also offers a strong human interest, although of a different kind from the *Girl with a Pearl Earring*. The viewer can discover an intense fascination in the very privacy and inaccessibility of the experience represented. Not only are we ignorant of the contents of the letter, but the woman's remoteness is reinforced by the table and chair in the foreground, which form a barrier separating her from us. At the same time, several cryptic details offer scope for speculation about her situation. Might there be other letters in the open box on the table? Does the map hold some special significance? A now widespread assumption about the *Woman in Blue* seems to have originated with another compatriot of Vermeer, Van Gogh, who described her as 'a dignified and beautiful Dutch woman who is pregnant' (Slatkes, *Vermeer*, p.59). This idea reinforces the impression that her apparent composure conceals deep feelings and, more generally, fosters a sense of her living presence. Edward Snow, an American literary critic, asserts that her pregnancy 'becomes an emblem for the fullness of inner life that requires our acceptance of her as other than ourselves' (*A Study of Vermeer*, p.6).

On the basis of our analysis of the *Woman in Blue*, we can isolate two distinct elements that help account for Vermeer's current reputation. He is celebrated, on the one hand, for the formal beauty of his design and, on the other, for his psychological insight and human feeling. It might perhaps be questioned whether these are strictly compatible. Certainly, some commentators have discerned something rather inhuman in the way that Vermeer takes the stuff of familiar life and freezes it into exquisite arrangements of colour and light. The quiet composure of his figures, who almost invariably interact neither with the

Plate 143 Piet Mondrian, *Composition with Red, Yellow and Blue*, 1921, oil on canvas, 40 x 35 cm, Haags Gemeentemuseum, The Hague. © Mondrian/Holtzman Trust, c/o Beeldrecht, Amsterdam, Holland and DACS, London, 1999.

viewer nor (where there is more than one) with each other, has been said to make them virtually indistinguishable from the surrounding objects.[4] The English painter and art critic Lawrence Gowing shared the view that Vermeer sought above all to depict the surface appearance of things, but denied that this apparent impersonality betrays any lack of feeling. On the contrary, 'the zone of emotional neutrality in which Vermeer suspends the human matter in his pictures is infused with the profoundest personal meaning' (*Vermeer*, p.26). In Gowing's book, the artist appears as a painfully reserved and diffident man, who is nevertheless irresistibly drawn towards humanity as it is embodied in feminine form (Snow has something similar to say in the quotation cited above).

However, it is important to stress that such interpretations are no more than conjecture. Neither Gowing nor Snow offers any documentary evidence for what they say about Vermeer. The argument that the paintings reveal his individual approach to the world, his unique personality, is logically flawed. To deduce what the artist must have been like from his paintings and then to interpret them in the light of this supposed character is a wholly circular process. Equally, the whole problem of interpreting Vermeer's paintings is here conceived in distinctively modernist terms. It is by no means clear that form and content could have been understood in the mid-seventeenth century as distinct categories in the way that we now understand them in the twentieth. Whatever the interest of comparing Vermeer to Mondrian or any other modern artist, it does nothing to help us understand the kinds of meaning that his paintings might have had in his own period. Similarly, the 'human interest' they have for a modern viewer tends to obscure their original cultural context. These are points that we will need to bear in mind as we consider how Vermeer came to be rediscovered and the interpretations constructed by earlier admirers of his work.

Vermeer in his time

First, we need to establish what kind of status Vermeer enjoyed in his own lifetime. To do so is not entirely easy. Much of the fascination of Vermeer derives from the enigma that has surrounded his life and work since the time of his rediscovery. In the nineteenth century, ignorance extended even to the correct form of his name; he was usually called Jan Van Der Meer. Since then, archival research has brought much new information to light but we still have no answers to some crucial questions, such as the name of the master under whom he trained. Part of the problem is that such documentation that does exist is of a legal, impersonal character and provides us only with the bald facts of his life.[5]

Within the framework of academic art theory, Vermeer could have been found wanting because he did not practise the noble genre of history painting. In fact, he seems to have begun his career by painting a number of mythological

[4] E.H. Gombrich, for example, says that Vermeer's paintings are 'really still lifes with human beings' (*The Story of Art*, p.433).

[5] The most important study of Vermeer based on these archival sources is Montias, *Vermeer and his Milieu: A Web of Social History*.

and biblical subjects but soon to have abandoned these to specialize in domestic scenes. (Part of the problem in studying Vermeer is that only two of his paintings are dated, so that all attempts to establish a detailed chronology of his artistic development are largely a matter of conjecture.) Nevertheless, this does not mean that he renounced the intellectual and moral ambitions of the history painter. The domestic interior could serve as the setting for serious and complex ideas, although this only becomes overt in the *Allegory of Faith* (Plate 144), which also differs from Vermeer's other paintings in its strongly Roman Catholic iconography. The artist (who had converted to Catholicism on his marriage in 1654) derived most of the elements of the allegory, such as Faith's hand on her heart and the crushed snake on the floor, from Ripa's *Iconologia.*[6]

See pg 83-85

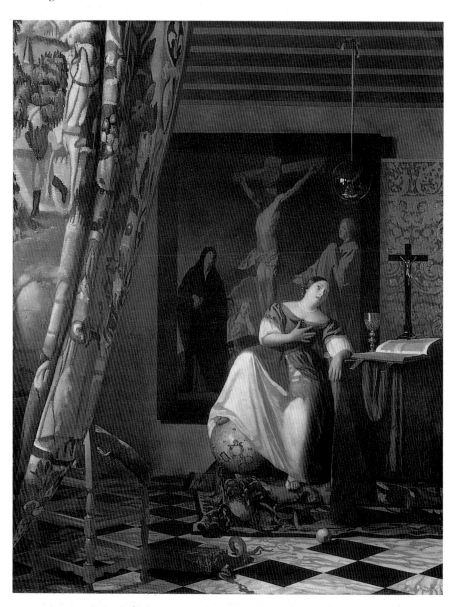

Plate 144
Johannes Vermeer, *Allegory of Faith*, 1672, oil on canvas, 114.3 x 88.9 cm, Metropolitan Museum of Art, New York. The Friedsam Collection, Bequest of Michael Friedsam, 1931 (932.100.18).

[6] For Ripa, see Case Study 2, pages 83 and 85.

For seventeenth-century Dutch artists, specialization in a specific genre was a necessary response to the demands of a highly competitive art market.[7] This had the advantage of allowing them to be much more productive than if they had worked in several genres. Vermeer, however, seems to have been a very slow worker, producing relatively few, carefully realized works over the course of more than 20 years. Although it is clear that a number of his paintings have been lost since the seventeenth century, it is unlikely that the total could have been very much more than the approximately 35 works known today. No fewer than 21 paintings by the artist, most of which can be identified with surviving works, appeared in a sale held in Amsterdam in 1696. Thanks to the researches of John Michael Montias, we now know that most of these paintings had been inherited by a Delft bookseller, Jacob Dissius, from his wealthy father-in-law, Pieter van Ruijven. Montias has argued that Vermeer worked principally for van Ruijven, who advanced him money and bought his paintings on a regular basis. Whatever the precise nature of the relationship between artist and collector, it must have given Vermeer a certain amount of financial security.

What we do know for certain is that Vermeer established a solid reputation as an artist of considerable merit. He became a master in the painters guild in Delft in 1653, at the age of only 22, and was later twice elected to serve as head of the guild. His renown also spread beyond Delft to the princely city of The Hague not far away. In 1663, a French art lover made the trip from The Hague to Delft one day to call on Vermeer only to find that he had no paintings to show him, while a young aristocrat from The Hague who visited the artist in 1667 referred to him as 'a famous painter named Vermeer' (*Johannes Vermeer*, p.50). In 1772, Vermeer and another Delft painter were called to The Hague to authenticate a collection of Italian paintings, which could mean that he was acknowledged as something of an authority on art. In general, it seems that Vermeer commanded fairly high prices for his paintings, although he died in debt. Far from indicating that his art had fallen out of favour, his financial problems were primarily due to the economic crisis in the aftermath of the French invasion of his country in 1672.

The question that remains is, why did the modest celebrity that Vermeer achieved during his lifetime give way to the obscurity in which he languished for two centuries after his death? The fact that he produced little and sold most of his work to a small group of buyers, van Ruijven and a few others, must have prevented his fame from spreading very far afield. Certainly, he would not have been so thoroughly forgotten had he lived not in a quiet little town like Delft but in the cosmopolitan city of Amsterdam. If he had, he would undoubtedly have received a proper entry instead of a bare mention in what became the major source on seventeenth-century Dutch art, Arnold Houbraken's *Groote Schouburgh der Nederlandtsche Kontschilders en Schilderessen* (*Grand Theatre of Dutch Painters and Women Artists*) (1718–21). Houbraken's ignorance of Vermeer meant that he was left out of subsequent surveys of Dutch art.

[7] The growing wealth of private, middle-class citizens known as *burghers* gave rise to an unprecedented demand for paintings in the Dutch Republic in the middle and later decades of the seventeenth century. Elsewhere in Europe, by contrast, art collecting continued to be dominated by royal and noble patrons.

Vermeer in transit

Almost every one of Vermeer's paintings now hangs in a museum somewhere in Europe or America. The main exception is *A Lady at the Virginal with a Gentleman* (traditionally known as *The Music Lesson*) (Plate 145), which is in the Royal Collection and, like the other paintings by Vermeer, will almost certainly never be put on the market. Until the twentieth century, however, his paintings regularly changed hands, with art dealers acting either as middlemen or on their own behalf. In order to understand the changes in Vermeer's fame, we need to examine the different identities and values that his work could take on in the process.

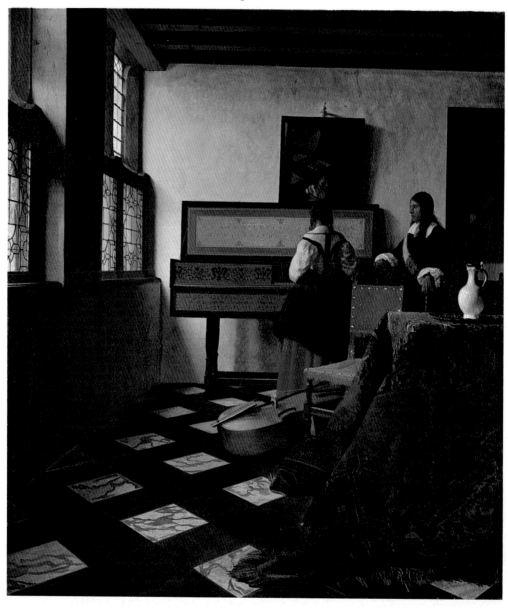

Plate 145 Johannes Vermeer, *A Lady at the Virginal with a Gentleman*, 1662, oil on canvas, 74 x 64.5 cm, The Royal Collection. © Her Majesty the Queen.

By the mid-eighteenth century, a Europe-wide taste for Dutch art had developed and Vermeer's paintings began to be sold abroad. Since his name meant nothing beyond Holland, some of them ceased to be identified as his work, even though most Vermeers are signed. Several acquired new attributions to then better-known Dutch artists, such as Gabriel Metsu (1629–67), who depicts some of the same themes as Vermeer in a quite similar manner (Plate 146). Money undoubtedly played a part in encouraging reattribution since, as you might expect, works by famous names fetched higher prices. However, the small size of Vermeer's output must have made it genuinely difficult for dealers to become familiar with his work as his

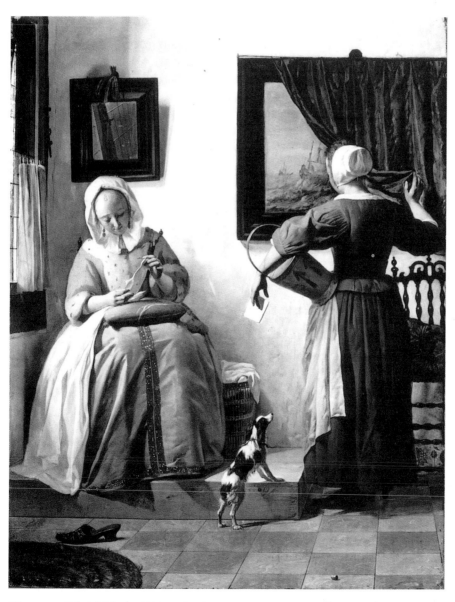

Plate 146 Gabriel Metsu, *Woman Reading a Letter*, *c.*1663–7, oil on panel, 52.5 x 40.2 cm, National Gallery of Ireland, Dublin.

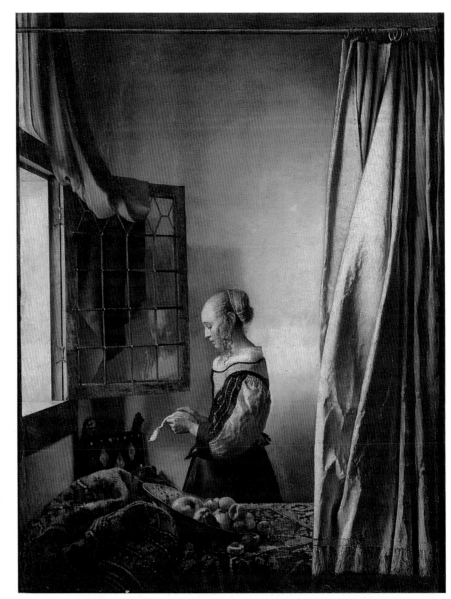

Plate 147
Johannes
Vermeer, *Girl
Reading a Letter at
a Window*, 1658,
oil on canvas,
83 x 64.5 cm,
Staatliche
Kunstsammlungen
Dresden,
Gemäldegalerie
Alte Meister.
Photo: Deutsche
Fotothek,
Sächsisches
Landesbibliothek.

paintings did not come up for sale very often. Under various names, works by the artist entered distinguished collections. The *Girl Reading a Letter at a Window* (Plate 147) was acquired by the Elector of Saxony in 1742 as a Rembrandt. When George III acquired *The Music Lesson* in 1762, it was believed to be the work of another Dutch painter, Frans van Mieris (1635–81). Clearly, Vermeer's paintings were much appreciated even when the artist's name was unknown.

In the late eighteenth century, art dealers started to realize that buyers could be attracted not just by famous names but also by the special cachet of rarity and unfamiliarity. This new marketing strategy took a while to succeed, however. In 1784, a Parisian dealer, Joseph Paillet, proved unable to persuade the French monarchy to buy Vermeer's *Astronomer* (Plate 148) on these grounds (this painting did end up in France but not until a century later). In

1792, a print after *The Astronomer* appeared in a catalogue of artists of the
northern schools published by another French art dealer, Jean-Baptiste-Pierre
Lebrun, husband of the painter Elisabeth Vigée-Lebrun.[8] The accompanying
text is carefully calculated to excite the interest of collectors, although this
does not mean that Lebrun was not sincere in his appreciation: 'This van de
Meer, never once mentioned by historians, merits special attention. He is a

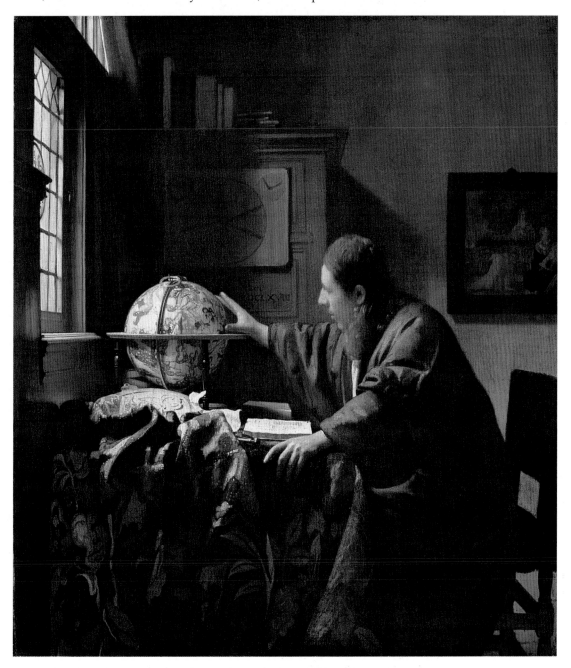

Plate 148 Johannes Vermeer, *The Astronomer*, 1668, oil on canvas, 50 x 45 cm, Musée du Louvre, Paris.
Photo: R.M.N. - R.G. Ojeda.

[8] See Emma Barker, 'Women artists and the French Academy', in Perry, *Gender and Art*
(Book 3 in this series).

very great painter in the manner of Metsu. His pictures are very rare, and are better known and more appreciated in Holland than anywhere else. He was especially fond of rendering effects of sunlight' (Blankert, *Vermeer*, pp.63–4). Lebrun's comments are usually regarded as a first step in the making of Vermeer's reputation.

The greater frequency with which Vermeer's work appeared on the Dutch art market in the late eighteenth century meant that, as Lebrun observed, he had achieved a certain degree of fame in his native country. By 1816, a pair of Dutch authors could declare that 'all amateurs of art know that his paintings are ranked with those of the greatest masters of the Dutch school, and are sold for great sums' (Blankert, *Vermeer*, p.65). However, it was only with the development of an international art market that Vermeer could be acknowledged as a great artist by the standards of Europe as a whole. The growing taste for Dutch painting among aristocratic collectors in France and other countries, for which dealers like Lebrun catered, prepared the way for a thorough revision of the existing academic canon based on the supremacy of history painting. Throughout the eighteenth and into the nineteenth century, an earlier taste for picturesque and lively depictions of merry peasants gave way to a new appreciation of elegant and restrained scenes of private life by artists like Metsu. Exactly why this shift took place we will examine below, but it clearly was crucial in allowing Dutch painters to be considered worthy of serious attention and the highest praise. As Lebrun's remarks indicate, Vermeer was first admired simply as another artist of this type.

For many years, no real attempt was made to distinguish Vermeer either from Metsu or from another painter of domestic scenes, Pieter de Hooch (1629–84), who had become one of the most highly regarded of Dutch artists by the mid-nineteenth century (Plate 149). In 1833, an English dealer, John Smith, could still write of Vermeer (*Catalogue Raisonné*, pp.110–242) in terms very similar to those used by Lebrun. Smith categorized Vermeer as a follower of both Metsu and de Hooch. 'Writers appear to have been entirely ignorant of the works of this excellent artist', Smith commented, adding that he was 'little known by reason of the scarcity of his works'. Significantly, Smith's catalogue included not a single identified domestic scene by Vermeer, although he did refer to one 'superb picture', the *View of Delft* (Plate 150), which had entered the Royal Cabinet of Paintings in the Mauritshuis in 1822 on the insistence of King William I. Until that date, no correctly attributed work by Vermeer had hung in a public gallery where it would be widely seen. This development apparently triggered off the subsequent 'rediscovery' of Vermeer by the French art critic and radical journalist, Théophile Thoré (1807–69), who resolved to find out more about the artist after being impressed by the *View of Delft* on a visit to the Hague in 1842.

Let us now review the argument so far.

Using the comments of Lebrun and Smith as your principal evidence, extract two key factors from the above account to explain how Vermeer remained an obscure figure even when comparable artists were highly appreciated. You should also take note of the type of book in which both dealers made their remarks, since this indicates what was needed to overcome these obstacles and establish Vermeer as a major artist.

Plate 149 Pieter de Hooch, *A Woman Peeling an Apple*, 1663, oil on canvas, 67.1 x 54.7cm. Reproduced by permission of the Trustees of the Wallace Collection, London.

Plate 150 Johannes Vermeer, *View of Delft*, 1660, oil on canvas, 96.5 x 115.7 cm, Royal Cabinet of Paintings, Mauritshuis, The Hague.

Discussion

The two key factors are the unfamiliarity of Vermeer's name and the rarity of his work. Both of the art dealers comment on the paucity of printed references to him as well as observing how few his paintings are. In each case, these remarks appear in a catalogue of the artist's works. (A catalogue serves to associate an artist's name with an identified group of paintings that constitutes his *oeuvre*, thereby creating a landmark on which his reputation can be based.)

◆◆◆

Rediscovery

After the failure of the 1848 Revolution, in which he had taken part, Thoré was forced to leave France and remained in exile until 1859. Unable to keep up with contemporary art in Paris, he started to write extensively on the art of the past under the pseudonym, William Bürger. His researches into Dutch painting culminated in the publication of a monograph on Vermeer in the *Gazette des Beaux-Arts* in 1866. In his introduction, Thoré declared that he aimed to right the injustice that had been done to Vermeer and bring him the notice that he deserved. He also drew attention to the difficulties involved in discovering anything about the artist by dubbing him 'the sphinx of Delft'. As a result of these endeavours, 'Thoré-Bürger' has gone down in the history of art as 'the man who rediscovered Vermeer'.

Thoré's right to this title has been contested, most recently by a Dutch art historian, Ben Broos, who declares that it was King William I and Smith who were 'the true rediscoverers of Vermeer' (*Johannes Vermeer*, p.59). Nevertheless, Thoré deserves credit for being the first person to hunt through museums in Holland and elsewhere in order to track down works by Vermeer. It was Thoré, for example, who reattributed two paintings in German collections, which until then had gone under the name of 'Jacob van der Meer'. Admittedly, he did almost as much to confuse matters as to clarify them by going to the opposite extreme and claiming far too many pictures for Vermeer. His catalogue of the artist's *oeuvre* contains no fewer than 73 entries, including works by de Hooch (such as Plate 149) and others as well as a group of landscapes by Jan Vermeer of Haarlem (1628–91). Some of these attributions were doubted from the first, but not until the early twentieth century was Vermeer's *oeuvre* brought down to its present size.

Without seeking to devalue Thoré's achievement, it is still possible to question some of the claims made on his behalf. In the standard account of the rediscovery of Vermeer, Thoré's activities are held to have a double significance. In the first place, it has been argued that his work on Vermeer represents a pioneering example of objective or 'scientific' art-historical methods, in which careful scrutiny of the styles or 'hands' of different artists is accompanied by documentary research in archives. Thoré did indeed present himself as a modern scholar as opposed to a traditional connoisseur, but the excess of zeal he brought to the task of rediscovering Vermeer hardly seems very objective. Recent discussions of Thoré's career, notably by Frances Jowell, suggest that he was in fact anything but neutral and disinterested in his approach. The second claim relates to the already mentioned theory that the rediscovery of Vermeer was made possible by comparable trends in nineteenth-century French painting (especially a shift towards everyday subject-matter and a new concern with effects of light). Thoré's appreciation of the artist supposedly depended on his knowledge of and sympathy for these developments. However, this view has been contested by Francis Haskell, who argues that Thoré's discovery was actually made 'in opposition to the most "advanced" trends in the art of his own times' (*Rediscoveries in Art*, p.150).

Before we go any further, it must be emphasized that Thoré's writing on art was profoundly informed by his political ideals. Paradoxically, his insistence on objective scholarship was in itself a political statement since, like other liberal thinkers of the period, he believed in the unity of science and progress. What drew him to seventeenth-century Dutch painting was his belief that it was a democratic art that was still relevant to his own century. Thoré praised the Dutch 'little masters' for depicting the ordinary people of their own time in a manner accessible to everybody. By contrast, history paintings in the classical style, representing gods and heroes, seemed élitist and backward-looking to him (he loathed French academic art, which perpetuated this tradition).[9] He explained the distinctive achievements of seventeenth-century Dutch artists by reference to the unique political and religious liberty enjoyed by the Dutch people at that period. Freed from the domination of priests and princes, they produced a national art that was nevertheless universal in scope,

[9] On changing attitudes to nineteenth-century French academic art, see Emma Barker, 'The museum in a postmodern era: the Musée d'Orsay', in Barker, *Contemporary Cultures of Display* (Book 6 in this series).

because its central subject was human life itself. Thoré coined the phrase 'l'art pour l'homme' (art for humanity's sake) to characterize the kind of painting he admired; it implied a criticism of the slogan 'l'art pour l'art' (art for art's sake), which had been coined some years earlier by French writers who believed that art should have no purpose outside of itself.

For our purposes, the interest of Thoré's ideas about art lies in what they suggest about the wider context in which the rediscovery of Vermeer took place. It can be argued that he makes explicit the underlying reasons for the previous growth in appreciation of Dutch painting in general and artists like de Hooch in particular. In other words, it is possible that this taste is tied to a gradual shift towards progressive, democratic values in Europe. The basic problem about this kind of argument is that, as we have seen, Dutch paintings tended to be owned by monarchs and aristocrats rather than middle-class people with liberal views. Nevertheless, it is clear that domestic scenes were so highly valued at least partly because they seem to depict ordinary people in familiar relationships with which almost any one can identify. In fact, they were often described in these terms even when the subject actually had nothing to do with universal human values. Vermeer's so-called *Music Lesson* (Plate 145), for example, was said in the eighteenth century to represent a father and daughter, despite the fact that nothing in the painting indicates the nature of the relationship between the two figures. Rather, as discussed earlier, they seem quite aloof both from each other and from us, the viewer. Nor can they convincingly be identified as 'ordinary' or middle-class but, as in most Vermeers, are wealthy and elegant people in finely furnished surroundings (we will return to this point later).

What is undeniable is that, far from being especially novel, Thoré's perception of Vermeer's art accorded in many respects with an existing tendency on the part of dealers and others to emphasize the human content of Dutch painting. He did, however, introduce a new element by comparing Vermeer not just to de Hooch but also to the magisterial figure of Rembrandt, whom he revered above all other artists for his profound understanding of human nature. The surest way of establishing Vermeer's claims to greatness, therefore, was by association with Rembrandt. Despite a total lack of evidence, Thoré insisted that Vermeer must have studied with him in Amsterdam, arguing that 'it was from Rembrandt that he took … his physiognomies that are so expressive, and his profoundly human naivety'. In Vermeer's paintings, Thoré added, the 'figures are completely absorbed in what they are doing … Here is life itself; one immediately works out the little drama that is expressed on their physiognomies' ('Van der Meer de Delft',[10] p.460). His assertion that the emotions experienced by Vermeer's figures are immediately intelligible to the viewer is bound to seem rather perverse today, given that it disregards all those subtle and enigmatic qualities that are now so highly valued in paintings like the *Woman in Blue* (Plate 142).

Thoré's praise for the human qualities that he discerned in Vermeer's work provides a neat contrast with the reservations he expressed about the French painter Édouard Manet (1832–83) when he again became active as an art

[10] For the English translation of extracts from this article, see Edwards, *Art and its Histories: A Reader*.

critic in the 1860s. What he found problematic in Manet's paintings was the indifference to subject-matter, the lack of human interest. In 1868, he complained: 'Manet sees colour and light, after that he doesn't bother about the rest … His present fault is a kind of pantheism which thinks no more of a head than of a slipper' (Hamilton, *Manet and his Critics*, pp.123–4). It is on the basis of comments like these that Haskell argues that Thoré looked to Vermeer for the qualities he felt were lacking in the most advanced art of his own time. Clearly, there is something in this contention, but it needs a certain amount of qualification. In the first place, Thoré acknowledges that Vermeer did not entirely conform to his vision of a painter devoted to humanity. He goes on to state that 'The most prodigious quality of Vermeer, taking precedence over his physiognomic instinct, is the quality of the light' (Thoré, 'Van der Meer de Delft', p.461). More fundamentally, it must be emphasized that Thoré's judgements result not so much from any artistic conservatism as from his political radicalism. However much he admired a painter's skill in rendering light and colour, he felt unable to endorse art that (in his view) ignored the cause of humanity.

We can conclude that Thoré was not only far from 'objective', as we understand the term today, but that the very idea of a non-partisan, disinterested approach to art was anathema to him. He was, first and foremost, a radical art critic whose view of art history was a polemical, not to say tendentious, one. (It was lucky for him that he never discovered Vermeer's religion since he abominated the church of Rome and attributed much of the distinctiveness of Dutch art to the influence of Protestantism.) However, Thoré was also active as an art dealer, buying several of the Vermeers he discovered for himself and persuading wealthy collectors to acquire others. It is impossible to separate his art-historical research on Vermeer from his commercial promotion of the artist.[11] Had he not had so many 'interests' in Vermeer (artistic, political, and financial), Thoré would almost certainly not have been such an effective advocate on his behalf.

Canonization

Largely as a result of Thoré's endeavours, Vermeer's reputation rose steadily in the second half of the nineteenth century. *The Lacemaker* (Plate 151), acquired by the Louvre in 1870, was the first acknowledged work by the artist to enter a museum outside Holland. Ironically, Thoré's scholarship was largely discredited over the same period. In a monograph published in 1888, the French writer Henry Havard provided many new facts, such as the correct date of Vermeer's death, and rejected the idea that he was a follower of Rembrandt: 'Not only is the drama of life not his major preoccupation but it is severely banished from his work, and his figures … make hardly any more sound than the multiple accessories that surround them … Many of his figures appear there, in effect, as no more than admirable touches of paint' (*Van der Meer de Delft*, p.20). Here, we have an interpretation of Vermeer's painting that is not so very far removed from that of twentieth-century commentators such as Gowing.

[11] New light has recently been shed on Thoré's activities as a dealer in Jowell, 'Thoré-Bürger – a critical role in the art market'.

Plate 151
Johannes
Vermeer, *The
Lacemaker*, 1665,
oil on canvas
transferred to
panel, 23.9 x
20.5 cm, Musée
du Louvre, Paris.
Photo: R.M.N. -
R.G. Ojeda.

The question that we have yet to settle, however, is whether or not the new appreciation of Vermeer in the later nineteenth century was tied to the emergence of new forms of art. On one level, there is simply no point in denying the existence of such a connection. Whatever the peculiarities of Thoré's interpretation, the fact remains that he valued Vermeer for being, in his words, 'an ancestor of artists in love with nature, of those who understand and express it in all its appealing sincerity'. He had in mind French realist painters, such as Gustave Courbet (1819–77).[12] Vermeer was also greatly

[12] For a brief discussion of Courbet's work, see Paul Wood, 'The avant-garde from the July Monarchy to the Second Empire', in Wood, *The Challenge of the Avant-Garde* (Book 4 in this series).

Plate 152 Édouard Manet, *Luncheon in the Studio*, 1868, oil on canvas, 118.3 x 153.9 cm, Neue Pinakothek, Munich, Staatsgemäldesammunlungen, Munich. Photo: Arthothek.

admired by artists themselves. Manet, for example, included a map on the wall in his *Luncheon in the Studio* (1868) (Plate 152) in an apparent act of homage to Vermeer, who showed maps in other paintings as well as the *Woman in Blue*. What we now need to decide is whether the characterization of Vermeer as a peculiarly modern artist made it possible to admire aspects of his art that could otherwise have presented problems.

To clarify this issue, we can use three texts dating from the time at which Vermeer's name was first becoming known. Each takes the *View of Delft* (Plate 150) as its starting-point. Consider their comments in the light of the painting, as you find it reproduced here, and analyse their responses. Do they seem justified to you?

> It is painted with a vigour, a solidity, a strength of impasto[13] rare in Dutch landscape painters. This Jan van der Meer, ... is a bold painter who proceeds by means of flat areas of colour broadly applied in thick touches that stand off the canvas.
>
> (Maxime du Camp, 1857, quoted in Meltzoff, 'The rediscovery of Vermeer', p.148)

> ... he has pushed the impasto to an exaggerated degree such as we occasionally find today with Monsieur Decamps. It seems as if he wanted to build his city with a trowel; and his bricks are made of real mortar. Too much is too much. Rembrandt never fell into such excess ... In spite of this masonry, however, the *View of Delft* is a masterly painting.
>
> (Thoré, 1858, quoted in Rosen and Zerner, *Romanticism and Realism*, p.194)

13 A term used to describe thickly applied layers of paint.

Its execution is crude, the impasto brutal and the aspect monotonous. [The writer goes on to praise another painting by Vermeer, the so-called *Milkmaid*.] You find nothing similar in other schools, unless it is in France among our modern realists. Courbet, Leleux and Bonvin, for example, often pursue similar effects: that is to say that they observe nature with eyes half shut, at some distance, so that they only see the broad forms, only then to move in close and discern certain subtleties.

(Charles Blanc, *Histoire des peintres*, vol.2, no pagination)

Discussion

The emphasis that we find here on the painting's unusual and even unpleasant character is, I think, bound to seem almost incomprehensible to viewers today. The *View of Delft* probably strikes you as highly realistic and almost photographic in its vividness and immediacy (although, of course, this is encouraged by the fact that you are looking at a reproduction). By contrast, each of these writers is distracted by Vermeer's handling of paint, which they find extremely thick and rough. The flecks of lighter-coloured paint that can be seen, even in reproduction, on the walls and roofs of the town, as well as on the boat at the right, can give us some idea of what they found so strange. You might think that the supposed similarity between Vermeer's handling of paint and actual bricks and mortar would be likely to seem a positive quality, enhancing the overall sense of physical presence (although the shadow enveloping the part of the town nearest to us, as well as the expanse of water in the foreground, simultaneously convey a sense of distance). What is especially interesting for our purposes is the way that Thoré and Blanc both try to make sense of Vermeer's work by drawing a comparison with artists of their own day working in what they regard as a similarly bold manner. However, Thoré is much more positive in his final assessment of the *View of Delft*.

◆◆◆

From these texts, it does seem that certain stylistic features characteristic of Vermeer could cause difficulties for nineteenth-century viewers. We can explore this point further with reference to the other painting discussed by Blanc, the *Woman Pouring Milk* (Plate 153), which is exceptional for the artist in depicting a working-class figure. She is also even more massively solid than usual. As in the *View of Delft*, moreover, parts of the surface are scattered with bright highlights, particularly the bread in the foreground. These are thought to derive from the blurring of light in a camera obscura (see footnote 2 on page 192). Somewhat similar effects can be seen in other works by Vermeer (notice the almost liquid effect of the skeins of thread in the left foreground of *The Lacemaker*, Plate 151). These tendencies contrast markedly with the minute detail and highly polished surfaces of other Dutch genre painters, notably Metsu and Mieris. By comparison to these so-called 'finepainters', whose work was highly prized in the period around 1800, Vermeer's broader handling of paint might well have appeared deficient.[14] This suggests that the emergence of new points of comparison, either as a result of innovations in painting or the invention of photography, could have fostered appreciation of his exceptional qualities.

[14] However, it should be emphasized that earlier generations of collectors had somewhat different tastes and would not have had any difficulty in appreciating paintings in the lesser genres characterized by a distinctively loose handling of paint (as we can see from the example of Watteau, discussed in Case Study 9).

Plate 153 Johannes Vermeer, *Woman Pouring Milk*, 1660, oil on canvas, 45.5 x 41 cm, Rijksmuseum, Amsterdam.

On balance, therefore, it seems that we can give at least some credence to the established explanation for the new appreciation of Vermeer during this period. What is most striking, however, is the swiftness with which any sense of boldness and roughness in his work is subordinated to a new emphasis on its cool elegance and vivid colour, especially the use of yellow. It became a cliché for writers to find Vermeer's art reminiscent of some exquisite oriental artefact, usually Chinese porcelain. The most famous example of this approach occurs in Marcel Proust's great novel, *À la recherche du temps perdu* (1913–27).

One of the characters, a famous novelist called Bergotte, collapses and dies while looking at the *View of Delft*; in his final moments, Bergotte keeps staring at 'a little patch of yellow wall' (in fact, an area of sunlit roof), which reminds him of his own deficiencies as writer. 'I ought to have … made my language precious in itself, like this little patch of yellow wall', he reflects (*In Search of Lost Time*, vol.5, *The Captive*, p.20). Here, in contrast to the comments quoted above, the painting has come to exemplify the purity and refinement of an art that is exclusively concerned with its own processes and utterly separate from the ordinary world. It is not what is represented that matters but rather the distinctive vision of the artist.

While writers from Havard to Proust celebrated the rare and precious qualities of Vermeer's art, the actual rarity of his paintings made them all the more precious to collectors. By the early twentieth century, prices had become so high that virtually the only people who could afford them were American millionaires. Henry Clay Frick acquired no fewer than three to hang in his New York house, now a museum. The acquisitiveness of American collectors aroused fears that *The Milkmaid*, which had belonged to the same Amsterdam family for nearly a century, would also end up in the United States. In 1907, the Dutch parliament voted funds to acquire it along with other works from the same collection. A contemporary cartoon shows 'Holland's best-looking milkmaid' rejecting the advances of her American suitor, Uncle Sam (Plate 154). Having saved the painting for the nation, the Dutch were left with a total of seven works by Vermeer. In a sense, they had won the battle but lost the war. It was precisely in this period that Vermeer ceased to be regarded as a purely Dutch artist and finally gained the status of one of the greatest figures in the whole of the history of art.

De Minister P. Rink en de melkmeid uit de collectie-Six

Raakt Holland op de beurs aan Sam zijn goeie geld kwijt,
Hij dingt er mee, brutaal, naar Hollands knapste melkmeid.

Maar — zegt zij — Hollands kunst volg' Hollands duiten niet,
Toe, laat me in Holland blijven bij mijn Piet!

Plate 154 Jan Rinke, cartoons from *Het Vaderland*, 9 November 1907. Reproduced by courtesy of the Rijksmuseum Amsterdam Archives.

Reviewing Vermeer

As we saw above, twentieth-century commentators have found it possible to reconcile Thoré's claim that Vermeer's true subject was life itself with a Proustian belief in the exclusively aesthetic significance of his work. What allows them to be brought together in an account of a painting like the *Woman in Blue* is their fundamentally ahistorical character. Just as human nature is regarded as universal and unchanging, so great art is thought to be of all times and all places. The Dutch art historian Albert Blankert is highly critical of this kind of approach:

> a belief in universals suggests a treacherous short-cut to the understanding of art; it suggests that the most ideal confrontation with a work of art is the most direct one, one unencumbered by ideas and information that come between the work and the viewer. Those scholars who stress what a work of art 'does to us' often forget that because of changes in cultural context our responses may be quite unrelated to what the artist originally wished to communicate.
>
> (*Vermeer*, p.71)

The danger of assuming that a great painting speaks to us directly across the centuries is demonstrated, Blankert argues, by the most notorious episode in the appreciation of Vermeer after his death.

In 1937, the distinguished art historian Abraham Bredius announced the discovery of a new masterpiece by Vermeer. Bredius drew attention to the presence in the *Supper at Emmaus* (Plate 155) of such distinctive features as

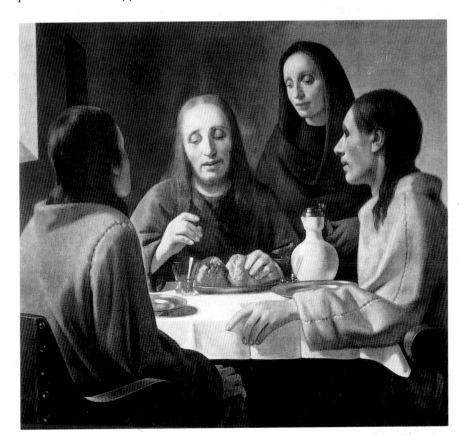

Plate 155 Hans van Meegeren, *Supper at Emmaus*, 1937, oil on canvas, 129 x 117 cm, Museum Boijmans Van Beuningen, Rotterdam.

the highlights (he called them *pointillé*: literally, dotted) on the bread and the yellow worn by one of the disciples. He was most impressed by the head of Christ, 'serene and sad'. In no other work by Vermeer, he declared, do we find 'such sentiment … a sentiment so nobly human expressed through the medium of the highest art' ('A new Vermeer', p.211). It was swiftly acquired by the Boymans Museum in Rotterdam. In 1945, however, an unsuccessful Dutch artist named Hans van Meegeren, who had been imprisoned on a charge of collaborating with the Germans during the Nazi occupation of Holland, confessed that he had forged the painting along with several other supposed Vermeers. In retrospect, it is hard to understand how anyone could have been taken in. The stiffness and flatness of the figures, their exaggeratedly heavy eye-lids and over-full lips and the uniform, unvaried texture of their draperies should all have given the game away. Its rather self-conscious 'nobility' and pathos seem, however, to have had a consoling effect at a time of extreme political stress and tension. Because it spoke to their situation so directly, Bredius and others were deluded into thinking it must be a great work of 'timeless' art.

Since the appearance of Blankert's careful monograph on Vermeer in 1978, the study of the artist has become much more concerned with his historical context. Above all, greater emphasis has been placed on uncovering the meanings that his paintings could have held in his own lifetime. As we have seen, writers such as Proust tended to play down subject-matter altogether in order to concentrate on the distinctive handling of paint. In Thoré's case, his view that Vermeer's paintings were universal depictions of human emotions led him to play down the complexity of their iconography. He noted, for example, that the painting of Cupid holding up a letter included in *A Lady Standing at the Virginal* (Plate 156) carried connotations of love, but insisted that it was all done 'without any emblematic pretension'. By contrast, modern interpretations of the painting rely on seventeenth-century Dutch emblem books in which images are explained by accompanying texts. Cupid is now believed to be holding a playing card and has been linked to a similar image in Otto van Veen's *Amorum emblemata* (*Emblems of Love*) of 1606, which is captioned 'Only one'. *A Lady Standing at the Virginal* does not therefore simply depict a girl thinking about her lover, as Thoré suggested, but conveys a specific message about the importance of fidelity.

However, the tidy moral messages of the emblem books are only one aspect of the cultural context in which Vermeer worked. Some art historians, notably Alpers, have reacted against what they see as over-reliance on these texts in interpreting Dutch genre painting. In this respect, we should point out that the card held up by Vermeer's Cupid differs from the one shown in van Veen's book in being quite blank. Ultimately, it would seem that the image is deliberately enigmatic and its message far from clear-cut. Other aspects of Vermeer's art also continue to defy all attempts to find definitive answers. Despite endless discussion of his possible use of the camera obscura, it is impossible to say for certain that the distinctive stylistic features we have examined do derive from this mechanism. What is clear is that Vermeer was the artist of a social élite: a painting like *A Lady at the Virginal with a Gentleman* (Plate 145) not only depicts wealthy, well-bred people but would also have been destined for a member of his exclusive clientèle. I would argue that the ambiguous meanings and idiosyncratic effects of Vermeer's paintings can only be explained in this context, since they assume a sophisticated audience able to appreciate them on different levels.

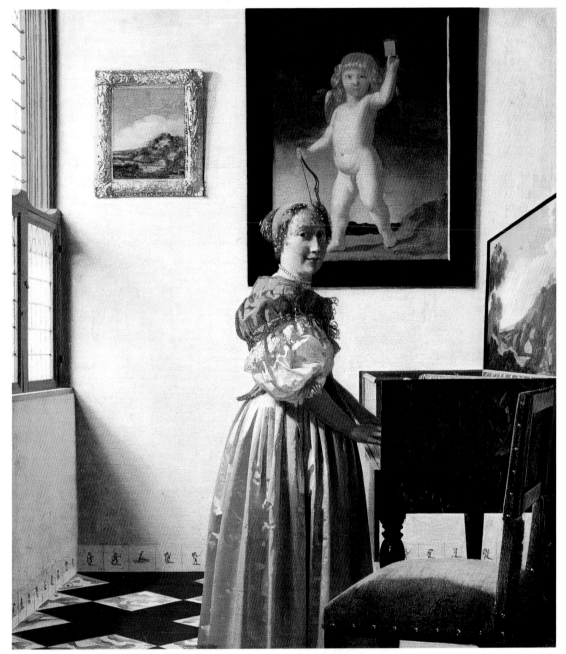

Plate 156 Johannes Vermeer, *A Lady Standing at the Virginal*, 1670, oil on canvas, 51.8 x 45.2 cm, National Gallery, London. Reproduced by courtesy of the Trustees of the National Gallery.

The problems involved in interpreting Vermeer's paintings cannot be developed here but, on the basis of the above comments, we can reconsider the point above about the supposedly universal significance of great art. In the quotation with which I began, Alpers wonders how an artist working in a particular time and place could have become so widely valued. This becomes all the more paradoxical once you realize that the artist's original significance was also defined in class-specific terms. Nor does this restriction disappear after his death. The idea that you need special discrimination to appreciate Vermeer is a recurrent feature of his posthumous fame. Lebrun evidently realized that his paintings would appeal to collectors who wanted to feel

superior to the common run of art lovers. Similarly, there was a definite element of snobbery in Proust's veneration for a great artist whose name was still not widely known. Only at the very end of the twentieth century, with the huge popular success of the Vermeer exhibition held in Washington and The Hague in 1995–6, did he gain a high public profile.

The discrepancy between the narrow context in which Vermeer worked and the extent of his current appeal suggests that we should not assume that the kinds of pleasure and interest that we now find in his paintings necessarily derive from the artist himself. There must be some continuity between his time and our own to account for the enduring value accorded to certain aspects of his work: the 'light of Vermeer', for example, has been singled out for special praise since the eighteenth century at least. All the same, it might be wise to resist the idea that we can all appreciate Vermeer in the same way on account of our shared human identity. For one thing, the ranks of Vermeer enthusiasts include Adolf Hitler, who seized for himself one of the artist's largest and most ambitious works, *The Art of Painting* (Plate 157), from a

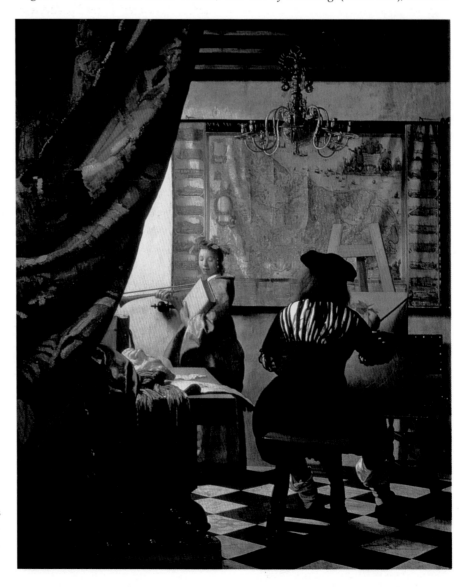

Plate 157
Johannes Vermeer, *The Art of Painting*, 1666, oil on canvas, 120 x 110 cm, Kunsthistorisches Museum, Vienna. Bridgeman Art Library, London/ New York.

collection in Vienna. For another, the hoards of Washingtonians who queued to see the 1995–6 exhibition included conspicuously few of the city's black majority. While Vermeer's art is certainly not wholly alien to present-day viewers, this does not mean that it has universal appeal. Rather, I would suggest, it is a peculiar combination of remoteness and familiarity that makes paintings like the *Woman in Blue* and the *View of Delft* so compelling.

References

Alpers, S. (1996) 'The strangeness of Vermeer', *Art in America*, May, pp.63–8.

Blanc, C. (1860–3) *Histoire des peintres de toutes les écoles: école hollandaise*, 2 vols, Paris.

Blankert, A. (1978) *Vermeer of Delft*, Oxford, Phaidon.

Bredius, A. (1937) 'A new Vermeer', *Burlington Magazine*, vol.71, p.211.

Edwards, S. (ed.) (1999) *Art and its Histories: A Reader*, New Haven and London, Yale University Press,

Gombrich, E.H. (1995) *The Story of Art*, London, Phaidon (first published 1950).

Gowing, L. (1952) *Vermeer*, London, Faber & Faber.

Hamilton, G.H. (1964) *Manet and his Critics*, New Haven and London, Yale University Press.

Haskell, F. (1980) *Rediscoveries in Art: Some Aspects of Taste, Fashion and Collecting in England and France*, Oxford, Phaidon.

Havard, H. (1888) *Van der Meer de Delft*, Paris.

Johannes Vermeer (1995) exhibition catalogue, National Gallery of Art, Washington D.C. and Royal Cabinet of Paintings, Mauritshuis, The Hague.

Jowell, F.S. (1996) 'Thoré-Bürger – a critical role in the art market', *Burlington Magazine*, February, vol.138, pp.115–29.

Meltzoff, S.J. (1942) 'The rediscovery of Vermeer', *Marysas*, vol.2, pp.145–66.

Montias, J.M. (1989) *Vermeer and his Milieu: A Web of Social History*, Princeton University Press.

Proust, M. (1996) *In Search of Lost Time*, trans. C.K. Scott Moncrieff and T. Kilmartin with revisions by D.J. Enright, 6 vols, London, Vintage.

Rosen, C. and Zerner, H. (1984) *Romanticism and Realism*, London, Faber & Faber.

Slatkes, L.J. (1981) *Vermeer and his Contemporaries*, New York, Abbeville.

Smith, J. (1829–42) *Catalogue Raisonné of the Most Eminent Dutch, Flemish and French Painters*, London.

Snow, E. (1994) *A Study of Vermeer*, Berkeley, University of California Press.

Thoré, T. (1866) 'Van der Meer de Delft', *Gazette des Beaux-Arts*, October, pp.299–330; November, pp.458–70; December, pp.542–75.

Subjects, society, style: changing evaluations of Watteau and his art

LINDA WALSH

The status and reputation of the French painter Jean-Antoine Watteau (1684–1721) have varied in accordance with the priorities and methods of several generations of commentators, from the early eighteenth century to the present day. The subjects and style of his paintings were judged by the Royal Academy of Painting and Sculpture in the eighteenth century to be inferior to those of the tradition of grand history painting. Yet in the nineteenth century Watteau was hailed as a romantic genius. The aim of this case study is to explore these shifts in Watteau's artistic status and to see what subsequent developments have taken place in the judgements expressed by modern academic art historians. As we shall see, the issue of artistic status is also bound up with the meanings attributed to Watteau's work.

Watteau's art and the hierarchy of genres

Gallantry versus heroism: how did Watteau's subjects match up to the Academy's standards?

Let us try to establish the way in which the Academy would have regarded Watteau's subjects. We can do this by comparing the reception piece submitted by Watteau in order to gain admission to the Academy, his *Pilgrimage to the Island of Cythera* (Plate 158), with a painting treating the kind of subject that was granted the highest status by the Academy, *Theseus Abandons Ariadne at Naxos* (Plate 159) by another French painter, Charles Le Brun (1619–90). Le Brun had been Director of the Academy for some years in the late seventeenth century: he helped to formulate an 'academic' style of history painting.[1]

Please look at Plates 158 and 159. Study these reproductions carefully and answer the following questions.

1 **Both paintings show a combination of landscape and human activity, but what is the balance of these two elements in each? (Think about the amount of space each takes up on the canvas.)**

2 **Can you make a guess about the kind of story that is being told in each painting? What kinds of clue might you draw on?**

Discussion

1 Watteau's canvas devotes a lot of space to the landscape setting – trees, banks, water, distant hills, and cliffs – whereas Le Brun's devotes a much larger proportion of the available space to the human figure. Watteau's figures, unlike Le Brun's, are dwarfed by the trees around them.

[1] See Linda Walsh, 'Charles Le Brun, "art dictator of France"', in Perry and Cunningham, *Academies, Museums and Canons of Art* (Book 1 in this series).

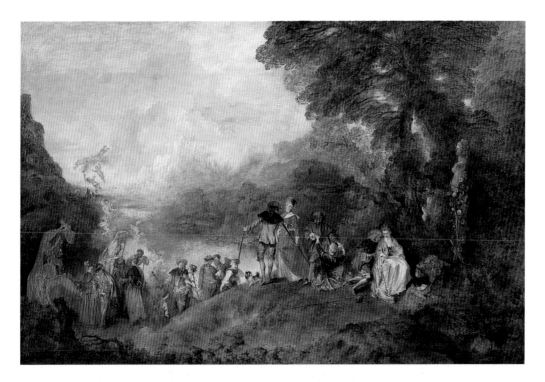

Plate 158 Jean-Antoine Watteau, *Pilgrimage to the Island of Cythera*, 1717, oil on canvas,129 x 194 cm, Musée du Louvre, Paris. Photo: R.M.N. - Gérard Biot.

Plate 159 Charles Le Brun, *Theseus Abandons Ariadne at Naxos*, 1664, oil on canvas, 97 x 131 cm, Private Collection.

2 The actions and expressions of the figures provide the most direct
 indication of the stories being told. (If you are familiar with Greek
 mythology the titles may also have helped you.) The individual identity
 of Watteau's figures is much more difficult to guess, as we see them in so
 little detail, and it seems to be less important. However, the boat and
 cherubs on the left, the lingering looks and intimate pairing of figures,
 along with the painting's title, suggest that this is a kind of outing (or
 'pilgrimage') for lovers. (The term[2] on the right is of Venus, goddess of
 Love, so it looks as if the lovers have come to pay homage to her by
 laying garlands.) The dying light in the sky and the fact that the lovers
 seem to be making their way slowly towards the boat, some more
 willingly than others, suggest that they are in the process of leaving the
 island. The woman in the centre who is being encouraged to move
 forward while glancing wistfully at the couple still engaged in
 conversation confirms this impression. The figures in the group on the
 left, however, appear quite jovial. It is difficult for us to decide whether
 this is a happy or sad episode.[3]

 Le Brun's painting shows a woman waiting in a boat while a man is
 being restrained by his two companions. They seem to prevent him from
 reaching back to a woman on the beach and encourage him to make his
 way to the boat. It is much clearer here that we are dealing with tragic
 events. Even without knowing the identity of the figures, the meaning is
 clearer than in Watteau's more ambiguous painting.

◆◆

Both paintings relate to Greek islands (semi-mythical for their contemporary
audiences) and to stories of love. The island of Cythera (also known as Venus's
island or the island of love) was a mythical Greek island in the Aegean Sea.
In Le Brun's painting, the man leaving the woman, apparently reluctantly, is
Theseus, the Athenian hero who was later to become king of Attica. The
woman on the right is Ariadne, daughter of Minos, king of Crete. After
successfully killing the minotaur (a destructive creature which was half bull,
half man) with Ariadne's assistance, Theseus fled to the island of Naxos,
where, unaccountably, he abandoned Ariadne on the shore.

In the eyes of the Academy, however, there were significant differences in
the paintings' subject-matter. The status of Watteau's painting, with its
apparently 'lighter' theme of flirtation, love, and gallantry and its less easily
identifiable figures and story lines, was a matter of some delicacy. By contrast,
Le Brun's painting was a demonstration of academic orthodoxy in that it
dealt with actions of the highest moral and emotional intensity, performed
by the heroes and heroines of Greek mythology, which was expected of history
paintings. (Let us leave aside for a moment our views on whether Theseus
really did act heroically in this instance: the main point was that both his

2 Pillar transformed at its top into a half-figure or bust.

3 Many early interpretations of this painting, stimulated by inaccurate versions of its title,
saw the lovers as boarding the boat in order to travel to the island of Cythera. Michael Levey
('The real theme of Watteau's *Embarkation for Cythera*) interpreted the painting as a scene of
melancholic departure *from* the island. Donald Posner, however, in 'Watteau mélancolique: la
formation d'un mythe', subjects such melancholic readings of Watteau's painting,
particularly prevalent in the nineteenth century, to critical scrutiny: he offers a 'happier'
interpretation of the figures' moods.

status and the dilemmas he faced stimulated moral and intellectual debates.) Le Brun's painting told a story, as clearly and boldly as it was able: a legible narrative would have been expected by the Academy.

In giving so much space to the landscape setting, and in offering anonymous lovers in contemporary dress in place of statuesque heroes of the classical tradition, Watteau set himself apart from the traditional concerns of history painting.

Watteau's subjects and contemporary culture and society

Watteau's origins and sources of inspiration aligned him and his work with paintings on the boundaries of, or outside, the canon established by the Academy. His position within the prevailing hierarchy of genres[4] was quite complex. In his early career he had dealt with a wide range of subjects, including military scenes (see, for example, Plate 160, which, in its references to contemporary scenes and comparatively realistic style, is closer to genre painting than to history); mythological subjects (for example Plate 161, of which the pose, composition, and subject are closer to the history genre, but the requisite moral gravity, particularly in the face, still appears lacking); religious works (for example, a Crucifixion: see page 240); arabesque[5] decorations (for example, Plate 162) inspired by one of his teachers, Claude Audran (1658–1734); and genre scenes (Plate 163). His production of arabesque decoration underlines the association of Watteau with the relatively 'low' category of decorative or ornamental work, deemed, by his associates at the Academy, to involve craftsmanship and superficial visual effect, rather than the 'high' intellectual qualities of the liberal arts.[6] The fact that his paintings of eighteenth-century gardens inspired contemporary garden designs such as those of Horace Walpole (an English man of letters), and that his work also inspired decorative details on Meissen pottery, further emphasizes the socially fashionable (as opposed to learned) status of some of his work.

Before he came to the attention of the Academy, Watteau had become known for scenes such as that represented in *The Prospect* (Plate 164), which told no particular story and carried no easily identifiable meaning. *The Prospect* shows a *maison de plaisance* ('pleasure' or 'holiday' home) and pleasure park[7] in which members of the leisured aristocratic classes dressed in finery engage in music and conversation. Watteau completed many paintings of this type, in which fashionable people idle away their leisure time in amorous and relaxed mood. Sometimes the setting was a cultivated park; other times it was a slightly wilder scene. Such scenes were far removed from the explicit and learned

[4] Alberti's treatise *On Painting* had specified history paintings or *istorie* as the 'highest' of the genres (see Case Study 1, page 40). See also the reference to the codification of genres in Linda Walsh, 'Charles Le Brun, "art dictator of France"', in Perry and Cunningham, *Academies, Museums and Canons of Art* (Book 1 in this series), p.93.

[5] 'Intricate linear surface decoration with curves, tendrils and flowing lines based on plant forms' (from *Thames and Hudson Dictionary of Art Terms*, ed. E. Lucie-Smith). Such decorations had been popular from the Renaissance onwards.

[6] It was acceptable for artists even of the highest standing to adapt their work to decorative purposes: Le Brun had himself transposed his paintings into tapestries. Tapestries, however, were considered a 'higher' decorative form, appropriate for the expression of prestige and propaganda.

[7] Believed to be the property of Montmorency (near Paris), which belonged to the financier Antoine Crozat (1655–1740), one of Watteau's early protectors. On Crozat's role in Watteau's artistic education, see below, page 233.

Plate 160 Jean-Antoine Watteau, *The March Past*, c.1709, oil on canvas, 32.4 x 43.2 cm, York City Art Gallery, York.

Plate 161 Jean-Antoine Watteau, *Ceres*, 1715–16, oil on canvas, 141.6 x 116 cm. Samuel H. Kress Collection, © 1997 Board of Trustees, National Gallery of Art, Washington, D.C. (1961.9.50 (1413)).

Plate 162 Jean-Antoine Watteau, *The Cajoler*, 1707–12, panel, 79.5 x 39 cm, Cailleux Collection, Paris. Photo: Lauros-Giraudon.

Plate 163 Jean-Antoine
Watteau, *The Saucepan
Cleaner*, *c*.1704–5, oil on
canvas, 53 x 44 cm, Musée
de la Ville de Strasbourg.[8]

Plate 164 Jean-Antoine Watteau, *The Prospect* (Museum gives the title *View through
the Trees in the Park of Pierre Crozat (La Perspective)*), *c*.1715, oil on canvas, 46.7 x
55.3 cm. Maria Antoinette Evans Fund. Courtesy, Museum of Fine Arts, Boston.

[8] On some of the problems relating to the attribution of this painting to Watteau, see Posner,
Antoine Watteau, p.18.

Plate 165 Le Nain brothers, *The Forge*, oil on canvas, 69 x 57 cm, Musée du Louvre, Paris. Photo: R.M.N. - Jean Schormans.

historical narratives of Le Brun. Nor were they like ordinary genre paintings, which tended to show more 'everyday' activities, narratives, and settings relating to less aristocratic classes of people (Plate 165).

The status of Watteau's paintings was additionally affected by the low cultural status of some of the aspects of contemporary life that inspired him. He added to his paintings elements borrowed from popular outdoor entertainments. He was familiar with the fairs organized in Paris and took a particular interest in the theatrical entertainments of the Saint Germain fair[9] (Plate 166). This fair attracted people of all classes and walks of life. Acrobats and outdoor theatre groups performed there. A common sight was a performance by actors in the tradition of the *comédie italienne* (French for the *commedia dell'arte* or Italian theatre), a popular entertainment whose roots can be traced back to Roman antiquity. Their stock characters included Harlequin (an ingenious but often unsuccessful intriguer, see Plate 167) and Pierrot, formerly known as Gilles (a comic simpleton, often duped by others but much loved by the crowd). It is possible that the painting of Pierrot shown in Plate 168, now highly regarded, was designed to fulfil the lowly function of a signboard. One of Watteau's most influential teachers, Claude Gillot (1673–1722), painted scenes inspired by the *commedia dell'arte*. Plate 169 shows a scene from a pantomime performed in 1695. The Italian players often improvised their performances on the basis of stock plots and characters. Short, slapstick sketches based on their work, known as *parades*, were often performed at the entrance to theatres.[10] These *parades* were adopted and adapted by the aristocracy, who incorporated them into their balls and masquerades. When Watteau showed the aristocracy in settings that were sometimes stage-like and costumes that often appeared theatrical (see Plate 181), he was therefore reflecting a common form of entertainment, which had been borrowed from popular culture by the élite.[11]

[9] Held between 3 February and Palm Sunday.

[10] For a full discussion of *parades* see Crow, *Painters and Public Life in Eighteenth-Century Paris*, pp.53–6.

[11] For a related discussion of theatre and popular art forms, see Gill Perry, 'Mere face painters? Hogarth, Reynolds and ideas of academic art in eighteenth-century Britain', in Perry and Cunningham, *Academies, Museums and Canons of Art* (Book 1 in this series).

Plate 166
Anonymous,
*The Saint
Germain Fair*,
engraving.
Photo:
Bibliotheque
Nationale de
France, Paris.

Plate 167 Jean-Antoine Watteau, *Harlequin, Emperor on the Moon*, 1707, oil on canvas, 65 x 82 cm, Musée des Beaux-Arts, Nantes.[12] Photo: H. Maertens.

[12] On the theory that Watteau may have collaborated on this painting with Claude Gillot, see Posner, *Antoine Watteau*, p.53.

Artifice and subtle codes for the expression of desire played a central part in these entertainments. Graceful dances, poetry readings, musical performances, and impromptu tableaux were included. Games of ambiguity and theatrical deception were conducted in carefully stage-managed surroundings (ballrooms and parkland), which included statues appearing, 'magically', to come to life. These distractions allowed the aristocracy to define itself as a leisure class, separate from and superior to the rest of society.

If we look at Watteau's *Do You Want to Succeed with Women?* (Plate 170), we can see how this kind of theatrical activity pervades his work. The painting shows the *commedia dell'arte* figures of Harlequin and Columbine (a coquette), although it is not quite clear whether the figures depicted are supposed to be actors, or merely people in disguise. Although some of Watteau's paintings illustrate specific scenes from particular plays, many are more ambiguous, somewhere in between theatre and other kinds of social entertainment which involve disguise. Even when he uses figures in *commedia dell'arte* costume, they often represent no easily recognizable scene or action. Watteau's paintings were creations of his own imagination.

Plate 168 Jean-Antoine Watteau, *Pierrot* (formerly known as *Gilles*), 1718–19, oil on canvas, 184 x 149 cm, Musée du Louvre, Paris. Photo: R.M.N. - Jean Schormans.

Plate 169 Claude Gillot, *The Two Sedans*, c.1707, oil on canvas, 127 x 160 cm, Musée du Louvre, Paris. Photo: R.M.N. - Arnaudet.

How was the Academy to assess Watteau's status?

The Academy showed great sympathy to Watteau's talent and broke its own rules by leaving the subject of his reception piece entirely up to him. Unlike many of his other works, his final choice, the *Pilgrimage to the Island of Cythera*, may possibly, from the title, tell a specific story. It was perhaps based on the final scene of a play, *Les Trois Cousines* (*The Three Cousins*), by the actor and playwright Florent Dancourt (1661–1725), in which a group of friends join a pilgrimage to Cythera in order to find partners in love.[13] Significantly, however, the Academy changed the painting's title to *Une Feste Galante* (modern spelling *fête galante*, a 'feast' or 'celebration' of gallantry), which effectively separated it from the scholarly and morally serious narratives of the history genre. Watteau was acknowledged, in effect, as the creator of a new genre, the *fête galante*. The apparent rigidity of the hierarchy of genres was relaxed in order to make space for a new category which would rate, in

[13] In '*L'Embarquement pour Cythère* de Watteau, au Louvre', Charles de Tolnay explores this connection with Dancourt's play. He also discusses the differences between the three versions of this subject painted by Watteau.

terms of status, somewhere between history and genre. The *fête galante* had the 'poetic' or idealizing qualities of history painting, but not its scholarship, classical roots, or moral instruction. There were precedents for Watteau's scenes of outdoor gallantry in paintings such as *Country Party* (Plate 171; then in the royal collection at Versailles) – originally thought to be a late work by the Venetian artist Giorgione (*c*.1478–1511) but later more generally accepted as an early picture by his pupil, Titian – and *Garden of Love* (Plate 172) by the Flemish artist Peter Paul Rubens (1577–1640). However, Watteau's sources did not include the more learned (according to the

Plate 170 Jean-Antoine Watteau, *Do You Want to Succeed with Women?*, *c*.1718, oil on canvas, 36 x 25.9 cm. Reproduced by permission of the Trustees of the Wallace Collection, London.

Plate 171
Titian
(formerly
attributed to
Giorgione),
Country Party,
*c.*1510, oil on
canvas, 110 x
138 cm, Musée
du Louvre,
Paris. Photo:
R.M.N. This is
an example of
the genre *fête
champêtre* (rural
festival).[14]

Plate 172 Peter Paul Rubens, *Garden of Love*, *c.*1634, oil on canvas, 198 x 283 cm, Museo del
Prado, Madrid.

[14] This genre is a precursor of the *fête galante*. Paintings of this type depict figures enjoying the pleasures of an open-air setting. The mood is often one of reverie, the figures appearing to be affected by the beauty of the pastoral landscape and, frequently, music (adapted from *The Dictionary of Art*, ed. J. Turner).

Academy) Roman school, with its emphasis on carefully drawn forms and morally austere subjects – the 'highest', intellectual aspects of art. In 1717, by admitting Watteau, but not as a history painter, the Academy both welcomed and snubbed him.

Watteau's paintings drew upon aspects of contemporary culture with a broad social appeal, and as such were generally popular with buyers and patrons and commercially successful. By 1713–14, Watteau had become an independent master and could make his living from his paintings and by selling his services as a decorator. The subjects of some of Watteau's most successful paintings were chosen by himself or made for collectors, dealers and antiquaries, financiers, merchants, the minor nobility, and government officials rather than for the aristocracy he depicted. In the early eighteenth century, after the decline of the court at Versailles, members of the wealthy middle classes with a lively interest in the arts became interested in buying from dealers or becoming antiquaries themselves.[15] It may well be the case that the popularity of Watteau's subjects with buyers exerted pressure on the Academy to broaden its interests and secure his membership, even though he could not be admitted as a practitioner of the highest genre. The Academy had to tread a fine line between maintaining its high ideals and retaining the support of the public, not least because educated members of that same public could help to secure important commissions. The Academy's practice of receiving artists within categories of membership defined by the hierarchy of genres had to become more flexible.

After Watteau's death, the people who bought his paintings disseminated them through a dealer network, centred mainly on the circles in which friends such as Antoine Crozat (see footnote 7 on page 223) moved, to wealthy collectors (such as Frederick the Great of Prussia), who helped to spread the paintings across Europe. By the 1770s, his works fetched high prices and enjoyed a higher status with buyers. The popularity of his work with an expanding and more prestigious buying public helped to keep it in the public eye until the time was ripe for a dramatic leap in his standing with the critical establishment.

Watteau's depiction of contemporary high society was part of his commercial success and in the eighteenth century many critics admired his concern with social reality. But this did not qualify his work as 'high' art; nor were his technical skills greatly appreciated in his own century. Denis Diderot (1713–84), an influential thinker, novelist, playwright, and art critic, declared that he would give ten paintings by Watteau for one by the Flemish artist David Teniers (1610–90). In 1762, the critic Dezallier d'Argenville wrote, 'The taste he has followed is appropriate to dalliance and revelry rather than serious subjects' (Levey, *Rococo to Revolution*, p.57). There were similar doubts about his style.

[15] One of Watteau's earliest commissions, a battle scene, was for the father-in-law of Edmé Gersaint (1694–1750), a picture dealer. He later painted another work, *Gersaint's Signboard*, for display at Gersaint's shop (see Plate 139).

Watteau's training and style and his status as an artist

Training

Watteau was born in the town of Valenciennes, near the Flemish border[16] and much of his early artistic activity in his home town consisted of sketches of street scenes. He undertook a painter's apprenticeship but, at that time, artists who operated outside the Academy were still very much regarded as craftsmen. He became a kind of journeyman, odd-jobbing for those artists who needed assistance with commissions. When he moved to Paris he was employed in a workshop responsible for the mass production of devotional images for provincial merchants, who bought them in bulk. In such workshops each apprentice specialized in a particular part of the images – skies, heads, draperies, highlights.

After being taught by Gillot, who specialized in decorative work, some of it for the Paris Opera, Watteau became a pupil of Audran. Audran specialized in arabesques, influenced by fairground culture, which were intended for the decoration of ceilings and panelling. Audran introduced Watteau to the works of Rubens (such as the Marie de' Medici cycle) at the Luxembourg Palace in Paris. Watteau later received protection and lodgings from his friend Comte de Caylus (1692–1765), an archaeologist, critic, engraver, and patron, and Crozat, who increased Watteau's familiarity with Flemish and Italian artists such as Van Dyck and Titian. According to Caylus,[17] Watteau was much more interested in the colouristic effects and rapid, delicate touch of some of these artists than in the compositional and drawing techniques of other history paintings. His artistic education and training were therefore only marginally connected with the methods and priorities of the Academy.

Style

Look again at Watteau's *Pilgrimage to the Island of Cythera* (Plate 158) and Le Brun's *Theseus Abandons Ariadne at Naxos* (Plate 159). What differences in style and handling of paint can you see between Watteau's *fête galante* and the academic history painting of Le Brun? (It is difficult to comment on brushwork or the handling of paint when working from reproductions, but have a go: try to work out how distinct and how 'loose' individual brush strokes appear.) When thinking about style, focus on colour, light, the approach to facial expression and to the human form. Your immediate impressions are the most important.

Discussion

Brushwork and handling of paint

In Watteau's painting we can see, even from a reproduction, how the paint is applied in small dabs or streaks – look, for example, at the leaves and the highlights on the costumes of the right-hand figures (see Plate 173). Le Brun's painting seems to offer a smooth paint surface or 'finish', in which it is difficult to detect individual brush strokes, although we can detect smaller dabs of

[16] The town had originally been Flemish and became French seven years before Watteau's birth.

[17] In a posthumous tribute to Watteau, read to assembled members of the Royal Academy on 3 February 1748 (reproduced in Goncourt, *French Eighteenth-Century Painters*, pp.10–33).

Plate 173 Jean-Antoine Watteau, detail of right-hand side of *Pilgrimage to the Island of Cythera* (Plate 158). Photo: R.M.N. - Jean Schormans.

paint in the leaves of the trees. The surface texture of Watteau's painting is much less even and there is a kind of 'shimmering' or 'sparkling' effect provided by small adjacent patches of light and shadow and by the reflection of one colour in another. You can see this in the figures' costumes and in the variations within the foreground grassy bank. Contrast this with Le Brun's painting, in which there are broader areas of more uniform colour (in, for example, the boat and sandy beach) and less surface 'dazzle'.

Colour

As well as the greater emphasis on surface effects, there is a greater range of colours used in the figures in Watteau's painting than in Le Brun's.

Light

There are frequent contrasts of light and shade in Watteau's painting, unlike the broader, unifying light which falls on Le Brun's figures. In Le Brun's painting the background is uniformly lit so that it seems flat, almost like a theatre backdrop, whereas Watteau's is alive with frequent tonal variations (or contrasts of light and dark areas). Again, there is a most unacademic 'dazzle' or emphasis on visual effect. Watteau's landscape exploits the rich potential of aerial perspective, that is, the method of suggesting depth and distance which is based on the way in which the atmosphere (and the light and particles within it) affect human sight: with distance, outlines become less precise; small details are lost; hues become more blue; colours become paler and colour contrasts more pronounced.

Plate 174 Charles Le Brun, *Sadness*, c.1668, pen on paper, Musée du Louvre, Paris, Département des Arts Graphiques inv. no. 28304. Photo: R.M.N.

Facial expression

Le Brun's faces have detailed features and expressions. He devised prototypes (see Plate 174) as a guide for other history painters. Watteau's faces, by contrast, give away very little. Many are turned away from us. We see facial features in far less detail. Look at the lady in the centre turning back to glance over her shoulder: it is her pose and the tilt of her head, rather than any explicit facial features, which seem to express a kind of melancholy or regret. Watteau's style does not provide the high degree of narrative legibility demanded of academic art.

The human form

There is a greater emphasis on bodily structure and detail in Le Brun's figures – their proportions, the articulation of their limbs, their musculature – than in Watteau's elaborately clothed figures.

◆◆◆

In many ways, Watteau's style of painting went against the grain of academic conventions and priorities. The Academy preferred a smooth paint finish and was suspicious of attempts to dazzle the eye by experimenting with the different textural and tactile effects of a looser finish: they would detract from the intellectual business of viewing art. Watteau's revelry in experiments with brushwork can be seen in the detail in Plate 158, where the smooth brushwork of the stockings of the man to the right of the dog contrasts with the dabs of paint representing the leaves and the broader strokes of the sky.

A controversial contemporary topic was the relative importance of colour in determining the status of a work of art. Many academicians, including Le Brun, had decided that although both colour and design were essential to

painting, design must be of greater importance. Others championed colour.[18] For Le Brun, while design was a spiritual creation, colour was 'merely' a physical property of objects:

> It must be considered that colour in painting cannot produce any hue that does not derive from the actual material which supports the colour, for one would not know how to make green with a red pigment, nor blue with a yellow. For this reason it must be said that colour depends entirely on matter, and, as a result, is less noble than design, which comes directly from the spirit.
>
> (Hourticq, *De Poussin à Watteau*, p.49, trans. L. Walsh)

In placing so much emphasis on effects of colour Watteau was, then, to some extent aligning himself with those who questioned academic prejudices or priorities.

Similarly, the dazzling tonal variations in his work went against the academic preference for broader, more unified effects of light and shade. The sense of movement or visual rhythm evident in Watteau's work was typical of the Rococo style. The term 'rococo' is often applied to art of the first half of the eighteenth century produced by Watteau and the French artist François Boucher (1703–70) as well as to the work of another French painter, Jean-Honoré Fragonard (1732–1806). It was originally a term of abuse invented at the end of the eighteenth century to describe art that was felt to be decorative, fanciful, and frivolous.[19]

Watteau's approach to facial expression did not provide the high degree of narrative legibility demanded of academic art. Nor did his figure drawing style apply the boldly delineated forms derived from observation of antique statuary followed by the Academy. In his posthumous tribute to Watteau (see footnote 17 on page 233), Caylus commented that Watteau had never formally studied anatomy. Nor had he drawn from the nude: he found such aspects of academic study disagreeable. When drawing the human figure he did not refer to classical models. Nor did he use a lay figure:[20] he preferred to work from nature or observation of everyday life. Nevertheless, his figure drawings (see Plates 175 and 176) were often incorporated into his paintings: in some cases they were executed with a particular painting in mind, in others not. When used in paintings, their poses were not always adjusted in relation to those of other figures: hence they often appear to turn strangely away from their neighbours. Caylus felt that in many ways Watteau took more pleasure in drawing than any other aspect of his work.

It has been suggested (by Tom Crow, *Painters and Public Life in Eighteenth-Century Paris*, pp.72–3) that Watteau's art provided an outlet for the life of the senses (visual recreation as well as a hint of erotic desire), which was denied by the more intellectual priorities of academic art, and found an opportune audience in those who prioritized such pleasures. Unlike

[18] See Linda Walsh, 'Charles Le Brun, "art dictator of France"', in Perry and Cunningham, *Academies, Museums and Canons of Art* (Book 1 in this series).

[19] The word derived from *rocaille*, a French word meaning rock and shell work for grottoes and fountains. Stylistically, Rococo art made extensive use of the S curves found in shells (think of the undulating arrangement of figures and light in the *Pilgrimage to the Island of Cythera*), asymmetrical forms, and pastel shades such as rose pink and sky blue.

[20] Jointed wooden model which can be arranged in different poses and which is used by artists to study the proportions of the human body.

Plate 175 Jean-Antoine Watteau, figure study/drawing for *Pilgrimage to the Island of Cythera*, c.1717, red, black, and white chalk, 33.6 x 22.6 cm. © The British Museum, London.

Plate 176 Jean-Antoine Watteau, *Three Studies of a Seated Woman*, 1716–17, black, white, and red chalk and pencil on beige paper, 22.6 x 29.3 cm, Musée du Louvre, Paris. Photo: R.M.N.

conventional academic art, Watteau's works emphasized the expressive and decorative potential of colour as well as the effects to be gained from paint as a physical, material substance. Caylus prided himself on his balanced assessment of the artist's strengths and weaknesses. He expressed concern at Watteau's tendency to slop paint thickly onto the canvas, using large dollops of oil to correct errors or spread paint around – particularly as Watteau was known to let dirt and dust get into his paint. He no doubt sensed how controversial such a technique would have been to academicians aiming, officially at least, at a precise finish. In style and technique too, therefore, Watteau was disqualified from the highest forms of artistic status available to contemporaries.

The influence of critical interpretation on the status of the artist

Watteau received no great critical acclaim in his lifetime. His critical fortunes were at an ebb in the late eighteenth century, when French revolutionary fervour was not conducive to admiration of paintings of the leisured aristocracy. The pupils of Jacques-Louis David (1748–1825), the French neo-classical artist who specialized in scenes of Roman republican and patriotic fervour, are said to have flicked bread in disgust at Watteau's *Pilgrimage to the Island of Cythera*. However, this situation was to change. Watteau's art was well known and increasing numbers of people came to appreciate it. The nineteenth-century novel *Cousin Pons* (1847) by Honoré de Balzac (1799–1850) focused on the rising prices of Watteau's works and the machinations of those determined to own them. This growth in popularity was crystallized when the brothers Edmond (1822–96) and Jules (1830–70) de Goncourt undertook their survey of what they considered to be the greatest art of the eighteenth century. The Goncourt brothers were French novelists, playwrights, collectors, and art critics who, lacking interest in much of the art and social and political change of their own time, turned to the art of the eighteenth century with a kind of sentimental longing for a past age of wit, gallantry, and gentle living. Such attitudes were becoming popular among those from both ends of the political spectrum wishing to reject the bourgeois, materialistic attitudes that they saw as the result of the Revolution. The Goncourts' essay on Watteau's art, the first in their book *French Eighteenth-Century Painters*,[21] written between 1859 and 1875, perhaps said as much about their own frustrations and fantasies as it did about Watteau. They shared a deeply conservative nostalgia for the fine living of pre-Revolutionary France. Their rhapsodic and euphoric style of writing blurred the boundaries between poetry and criticism and they indulged in a literary reconstruction of Watteau's personality derived from other writers of the Romantic movement in literature. Dedicated scholars of art, the Goncourt brothers collected many documents relating to Watteau's life and work. They wanted to carve a place for him in the canonical group of artists constituting the very best of the 'French school'.

[21] Extracts from this work are included in Edwards, *Art and its Histories: A Reader*.

The Goncourts were not the first to rediscover or celebrate Watteau, but they enhanced his critical standing in an unprecedented way. They celebrated Watteau's technique, particularly his graceful touch which suggested 'that subtle thing that seems to be the smile of a contour, the soul of a form, the spiritual physiognomy of matter' (*French Eighteenth-Century Painters*, p.1), as well as his rhythmic compositions and the beauty of the costumes he created. These were seen as the most appropriate treatment of the romantic and gallant subjects he chose, a charming 'lovers' kingdom' cut out with 'beribboned scissors' (p.6). Unlike Watteau's academic contemporaries, the Goncourts took an almost nationalistic pride in what they described as his 'erotic' brushwork: this, they said, was typically French. But the Goncourts' discussion of Watteau also brought to a new intensity a trend within the Romantic movement that was to have a long-reaching influence on subsequent interpretations of the artist's works: a tendency to explain them in terms of the biographical and psychological detail relating to the artist himself. In the remainder of this case study we will be looking at the ways in which this approach has shaped the reputation of the artist, the meanings attached to his works, and at more recent challenges to this approach.

The Romantic artistic personality

'Sombre and melancholic, like all persons of atrabilious[22] disposition' (Goncourt, *French Eighteenth-Century Painters*, p.32) – this was Caylus's description, in terms of ancient physiology,[23] of Watteau's temperament: melancholy, a kind of black bile,[24] gave rise to the 'atrabilious' or ill-tempered personality. But Caylus distinguished carefully between Watteau the man and 'the Wateau [*sic*] of his pictures': the mood of his work was often 'tender, agreeable, faintly bucolic' (Goncourt, *French Eighteenth-Century Painters*, p.22). The Goncourt brothers, however, emphasized this melancholic temperament and saw it expressed in many aspects of Watteau's work: they saw the meaning of the paintings in the temperament of the artist. They deployed the Romantic conception of the artist as a suffering soul, alienated from society and prey to an early death.[25] According to the Goncourts (*French Eighteenth-Century Painters*, p.46), Watteau 'announced the type of the modern artist in the fine, the disinterested sense, the modern artist in pursuit of an ideal, despising money, careless of the morrow, leading a hazardous – and, I had almost said, if the word had not sunk so low, a bohemian – existence'.[26] His disdain for commercial transactions was legendary and used as further proof of his absorption in inner suffering. This critical tradition persisted well into the twentieth century, inevitably colouring interpretations of both Watteau and his paintings. In more recent times the myth of 'melancholic Watteau' has been challenged and deconstructed: like a form of superstition its foundation has been undermined, its workings and applications exposed to scrutiny.

[22] From the Latin *atra bilis*, black bile.

[23] See Case Study 6, page 153.

[24] From the Greek *melagkholia*, black bile.

[25] The image of the artist or poet as 'cursed' was common in Romantic poetry, such as that of the French poet Charles Baudelaire (1821–67).

[26] The term 'bohemian', derived from Bohemian travellers, signified in the nineteenth century the socially unconventional, living on the margins of society.

The Goncourt brothers felt that, beneath the erotic charm of Watteau's art, there lay a melancholy reflection of the artist himself. Read their thoughts on this subject in the extract below. As you read, jot notes in answer to the following question. How do the Goncourt brothers attempt to establish a relationship between Watteau's art and personality?

It is indeed true that in the recesses of Watteau's art, beneath the laughter of its utterance, there murmurs an indefinable harmony, slow and ambiguous; throughout his *fêtes galantes* there penetrates an indefinable sadness; and, like the enchantment of Venice, there is audible an indefinable poetry, veiled and sighing, whose soft converse captivates our spirits. The man impregnates his art; and it is an art that we are made to look upon as the pastime and the distraction of a mind that suffers, as we might look, after its death, upon the playthings of an ailing child.

The painter stands revealed in his portrait. First, that vivid portrait of his youthful appearance: a thin, anxious, nervous face; arched, feverish eyebrows; large, restless, black eyes; a long, emaciated nose; a dry, sad, sharply defined mouth – with the extremities of the nostrils extending to the corners of the lips – a long fold of flesh seeming to distort the face. And from one portrait to another, almost as from one year to another, we may observe him, always melancholy, always getting thinner, his long fingers lost in the full sleeves, the coat doubled over on his bony breast, old at thirty, his eyes sunken, tight-lipped and angular of face, only preserving his fine brow relieved by the long curls of a Louis XIV wig.

Or, rather, let us look for him in his work: that figure with the eyeglass or that flute player – it is Watteau. His eye rests negligently upon the entwined lovers, whom he diverts with a music to whose flow of notes he gives no heed. His silent glances follow the embraces, and he listens to the love-making, listless, indifferent, morose, consumed by languor, and weary, like a violin at a marriage of the dances it directs, and deaf to the sound, to the song of his instrument.

(*French Eighteenth-Century Painters*, pp.8–9)

Discussion

In the first paragraph the Goncourt brothers suggest that Watteau 'impregnates his art': his spirit is there beneath its surface, penetrating it with sadness and suffering. They then go on to reinforce their impression that Watteau was sad and suffering by referring to portraits of the artist, in which he seems to be progressively more wasted and withering, reaching an early death in his thirties. In the final paragraph they suggest that Watteau bases some of the figures in his works on himself: from their description he seems to play the part of the melancholy outsider.

◆◆

Watteau did die in his thirties. Furthermore, we know that he suffered from tuberculosis. Edmé Gersaint (see footnote 15 on page 232) referred to him as in 'poor health', 'anxious', 'discontented with himself', 'a little melancholy', and as possessing a generally difficult personality.[27] The portraits of Watteau by himself, Boucher and the Italian painter Rosalba Carriera (1675–1757) (Plates 177, 178, and 179) could be interpreted as expressing a melancholic inwardness, but did the Goncourts read too much into such portraits? Watteau worked hard until his death (his last work was a Crucifixion) and did not act like a man who was slowing down until the very end. Also, as Posner suggests (see footnote 3 on page 222), many eighteenth-century commentators had interpreted his work as joyful fantasies.

[27] *Catalogue de la collection du feu M. Quentin de Lorangère*, 1744, quoted in Brookner, *Watteau*, p.22.

Plate 177 Louis Crépy, *A. Wateau* (*sic*), 1797, engraving, after Jean-Antoine Watteau, *Watteau* (self-portrait, original painting lost), École Nationale Supérieure des Beaux-Arts, Paris.

Plate 178 François Boucher, *Watteau*, c.1722, red, black, and white chalk, 21.3 x 23.8 cm, Musée Condé, Chantilly. Photo: Giraudon.

Among the paintings that are thought to include a figure representing Watteau himself is his *Venetian Festivities* (Plate 180). This shows a couple dancing rather stiffly, watched by others engaged in conversation. Near the end of a wave-like grouping of people between the dancing lady and the right-hand side of the image is a man playing bagpipes. He is quite still and needs to expend relatively little effort as air is pumped, rather than blown, into his pipes. This figure is taken to be Watteau. It is thought that the subject of the painting was suggested by a dance sequence in a contemporary ballet that was often performed at the Paris Opera, entitled *Les Fêtes Vénitiennes*. The painting is also thought to contain other biographical or contemporary references. The 'dancing' woman is sometimes identified as the actress Charlotte Desmares. The man on the extreme left is believed to be the Flemish painter Nicolas Vleughels, with whom Watteau shared a house in Paris in 1718 and 1719. His oriental costume is thought to have been inspired by drawings made by Watteau in 1715. A figure in a black cloak looks back at Vleughels as he gestures towards a nude statue which seems to be coming to life in the theatrical manner described earlier: Watteau's art often plays on such ambiguities of marble/flesh, stage/life.

Plate 179 Rosalba Carriera, *Watteau*, 1721, pastel, 55 x 43 cm, Museo Civico, Treviso.

Plate 180 Jean-Antoine Watteau, *Venetian Festivities*, *c*.1717, oil on canvas, 56 x 46 cm, National Gallery of Scotland, Edinburgh.

The scholar Norman Bryson[28] considers that the figures in this painting 'imply more than they state' (*Word and Image*, p.73). As is often the case in Watteau's *fêtes galantes*, there is no clear narrative for us to hold onto. This has encouraged modern commentators to read the images in terms of their emblematic or symbolic qualities: in this case, the bagpipe as a symbol of the male sexual organs;[29] the goat on the urn as a symbol of lust; the statue coming to life a sign of stirring desire, so that the whole painting becomes a coded reference to repressed desire. This focus on erotic symbolism, to which both eighteenth-century and modern commentators have been alert, undermines

[28] Bryson uses a semiological approach (see page 245) in order to reach his conclusions about Watteau.

[29] On this coded reference, see Crow, *Painters and Public Life in Eighteenth-Century Paris*, p.63.

somewhat more melancholy, Romantic interpretations of Watteau's art.[30] But the Romantic search for biographical resonances also remains popular. Thus, we might focus on Watteau the bagpipe player, a kind of sad clown, his body 'fully tubercular: haggard and wasted, the face anxious and nervous, the eyes dark and restless, he is already at death's door' (Bryson, *Word and Image*, p.66). Bryson explains how generations of critics and scholars, encouraged by the Goncourts, have read into Watteau's paintings expressions of the artist's invalidism, reverie, melancholy, and psychological depth. Their subtle use of visual effects encourages elaborate discursive (literary, verbal) readings, culminating in Michael Levey's reading of Watteau's *Pilgrimage to the Island of Cythera* (see footnote 3 on page 222) as a melancholic departure.

However, the elusive meanings of Watteau's works, which are open to many interpretations, should serve to warn us against any convenient 'melancholic' reading of them. As we saw earlier, Watteau's reception piece, *Pilgrimage to the Island of Cythera*, has been variously interpreted, over time, as a scene of both contented and melancholic love. It is tempting to fill what Bryson calls the 'semantic vacuum' of Watteau's work by letting biographical and psychological aspects of the artist fill the gap, but this would be to deny the work its complexity.

When the Goncourts indulged in interpretations of Watteau as sickly music- or art-maker, they were influenced by Romantic conceptions of art and its making that resulted in a kind of mythologizing of the artist. According to the writers and theorists of the Romantic movement, which had dominated much art and literature of the late eighteenth and early nineteenth centuries, art was above all a means of expressing the inner feelings and personality of the artist. We are now so accustomed to this idea that we find it unsurprising. To those accustomed to the methods and teaching of the Academy, however, in which learning, intellect, and the acquisition of classical drawing skills were paramount, a 'Romantic' conception of the artist did not seem so obvious. The Academy had laid down such a testing scheme of study and such an influential hierarchy of subjects that there was relatively little encouragement to artists to turn to their own emotions for inspiration. Whenever they *were* asked to study their own emotions, this was normally in the interests of appreciating more precisely the idealized facial expressions and bodily poses of classical sources. But the Goncourts were well attuned to the idea that the most authentic art was that which expressed the artist's sensibility (feeling) or 'inner truth'. They had also inherited from Romanticism the traditional notion of the 'genius', which had evolved by the end of the eighteenth century into a kind of ideal human type (akin to the heroes, sages, saints of previous ages) and a representation of the artist as someone fired spontaneously by imagination and emotion, rather than by reason or intellect. The German artist Caspar David Friedrich (1774–1840) summed up the priorities of the Romantic artist when he said, 'The artist's feeling is his law' (Vaughan *et al.*, *Caspar David Friedrich*, p.102). With such attitudes in mind the exploration of an artist's life and feelings became viewed as a legitimate way of deriving meaning from and attributing status to his or her works of art.

[30] In the *Pilgrimage to the Island of Cythera*, one of the putti (winged cherubs) flying near the ship carries a torch, a symbol of the flames of love; the scallop shell (the French word for which was *coquille*) would have been recognized by eighteenth-century viewers as a punning reference to female genitalia.

Sign and meaning: the 'death' of the author/artist

These biographical and psychological methods of interpreting and evaluating Watteau's art have been undermined by a method of analysing art, literature, and verbal language known as structuralism. Structuralism, an approach borrowed by art history from literary theory, has since been refined, challenged, or replaced by a host of other ways of looking at art, but it changed fundamentally the Romantic assumptions on which many preceding analyses had been based. The theory, popular in art history from the 1970s onwards, derived from the views of the linguist Ferdinand de Saussure (1857–1913) on the structures underlying the workings of language and was further developed and modified in the work of writers such as Barthes.[31] A structuralist analysis of art draws on the rules governing the 'grammar' of art. We can study verbal language to see how individual letters, sounds, and words are combined within structures of meaning: opposite terms such as 'thick' and 'thin' help to define one another; other words (such as 'grand', 'noble', 'magnificent') are linked by the association of their meanings, reinforcing our understanding of the contexts in which they appear. In a similar way, we can study visual language (marks on the canvas; combinations of shapes and colours which make up representations of particular facial expressions; clusters of objects within a particular compositional framework; contrasts of light and dark, bright and dull; and so on) to see what structure or communicative system underlies it. In each case it is the deep, underlying *structure* of the painting, poem, or novel, the interrelationship of its constituent elements (words, shapes, brushstrokes), that counts, rather than a description of its surface content (what it is 'about' or what recognizable objects it shows). Any reference outwards from the work of art to what might be 'true' or 'real' in the outside world (or in the artist) is not the primary route to its essential meaning. The fact that we can recognize in a painting something approximating to a real tree is significant, but less so than the way in which the shape, colour, light, and other characteristics of that tree trigger ideas in association with other elements of a painting. The amount of realistic detail in a visual form will vary according to the particular visual language or code within which it functions. Thus, a face painted by Rembrandt will signify a number of ideas within a language or code of detailed psychological insights, but if we simply want to signify the simple ideas, 'face' or 'smile', the minimal marks ☺ will suffice.

In structuralist analysis the author (or artist) is 'dead', in the sense of irrelevant, since a work of art is no longer regarded as the expression of an individual human identity. The artist uses a set of signs or signals in the same way that we all use verbal language when we speak, and it is the system of relations between these signs which is the real key to meaning. In other words, the artist's views, intentions, and feelings are less important in the final

[31] For a summary of the main development and significance of structuralism, see Fernie, *Art History and its Methods*, pp.19, 20, 352, 359.

interpretation of his work than the internal force and logic of the signs used. These signs derive from a deeper and more extensive social and aesthetic reality than can be formed or encapsulated in an individual's thinking or creativity. This movement away from an individual artistic identity (alongside a corresponding movement away from conventional arguments about the 'quality' of a work of art) threatens the basis upon which many judgements of the canonical value of art have, traditionally, been made.

The study of non-verbal signs is usually described as semiotics or semiology. The basic element of visual language, the *sign*, is made up of two parts: a *signifier* (a mark or combination of marks on the canvas) and a *signified* (a thought or concept evoked in our minds by that particular signifier). The signified can be a specific visual idea (such as the idea 'goat' conjured up by the particular configuration of marks in *Venetian Festivities*), or a broader, more general idea (such as 'animal' or 'rural'). Think of a painted red circle on a white rectangular canvas. If you see nothing else on the canvas, you might read this simply as a red circle, both the colour and the shape of the painted form being defined, in part, in relation to the white, rectangular canvas on which they might appear. If the red circle now appears in a vertical arrangement with amber and green circles, however, you might read it as a traffic light or as signifying the idea 'stop'. The underlying structure and internal relationships of the painting have changed and these relationships are crucial to meaning: they lead us to associate the signifier (the red circle) with a different signified.

The relationship between signifier and signified can vary from one language (verbal or visual) to another. This is why it is so important for us to work out the system or structure of the particular visual language within which a painting is operating. Take, for example, the goat (on the urn) in Watteau's *Venetian Festivities*. I have already said that the marks made in the relevant section of this painting could signify the simple idea, 'goat'. It might, however, be possible to read this section of Watteau's painting as part of yet another language or signifying system, because of its context or relationship with other signifiers in the painting he completed: the glances and gestures of the pairs of figures, the erotic statue, the brushwork of trees and costumes which seems to appeal to the senses. Once we see the goat in this different signalling (sign) system or *language*, we can associate it with the signified, lust. (The goat was often associated with the gods of nature and fertility, Bacchus and Pan, and the lusty satyrs of Roman mythology.) In order to guess this, we would have to have some knowledge of the symbolic visual language in play in some eighteenth-century paintings.[32] We have to know how a particular sign system works before we can interpret individual elements within it. And herein lies one of the principal difficulties of a semiological approach. In emphasizing the internal structures and relationships of language, it neglects the relationship between language and its historical context.

[32] We should note here that a structuralist account of a painting will incorporate an iconographic account (see Case Study 6). The symbol is just one of the different types of sign that contribute to the painting's meaning; others include the way in which the paint is applied, the pose and positioning of figures, and the use of light.

Plate 181 Jean-Antoine Watteau, *Outdoor Recreation*, c.1717, oil on canvas, 60 x 75 cm, Gemäldegalerie Alte Meister, Dresden.

Study Plate 181, a reproduction of Watteau's *Outdoor Recreation*, and then answer the following questions.

1 What possible signifieds might you derive from the following signifiers, viewed in relation to one another: the poses, activities, faces, and costumes of the figures; the use of light; the painted landscape; the details of the foreground setting? (As this is an introductory exercise in terms of this topic, I will offer the kind of clue which, for self-respecting structuralists, would be deemed irrelevant: think of the title of the painting. I will also offer a looser version of the question, to get you started: what network of associations or ideas do the poses, activities, etc. taken together trigger in your mind?)

2 Can you think of any alternative set of signifieds with which you might want to associate these signifiers?

3 Do you see any problems in conducting this kind of analysis?

Discussion

1 When I look at the painted poses, actions, faces, and costumes of the figures I associate them with notions of finery (the silk costumes), ease (the relaxed poses), sunshine (falling on the figures), and pleasure (the actions seem leisured rather than functional; the faces, turned to one another, suggest social intercourse and amusement). I am tempted to think I am locating these signifiers within the right visual language because of their relationship to others (the tall trees and stone structures of a park or garden; the carefully positioned resting place).

2 Did you think of any other relevant code or language? It occurred to me that the whole painting could be 'decoded' as theatrical performance. In this case, the stone platform of the foreground could act as a signifier for the signified, stage. The light becomes a theatrical spotlight, the figures' costumes become theatrical costumes, and the landscape, viewed in relation to all of these, becomes a painted stage backdrop.

3 The main difficulty, it seems to me, arises from trying to put together or decide between the different references made in 1 and 2 above. Watteau's work is renowned for its ambiguities: the signifiers are so subtle and open to varied interpretations that they suggest a range of possible signifieds. Look, for example, at the extreme left: is this an inanimate statue or a moving human form – a 'living statue' perhaps? (As noted earlier, such statues were a common feature of aristocratic garden parties.) If Watteau's painting is an extreme example of such ambiguity, there are surely many other paintings in which a structuralist reading causes similar problems? The idea of 'decoding' implies that the viewer may access a single, unambiguous meaning. In most works of art, meaning is not so easily fixed.

The other difficulty you may have found lies in the fact that signifiers seem to function not simply as part of a deep structure within a painting, but also as a visual shorthand for historically explicit phenomena – such as the fashion for living statues. Without knowledge of the social, historical, and cultural context of a particular painting, it is difficult to offer any thorough or convincing 'decoding'.

◆◆◆

It is important to be aware of structuralism as one possible approach to identifying the meaning of a work of art. However, the theory has its critics and you should try to make your own evaluation of how useful you feel it is.

Conclusion

In his own time, the hierarchical values of the Academy had a great influence on the status of Watteau and his work. Even then, however, social fashions and market forces supplied a different way of acquiring status. Since the eighteenth century, Watteau's status, as we have seen, has been affected by the different criteria suggested by always evolving critical and historiographical concerns. Structuralism undermined the assumptions of Romanticism. However, with a recognition of the inability of the structuralist sign to signify effectively independently of any historical precision, there is, currently, a great deal of interest in interpreting Watteau's art in the light of the prevailing cultural practices of his time. Crow has opened up various ways of reading Watteau's work in terms of contemporary social and cultural politics. In *Watteau's Painted Conversations*, Mary Vidal, drawing on more refined, socially élitist aspects of Watteau's works than Crow, has looked at the relationship between both the content and style of Watteau's art and the manner and content of the art of conversation in the early eighteenth century. These analyses tend to 'bypass' the artist as an individual in order to view his work as part of a broader network of cultural values and practices. At the time of writing (1998), it remains largely unfashionable in academic circles

(except in psychoanalytical approaches to art) to place too much emphasis on the personal experiences of artists when discussing or interpreting their works. The artist-as-personality seems to veer between commercial super-stardom (ample details of their life experiences feature in blockbuster exhibitions and Sunday supplement features) and academic neglect.

References

Brookner, A. (1967) *Watteau*, London, Hamlyn.

Bryson, N. (1981) *Word and Image*, Cambridge University Press.

Crow, T.E. (1985) *Painters and Public Life in Eighteenth-Century Paris*, New Haven and London, Yale University Press.

Edwards, S. (ed.) (1999) *Art and its Histories: A Reader*, New Haven and London, Yale University Press,

Fernie, E. (ed.) (1995) *Art History and its Methods: A Critical Anthology*, London, Phaidon.

Goncourt, E. and J. de (1948) *French Eighteenth-Century Painters*, London, Phaidon.

Hourticq, L. (1921) *De Poussin à Watteau*, Paris.

Levey, M. (1961) 'The real theme of Watteau's *Embarkation for Cythera*', *Burlington Magazine*, vol.103, pp.180–5.

Levey, M. (1966) *Rococo to Revolution: Major Trends in Eighteenth-Century Painting*, London, Thames & Hudson.

Lucie-Smith, E. (ed.) (1984) *Thames and Hudson Dictionary of Art Terms*, London, Thames & Hudson.

Perry, G. and Cunningham, C. (eds) (1999) *Academies, Museums and Canons of Art*, New Haven and London, Yale University Press.

Posner, D. (1973) 'Watteau mélancolique: la formation d'un mythe', *Bulletin de la Société de l'Histoire de l'Art Français*, pp.345–61.

Posner, D. (1984) *Antoine Watteau*, Ithaca, Cornell University Press.

Tolnay, C. de (1955) '*L'Embarquement pour Cythère* de Watteau, au Louvre', *Gazette des Beaux-Arts*, vol.45, pp.92–3.

Turner, J. (ed.) (1996) *Dictionary of Art*, London, Macmillan.

Vaughan, W., Börsch-Supan, H., and Joachim Neidhardt, H. (1972) *Caspar David Friedrich 1774–1840: Romantic Painting in Dresden*, London, Tate Gallery.

Vidal, M. (1992) *Watteau's Painted Conversations*, New Haven and London, Yale University Press.

Conclusion

KIM WOODS

The theme of this book has been the shifting nature of ideas about artists and their status over time and place. Through the individual case studies we have uncovered a more varied picture of artistic status than the 'one' represented to us in everyday mythology or in a linear history. We have emphasized the importance of examining particular artistic contexts for producing this more intricate account. Nevertheless, we noted that emergent humanist ideas gave rise to *some general* changes in attitude and belief in Renaissance Europe of relevance to our topic: in particular, the concept of the 'free' and autonomous individual, worthy of praise and capable of producing inspired work.

We cannot assume, though, that even this more general influence was universal, particularly in the fifteenth century, as the opening of a written dialogue from 1450 entitled *De Mente* (*On the Mind*) by the humanist philosopher Cardinal Nicholas Cusa reveals. Cusa began by drawing on an ancient Greek text by Plato (*The Republic*). In Cusa's version,[1] the character of the *idiota* (Latin, ordinary layman) declares that spoonmaking is superior to art and poetry as it involves the making of something new rather than simply representing nature, as do poetry and painting. Cusa was an appreciator of art, and we cannot assume that he (unlike Plato) was deliberately setting out to downgrade artists. Nevertheless, the fact that he excluded them (and even more controversially poets) from the humanist-approved process of innovation, shows how fluid was the debate about artistic status at the time. Van Mander also, writing at the turn of the seventeenth century in northern Europe, evidently recognized that the high standing of artists could not be taken for granted. He referred to his lives of famous Netherlandish and German painters rather defensively as 'subject matter which perhaps, or rather certainly, could be judged by some to be too banal or trivial'.[2]

The diversity of ideas about artistic status is one aspect of the debate we have sought to address in this book. A second aspect is the authority of Renaissance ideas: however powerful the Renaissance rhetoric about the high standing of its artists may have been, there were and are other terms of reference. We should not be deceived into downgrading art produced outside of the Italian-inspired Renaissance model. Neither should we assume too readily that preceding centuries did not share some of its ideas. Rather than envisaging an artificial rift between the practice of the Middle Ages and the status-conscious Renaissance, as Vasari did, it is perhaps more fruitful to look at continuities in the debate.

By way of conclusion to the book, then, we will summarize those features relating to the position of the artist that survived the sixteenth century and are, in one form or another, with us still.

[1] Plato's comparison was between an artist and a carpenter.

[2] In his treatise on painting of 1604, *Het Schilderboek* (*The Painter's Book*), quoted in Fernie, *Art History and its Methods*, p.47.

A key issue in the debate over status, and one of greatest concern to the humanists, was the claim that art should be recognized as an activity involving learning. This claim was an enduring one, although it sometimes needed reiterating. Even as late as the end of the eighteenth century, in his third discourse on art, the English painter Joshua Reynolds carefully differentiated the painter from the 'mere mechanic'.[3] While remaining essential to the functioning of the academies, this idea was rivalled by the conviction that art did and should emanate from the heart and psyche of the artist, which is so evident in the recreations of the artistic personality of Watteau (Case Study 9). Whereas Vasari's anecdotes about the character traits of Renaissance painters encouraged the idea of the artistic temperament, it was primarily the Romantic movement that forged the concept of art as self-expression. Ultimately, these two contrasting views of the artist could produce rival canons, according to whether art was prized primarily for erudition or expression. In either case, in theory at least, art was valued not just for its material value, function, or for the way it reflected a patron's requirements, but for the identity and skill of the artist. We are the inheritors of these values, and one aim of this book has been to probe the assumptions that lie behind them.

The shift in initiative from patron to artist, illustrated by the career of Cellini (Case Study 3), is of the utmost significance in subsequent art history, for its relationship with the idea of an artist creating out of an inner idea or necessity rather than in response to a particular patron, time, and culture. The fact that Vermeer's paintings, for example, have been viewed variously in terms of a modernist emphasis on formal design and, in contrast, as the reflections of a democratic, Protestant Holland bypasses the question of his specific clientèle entirely, as Case Study 8 demonstrates. The cliché that a work of art can speak to any age can sometimes seem not so much a test of greatness as an assumption that the work cannot have been intended to address any age or class in particular. When Dürer spoke of the artist as 'inwardly full of figures' always with 'something new to pour forth by the work of his hand' (Case Study 4, page 111), he was simply trying to defend the mystery of artistic talent, but it is not difficult to see how this sort of idea could subsequently evolve so that 'new' becomes the absolute necessity for creative originality and an 'inward' idea inexplicable genius that makes an artist independent of his time.

For all that the artists he was writing about usually employed workshop assistants, Vasari (and many other critics and art historians after him) treated works of art as the sole, unaided efforts of an individual creator. Connoisseurship, the practice (however erroneously) of identifying the particular artistic name responsible for a work of art, and of establishing value on that basis, has been with us ever since, reinforced by the collecting habits of aristocratic patrons who replaced the church as the major consumers of art after the Reformation (see Case Study 7, page 172). In a sense, the artist's name might be seen as successor to the craftsman's marks of Brussels and Antwerp (Case Study 5, page 134) in guaranteeing both quality and authenticity in a commercial art market preoccupied with the artist's unique

[3] See Gill Perry, 'Mere face painters? Hogarth, Reynolds and ideas of academic art in eighteenth-century Britain', in Perry and Cunningham, *Academies, Museums and Canons of Art* (Book 1 in this series).

touch (see the Introduction to Part 3, page 189). Nevertheless, to assume that artistic practice necessarily coincided with the new ideal of the lone creator-artist would be a mistake. It was not only commercial painters such as the eighteenth-century English portraitists who continued to rely heavily on workshop assistance,[4] some very famous 'old masters' such as Rubens ran large workshops, and collaboration remains essential to this day in much sculptural work and in architecture.

At the start of this book we noted the pervasive influence of Vasari. Although the Italian fifteenth- and sixteenth-century art and artists championed by Vasari in his *Lives of the Artists* are sometimes seen as paradigmatic even now, for over two centuries the interest of collectors, galleries, and art historians in northern art has grown. This fame includes not just the long-revered Rubens and Rembrandt, but Dutch genre painting and the so-called 'Flemish Primitives' like Van Eyck, whose lives were recorded by Van Mander.[5] For all that northern artists did not necessarily construct their figures in the classical manner approved in Italian art theory, they can claim stature by the humanist criteria of invention and innovation: both oil painting and the technique of producing prints originated in the north rather than in Italy. The primacy of the Italian Renaissance once taken virtually for granted is now much more difficult to defend.

Perhaps the most significant and lasting legacy of the Renaissance that we have examined is artistic fame, both as a legitimate goal for artists and as an idea to be fostered by subsequent critics and consumers of art. In recording the lives of artists and preserving artistic reputations for posterity, Vasari has been seen as a sort of father of art history. It is ironic, then, that it is this very hard-won claim to fame that can hinder the work of the art historian today.

References

Fernie, E. (ed.) (1995) *Art History and its Methods: A Critical Anthology*, London, Phaidon.

Perry, G. and Cunningham, C. (eds) (1999) *Academies, Museums and Canons of Art*, New Haven and London, Yale University Press.

[4] See the reference to studio assistants employed in the production of the eighteenth-century portraits in Gill Perry, 'Mere face painters? Hogarth, Reynolds and ideas of academic art in eighteenth-century Britain', in Perry and Cunningham, *Academies, Museums and Canons of Art* (Book 1 in this series).

[5] See Anabel Thomas, 'The National Gallery's first 50 years', in Perry and Cunningham, *Academies, Museums and Canons of Art* (Book 1 in this series).

Recommended reading

The following list includes books of general interest that are relevant to the overall themes of this book:

Barthes, Roland (1977) 'The death of the author', in *Image–Music–Text*, ed. and trans. Stephen Heath, London, Fontana, pp.142–7.

Battersby, Christine (1989) *Gender and Genius: Towards a Feminist Aesthetics*, London, The Women's Press.

Buck, Louisa and Dodd, Philip (1991) *Relative Values*, London, BBC Books (Chapter 1, 'The Agony and the Ecstasy').

Kris, Ernst and Kurz, Otto (1979) *Legend, Myth and Magic in the Image of the Artist*, New Haven and London, Yale University Press.

Pollock, Griselda (1980) 'Artists mythologies and media genius, madness and art history', *Screen*, vol.21, no.3, pp.57–95.

Warnke, Martin (1993) *The Court Artist: On the Ancestry of the Modern Artist*, Cambridge University Press.

Wolff, Janet (1981) *The Social Production of Art*, London, Macmillan (second edition, 1993).

The following list includes works that relate to specific case studies in this book:

Part 1

Baxandall, Michael (1972) *Painting and Experience in Fifteenth Century Italy: A Primer in the Social History of Pictorial Style*, Oxford University Press (second edition, 1988).

Hughes, Anthony (1997) *Michelangelo*, London, Phaidon Press.

Kemp, Martin (1997) *Behind the Picture: Art and Evidence in the Italian Renaissance*, New Haven and London, Yale University Press.

Rubin, Patricia (1995) *Giorgio Vasari: Art and History*, New Haven and London, Yale University Press.

Wackernagel, Martin (1981) *The World of the Florentine Renaissance Artist: Projects and Patrons, Workshop and Art Market*, trans. A. Luchs, Princeton University Press.

Welch, Evelyn (1997) *Art and Society in Italy 1350–1500*, Oxford and New York, Oxford University Press.

Woods-Marsden, Joanna (1998) *Renaissance Self-Portraiture: The Visual Construction of Identity and the Social Status of the Artist*, New Haven and London, Yale University Press.

Part 2

Baxandall, Michael (1980) *The Limewood Sculptors of Renaissance Germany*, New Haven and London, Yale University Press.

Gibson, Walter S. (1977) *Bruegel*, London, Thames & Hudson.

Harbison, Craig (1995) *The Art of the Northern Renaissance*, London, Everyman Art Library.

Hutchinson, Jane Campbell (1990) *Albrecht Dürer: A Biography*, Princeton University Press.

Koerner, Joseph (1993) *The Moment of Self-Portraiture in German Renaissance Art*, Chicago and London, University of Chicago Press.

Melion, Walter S. (1991) *Shaping the Netherlandish Canon: Karel van Mander's Schilder-boeck*, Chicago and London, University of Chicago Press.

Part 3

Crow, Thomas E. (1985) *Painters and Public Life in Eighteenth-Century Paris*, New Haven and London, Yale University Press.

Johannes Vermeer (1995) exhibition catalogue, Washington, National Gallery of Art and The Hague, Royal Cabinet of Paintings, Mauritshuis.

Posner, Donald (1984) *Antoine Watteau*, London, Weidenfeld & Nicholson.

Westermann, Mariët (1996) *The Art of the Dutch Republic 1585–1718*, London, Everyman Art Library.

Index